FERNAND LEGER

Drawings and Gouaches

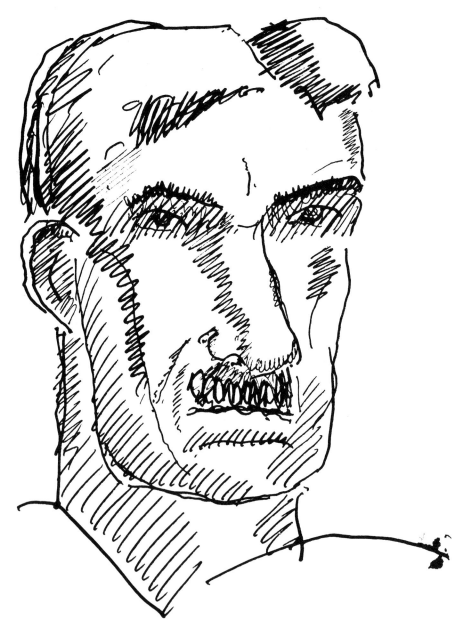

Self-portrait *c.* 1930 (ink)

FERNAND LEGER

Drawings and Gouaches

Jean Cassou and Jean Leymarie

382 illustrations, 28 in colour

 Thames and Hudson · London

R 709.04

Documentary research associate Michèle Richet
Translation from the French by W. K. Haughan

First published in Great Britain in 1973
by Thames and Hudson Ltd, London

Printed and bound in France

ISBN 0 500 23188 5

R 709.04

Contents

Foreword

The complete catalogue of the works of Fernand Léger has still to be compiled, and it was not our intention to draw one up for his drawings and gouaches; those we have selected from a particularly rich output have been chosen above all because they are representative of the different periods of Léger's artistic activity. None of his engravings has been included. Only a few of his book-illustrations and decorative works are mentioned.

In order to show Léger's creative process clearly, we have decided to compare the drawings and gouaches with some of the paintings to which they led. These appear in small format among the captions, and represent only a small proportion of the many possible examples.

Léger sometimes took up a theme again after an interval, and this has sometimes made the continuity of our account difficult. Chronological order has been respected as scrupulously as possible. As Léger was in the habit of dating works on the day when he gave them to his friends, we have restored the probable date of execution.

From a technical point of view: with very few exceptions, the works reproduced are drawings in ink or pencil, or gouaches, on white or coloured paper. But here it is necessary to qualify. Those who knew Fernand Léger assure us that he never used watercolour, even when one would otherwise assume that this technique was present. Subscribing to the opinion of M. Lefebvre-Foinet on this matter, we feel that the distinction between gouache and watercolour, for which a chemical analysis of the pigments would be needed, is of little interest; a gouache with a very diluted pigment does not allow of corrections any more than a watercolour.

We are very grateful to the museums and other institutions, and to the many individuals, some of whom have preferred to remain anonymous, who have given us their assistance in preparing this work, by permitting us to reproduce works in their possession and by providing us with information. In the analysis of the works, Bertrand Marret's assistance has been invaluable.

Léger and the Image

I know a very fine Léger drawing. It can be found under the entry 'Stained Glass' in volume IX of Viollet-le-Duc's *Dictionnaire raisonné de l'architecture française* (1854–68). It is the face of St Timothy, taken from a stained-glass window in Alsace which probably dates from the middle of the twelfth century. But what is important is to consider the impression suddenly made, as we leaf through the *Dictionnaire*, by this fixed look from under high, curved brows, the straightness of the nose and the two vertical lines framing the rounded shape. The technique of our oldest known makers of stained-glass windows, the shapes they gave to the coloured glass, and the decisive sharpness of the lead outlines, have here formed an image which registers at once as a Léger face, as being his style. I have just used the word 'image'; this is an image, a sign, rather than a picture. Our eye has instantaneously seized on the resemblance; the image is made to be taken in at a glance.

It was no doubt the specific technique involved in making stained-glass windows that resulted in this style. There was a later development: the original, purely technical function of the lead took on an aesthetic function, as the craftsmen's mode of expression evolved towards Gothic naturalism. From a distance —as our gaze moves from the worshipper shown kneeling on the ground up to the high window depicting heaven itself—the harsh leaden outlines merge with the shadow, or with the shapes painted near the edge of each piece of glass. Hence a plastic effect which marks a slight movement away from the image towards the picture.

But—it will be objected—the same conditions of craftsmanship, the same strict technical demands, were not imposed on Léger; if Léger created a style which was analogous to this, he did so by choice. This is true; but makers of Romanesque stained-glass, though inevitably guided, as they set their pieces of glass in lead, towards an 'image', must surely still have been able to find in this some satisfaction for their own secret aspirations. There was in this, as in all artistic processes, the conjunction of a figurative and expressive design with the nature of the

material and its requirements. As far as Léger was concerned, if he did outline his forms, it was clearly not because the material he was using obliged him to do so. Léger, with his thick black lines, returned instinctively to a formula which had a strictly technical origin. He made it his own, *as if* some law imposed by material and tools—and not merely his own fancy—had been pushing him in that direction as it had done long ago with his Romanesque compeers. The heavy outline had had its justification then; and his work still bears the mark of that modest craftsmanly logic.

However one may explain it, the similarity is striking. The motives of the twelfth-century glazier and those of the twentieth-century Cubist do not correspond in their details, but they reveal themselves as being of the same nature; above all, they share the resolution to use all the materials, whether chosen or imposed, to create an image.

To return to that word, and what it means. Those medieval craftsmen called themselves *imagiers*, image-makers. The word 'image', then as now, has a sense in which it means something very different from what we understand by the words 'picture', 'imitation', 'representation', 'transposition' or 'interpretation'. All these words imply above all a relationship between man and nature, a relationship of which man becomes aware to the extent that he wishes to give it expression. The wish may result in a representation very unlike nature, and unlike whatever selected things in nature have inspired the man to represent nature; but the relationship remains the essential part of the process. 'Image', in the sense in which I am using it, does not comprehend this relationship, nor the subjective distortions to which it gives rise. The image is *not* the fruit of a marriage between an intention to reproduce and an inspiration. The image is an icon: it designates and it teaches. It is easy to read, because it calls for none of those multiple, complex contingencies which have infinitely enriched the process of representation. The image sets forth an axiom, a self-contained, direct, simple truth such as the worshipper in a Romanesque church apprehended in raising his eyes to a stained-glass window. The illustrations in a child's very first book, the A B C, are images in this sense, as are the French popular woodcuts, the *images d'Epinal*, which show the Wandering Jew, or St Nicholas reviving the three children in the salting-tub, or the highwayman Cartouche attacking a stagecoach. The figures in Fernand Léger's *Grand Déjeuner* (*The Meal, Large Version*) are related to all these examples. They are images. In this, they break with all contemporary categories, although Léger did, in his own way, take part in the Cubist revolution.

The image-makers in the history of Western art are a group with many things in common. Theirs is not a relationship with nature, as such, but with substances: lead, and also the wall and everything that goes to make a wall, and everything that can be used to draw and paint on it. And when a piece of work has been finished it is the occasion of research, discussion, advice and teaching within a community of craftsmen which is founded not on any union of goods and privileges but on the common skill of the workers; it transcends time and space.

We could not imagine this brotherhood of craftsmen without postulating certain moral principles, which are of necessity aristocratic. For their characteristic aim will be to produce *well-made works*, works containing their own justification, whose purpose is their own excellence and perfection. The maker is striving to make something in the best way: it is in this that he is an aristocrat, that is to say a champion of what is best. And in adhering to this vocation, he rejects pretence, exaggeration and affectation: and it is in this that he is moral.

The image has power only because of the way it is made, and it requires no other recommendation than this: that it is well made. Every part of it answers for itself, and consequently fits in with the next part all the more completely and with a more distinctive rhythm. Or, alternatively, it stands out from its context right away, which is another way of attaining clarity. For that is what is important: to make things clear, to isolate them, to stress the individuality of each one, even if they are interrelated like the parts of a machine. And yet, by this very fact, they will be cut off from certain other associations, which are the normal ones, the ordinary ones. For, as Léger said, in the eyes of 'the epic character to whom we generally give the name of inventor, artist, poet', the elements of normal, ordinary composition are cross-cut, juxtaposed and contrasted in a way that is completely new and above all *free*. Free: Léger lays great stress on the word in his writings. His is a heady freedom vibrant with syncopation, like the poetry of Cendrars or the music of Milhaud.

The image designates, as I have said; it is a design, a drawing. To say of Léger that he is an image-maker is to say that he is a draughtsman. He said so himself. His drawings were 'preparatory work' for his paintings, but this was the work that mattered, and it was here essentially that Léger displayed his temperament and his inalienable strength in organization. Thus, he said, in words recollected by Dora Vallier: 'I do a lot of preparatory work. First of all, I make a number of drawings, then I do some gouaches and finally I go on to canvas, but when I attack it I am 80 per cent certain. I know where I am going.' The hardest

work had been done—slowly, and without improvisations, but done. For Léger the essential process of preparation was also a moral act, exemplifying the Renaissance concept of *virtù* in both its aspects: the artistic, signifying the power to make, and the ethical, signifying stoical self-betterment. Ingres, who was himself a man of the people, meant exactly the same thing by his maxim that drawing is integrity in art. To draw a thing is to seek out the very tenor of it.

It is true that in Léger's first period, that of Cubism, he gave his public no objects whose identity it could recognize. But his basic drawing technique was as it would always be. There is that same attention to internal relationships, in machinery, in the human body and in the urban or natural landscape. The springtime of Cubism, in which Léger was one of the moving spirits, caused his basic technique to manifest itself through a strange new approach involving an astonishing multiplicity of fragmentations. The result was not a view of the world but an image inspired by the world, with nature itself interlocking with the modern industrial scene. Plumes of smoke over the city combine with the chimneys and the roofs, as solid bodies in their own right; their outlines are not geometrical analyses of visible bodies, but bodies themselves, elementary and rudimentary, conjoining to form an image. If certain of these forms break up the plane surfaces, accentuate their own volume—one of the problems clearly stated by Léger—the shadow which emphasizes their contours is not cast by an external light, as it was in those old stained-glass windows where it marked a progress towards a kind of realism: here shadow is allied with circular or cylindrical forms for no other purpose than to show that they are revolving shapes. Similarly, when, in this period, the artist explores a number of possible arrangements, he uses his ingenuity to represent them in their most simplified state, so that the ordinary appearance of a wheel or a screw or an accordion does not leap to the eye as it does in later works. The accordion, whether opened out to full volume or silently compressed to three vertical lines, is a favourite object which appears in some of his most complex pictures, and a progression is clearly visible in his treatment of it: later, when the pictures became more immediately accessible, it would immediately show itself to be an accordion in the hands of an accordion player. But the observant eye and the sure hand always remained the same.

We may define Léger's genius by its positive tendencies, and also by its negatives: what he rejected, what he hated. Léger was known to have two pet aversions: Impressionism and the fluent, melodious line. It could not have been otherwise with one

who had a genius for drawing; for no impression can produce a drawing. Impressions do not fit together, as Léger's visual machinery does. If they are juxtaposed, it is so that they may influence each other; and any discord they may produce still obeys the laws of harmony, being resolved on the retina. But Léger's contrasts cannot possibly be resolved; they cohere in space as if space were totally abstract, insensible to all the influences of light, time, season, atmosphere or environment. Léger's manner of drawing guarantees his forms against all risk of fusing with anything at all. For that is the obsession of the true draughtsman: to find the object which, when juxtaposed with the one he has just drawn, will most forcefully mark it out as distinct. Cubism, and Léger's art in particular, is the art of the discontinuous.

One day in 1930, Léger had, in his own words, 'done a bunch of keys on a canvas'. And he wondered what on earth he could put beside them that would be in absolute contrast with the keys. He went out, still puzzling over this, and suddenly caught sight of a postcard of the *Mona Lisa* in a shop-window. 'I realized right away', he said. 'That was what I needed; what could be a greater contrast with the keys? And so I put the *Mona Lisa* on the canvas.'

The draughtsman's pleasure in creating images was renewed from day to day by means of sketches taken from life, whether it was the life of trees or flowers, the human body, or a machine in motion. Léger delighted in machines; he relished their gears, their thrusting and working motion. It was no less enjoyable to take an object—any object—and suspend it in isolation; and then the object would expand by virtue of its own inner energy. With what passion he would draw it then! How fascinating a hand is, or a leaf! Joy in drawing is essential to Léger; it is so absorbing, so complete that it is still at the heart of the act when the act has become a gouache or a painting.

It frequently happens that, when one has to praise the greatness of an artist's drawings, one values him less highly as a painter, or vice versa. That is because it is accepted that these are the two basic tendencies of artistic creation, which can be taken as a basis for a preliminary, elementary classification. Léger was certainly a draughtsman; colour was not his prime concern. And yet he himself described it as the culmination of his creative process; and, from the very beginning of Cubism, Delaunay and he set themselves apart from the others by using colour rather than monochrome. So colour was always in his mind, but as an ultimate reward rather than an initial stimulus. Here he used the same method of contrast and con-

frontation as he applied to drawing: he used colours in their pure state and kept them separated one from another. Just as he refused to situate his objects even on a table, to avoid contamination by their surroundings, in the same way he would not allow his colours to mix, or even to be complementary. He did not allow them to modulate, or to sing. 'I wanted to end up with colours which were isolated,' he said; 'a red that was very red, a blue that was very blue.' As he did with his curved lines, his straight lines, his volumes and his forms, he raised each colour to the most intense affirmation of its own identity and essence. And since this affirmation is not attended by any unexpected consequence, any effect external to itself, the results strike the beholder as utterly exceptional works of art. Léger was always suspicious of schools of painting which strove after effect or operated on the senses. He sometimes wondered if he were not a classical artist. There can be no doubt of the answer: he was.

His classical intelligence manifests itself in a particularly delightful way in the process by which he moves by way of gouache to the painted picture. For someone who begins work with a multiple, continuous series of drawings, gouache is the perfect way of introducing colour. For, with gouache, the colour cannot possibly have thick patches or move in sweeps as it can with oil paints. And the colour in Léger's gouaches is particularly exquisite. Apollinaire, who died in 1918, knew only the very first part of Léger's output; we might say today that he began with the most difficult part. And yet he seems to have foreseen everything: 'Vous voilà, belles teintes, couleurs légères. . . .'

Plenty has been said about the power and energy of Léger's work, and his ability to work on a huge scale. This praise has not always been bestowed with the best of intentions; forcefulness in a painter's work is widely assumed to entail crudity and lack of discipline. But, for Léger, there was no strength without an awareness of the problems it posed. The subtlety of Léger's solution to the problem of colour is particularly striking in his gouaches; because of its clarity, its limpidity and its lightness, his technique here still remains close to pure drawing. Gouache seems to have been chosen especially so that Léger could show, in its use, his liking for restrained, subdued colouring that was strictly and completely pure.

Apollinaire also felt the originality of the drawing method used by his friend. As with his way of using pure colours, it was simplicity itself: the rejection of all illusion, all deceptive appeals to the senses, which are contrivances that a creator of images can do without. 'Another slight effort, to get rid of perspective, the wretched trick of perspective, this fourth dimension in reverse,'

cried Apollinaire; 'perspective, the infallible way of reducing everything in size!' Perspective had been an admirable invention; but to expose it as a trick was no less admirable. This point of departure in turn made necessary all kinds of new inventions, different from those which resulted from perspective, and all admirable in their own way. Perspective makes things smaller in order to make us see what is big; but Apollinaire, with his intuitive genius, understood that Léger's art consisted in rejecting this subterfuge so that what is big stays big all the time, and there is room only for what is big. All the art of Léger's drawing lies in this largeness.

His image of a bunch of keys is big. And the keys in it are big, because he could not bring himself to make an object smaller in aid of this or that effect: this would mean forcing it away from its ontological reality and transposing it into an illusion. Léger's creative tension lay in a search for reality. There was nothing painful in this tension; a benevolent curiosity, constantly alive to the world and its inexhaustible abundance of objects and living beings.

One can imagine that this passion for observing would be magnified a hundredfold on the occasion of his first trip to the United States in 1931. There indeed, according to popular opinion, the shape of the present-day world was revealed in its newest and most profound aspects. But his astonishment at the colossal architecture was no different in kind from that aroused by the prickly outline of a holly leaf at home on the outskirts of Paris. In a letter to Simone Herman, he describes a rather gloomy train journey from Chicago to New York. He went alone to the platform at the rear, and noticed a little piece of rag caught in a great shining brass screw. The slipstream made the rag dance 'a hellish dance round the big, hard, unmoving, shining screw'. It was, he said, 'a frantic ballet', and one thinks of his *Ballet mécanique*, the outrageous comic masterpiece created some years previously, in 1924, which brought to light wonders equally minute in our eyes and equally huge in the eyes of the image-maker. The rag continued its 'thin, raging dance'. 'For an instant it was like an insect caught by one leg and trying desperately to free itself, then again it was caught in a different current of air, which made it fly straight out, immobile.' This seduction scene, with all its vicissitudes, went on until the Negro guard had occasion to do something or other on the observation platform and set the rag free. Thus ended the tale of the Screw and the Rag, told by a real storyteller in the popular tradition. He avoided in his art everything that produced liaison, continuity, and therefore narrative. But this tale is not a discourse.

It is not planned, but original, direct and unpolished: a speaking image. And it is in the same direct style, the style used for folk tales and fables, that all the entities, elements, objects, forms in his works speak to us: all the pipes, ropes, parts of tugboats, arms and female torsoes, rungs of ladders and bricklayers on their ladders, and that yellow that is a yellow, and that blue that is a blue, both of which will keep in their own places, restricting their dialogue to this statement of their existence and never mingling tones to give birth to a green. The Story of Yellow and Blue is as fine as that of the Screw and the Rag. It can be read in an image. It is told in a language that is concise in the extreme, so concise that we should say that it is not so much told by it as contained in it. Everything here is a thing in itself, individual and perfectly autonomous; and so is the image-maker himself. He can be approached only in his own terms, in terms of his vocation as an *imagier*. If we lose sight of this, we risk belittling him and losing ourselves in the ornate irrelevances which his passionate lucidity abhorred above all. We can know Léger only on his terms, only in terms of his essential truth.

Chronology

1881 Fernand Léger born on 4 February at Argentan, the son of Henri-Armand Léger, a stock-breeder, and Marie-Adèle Daunou.

1897 After attending schools at Argentan and Tinchebray, Fernand Léger, who had lost his father, was apprenticed to an architect at Caen.

1900 He left Caen for Paris, where he worked as a draughtsman with another architect.

1902 Military service at Versailles.

1903 Admitted to the Ecole des Arts Décoratifs. Refused by the Ecole des Beaux-Arts, he followed, as a free pupil, the courses run by Gérome and Ferrier.

1904 Shared the studio of the painter André Mare.

1905 Painted his first works. Subsequently destroyed many of the paintings executed between 1905 and 1910 and kept drawings only.

1906 Spent the winter in Corsica on account of illness. Painted Corsican landscapes.

1907 Strongly influenced by the retrospective exhibition of Cézanne's works at the Salon d'Automne.

1908 Settled at La Ruche, in Paris. Met there Archipenko, Chagall, Delaunay, Laurens, Lipchitz, Soutine, as well as Apollinaire, Blaise Cendrars, Max Jacob and Reverdy.

1909 Made the acquaintance of Henri Rousseau.

1910 Kahnweiler admitted him into his gallery, where Braque and Picasso exhibited. Léger saw their paintings there.
Attended the meeting at Jacques Villon's home which led to the formation of the group called *La Section d'Or*. Exhibited a drawing at the Salon d'Automne.

1911 Exhibited his painting of *Nudes in the Forest*, which created a scandal, at the 'Salon des Indépendants'. Also exhibited two drawings there.

1912 Exhibited *The Woman in Blue* at the 'Salon d'Automne'.

1913 Took his studio at 86 rue Notre-Dame-des-Champs.
Signed an exclusive contract with D. H. Kahnweiler. This contract stipulated: 'Monsieur Kahnweiler commits himself to buying all that Monsieur Léger shall produce in the way of oil paintings, as well as at least thirty heightened drawings and twenty line-drawings.'
His contribution to a Cubist exhibition in Barcelona consisted of drawings.

1914 Lecture, 'Réalisations picturales actuelles', at the Akademie Wassilieff in Berlin.
Mobilized as from 2 August. (Léger was to do many sketches at the Front in the course of the war.)

1915 His unit transferred to Verdun.

1916 Painted *The Soldier with a Pipe* when on leave.

1917 After being gassed at the front at Verdun, he was hospitalized at Villepinte.
Painted *The Card Game*.
The review *De Stijl* was founded in Holland.
1918 Illustrated Blaise Cendrars' *J'ai tué*.
1919 Painted *The City*.
Married Jeanne Lohy.
Illustrated *La Fin du monde filmée par l'ange Notre-Dame* by Blaise Cendrars.
Visited Sweden.
Léonce Rosenberg became his dealer.
1920 Meeting with Le Corbusier; founding of *L'Esprit nouveau*.
Illustrated Ivan Goll's *Die Chapliniade*.
1921 Illustrated André Malraux's *Lunes en papier*.
Commissioned by Ballets Suédois to design the curtain, scenery and costumes for the ballet *Skating Rink* by Rolf de Maré, music by Arthur Honegger.
Painted *The Meal, Large Version (Le Grand Déjeuner)*.
1923 Designed scenery and costumes for *La Création du monde*, with music by Darius Milhaud and libretto by Blaise Cendrars.
Helped to design the sets and costumes for Marcel L'Herbier's film *L'Inhumaine*.
Illustrated *Le Nouvel Orphée* by Ivan Goll.
Published 'L'Esthétique de la machine' in *Der Querschnitt*, Berlin.
1924 Painted *Reading*.
Opened a free studio with Ozenfant.
Composed and made *Le Ballet mécanique*, 'the first film without a story' (photography by Man Ray and Dudley Murphy, music by Georges Antheil).
Italian journey with Léonce Rosenberg.
On his return, he visited the modern theatre exhibition organized by Friedrich Kiesler in Vienna, to which he contributed (drawings for the scenery and costumes of *La Création du monde* and *Skating Rink*).
1925 Showed some mural painting in the *Esprit nouveau* pavilion at the 'Exposition des Arts décoratifs', and, with Delaunay, was commissioned by Mallet-Stevens to provide the décor for an entrance-hall to a model French embassy built in the exhibition.
Published the article on popular dancing in the twelfth issue of *L'Effort moderne*.
1929 Taught at the Académie with Ozenfant.
1930 Painted the *Mona Lisa with Keys*.
1931 Made his first trip to the United States.
1932 Taught at the Grande Chaumière.
1933 Travelled to Zurich for an exhibition of his works at the Kunsthaus.
1934 Stayed with Mr and Mrs Murphy at Antibes.
Designed marionettes for Jacques Chesnais.
1935 Provided mural decorations for a gymnasium, for the International Exhibition in Brussels.
1936 Took part in debates, together with Aragon and Le Corbusier, on the *Querelle du réalisme*, at the Maison de la Culture.
1937 Executed the mural painting *The Transmission of Power* for the Palais de la Découverte and designed the scenery for Serge Lifar's ballet *David triomphant* (music by Riéti).
1938 Created the décor for the apartment of Nelson A. Rockefeller Jr.
1939 Finished the *Composition with Two Parrots*, on which he had been working for three weeks.
1940 October: embarked at Marseilles for the United States. Was asked to lecture at Yale University.
1941 Professor at Mills College, California.
1942 Painted *The Three Musicians*.
1945 December: returned to France.
Member of the French Communist Party.

1948 Some illustrations in Guillevie's *Coordonnées*.

1948–49 Painted *Leisure: Homage to Louis David*.

1949 Finished the mosaic which Fr. Couturier had commissioned for the church at Assy.

Illustrations for Rimbaud's *Les Illuminations*.

Made his first ceramics at Biot (Alpes-Maritimes).

1950 Death of Jeanne Léger.

Text and illustrations for *Le Cirque* (Tériade, Paris).

Scenery and costumes for *Bolivar* (music by Darius Milhaud), for the Opéra in Paris.

1950–51 Painted a series of pictures on the theme of *Constructors*.

1951 Stained-glass windows for the church at Audincourt.

1952 Married Nadia Khodossevitch, his assistant and pupil since 1924.

Mural for the great hall of the UN Building in New York.

Bought Le Gros Tilleul at Gif-sur-Yvette and settled down there.

1954 Finished *The Grand Parade*, his last big composition.

1955 Awarded the main prize at the Biennial Exhibition at São Paulo.

Died at Gif-sur-Yvette on 17 August.

1959 Publication of *Aquarelles, gouaches, lavis, crayons*, with a preface by Aragon (Au Vent d'Arles, Paris), and *La Ville* (Tériade, Paris).

1960 Publication of *Mes Voyages* (Éditeurs français réunis, Paris), poems by Aragon and lithographs by Léger.

1961 Inauguration at Biot (Alpes-Maritimes) of the Musée Fernand Léger, founded by Mme Nadia Léger and M. Georges Bauquier.

1 Early Career 1904–13

Léger destroyed practically all his early works up to 1909. A few paintings which have been preserved, dating from 1905, reveal the influence of Pointillism, which was then very fashionable, but still show a solicitude to avoid chromatic dilution and keep to solidly based form and the control of light. The many and varied extant drawings from this period reveal a basic need for linear expression as well as acting as stylistic landmarks. The earliest of them (1903) are portraits or caricatures of his friends and comrades at Argentan, such as the painter André Mare (1), whose studios at Montparnasse he shared before he settled down at La Ruche, or Henri Viel (2), a civil servant who was posted to Corsica, and whom he met again on several occasions. These are usually small, half-length sketches in charcoal or water-colour, intimate and truthful.

Repelled by the official artistic training, which he followed only sporadically, Léger preferred sessions of unsupervised work in private academies, the Grande Chaumière or the Académie Julian, where he conditioned himself, over a period of several years, to draw live models every evening. A series of drawings of nudes, most of them initialled and dated, covers the whole of this period before the war, and shows a constant process of development. Technically, chronologically and stylistically, these drawings fall into three main groups, and some examples from each are reproduced here.

The drawings in Indian ink from 1905 to 1912 are essentially straight life studies, bold and spontaneous. Apart from an occasional hint of a table on which the model is leaning all his weight (11), they emerge from a neutral background. The hands and feet are treated schematically, the head reduced to its basic oval shape, the limbs dislocated. Léger rejects the rules of anatomy and the sensual implications of the nude to stress, by

the force of outline alone, the plastic structure and rhythm of the human body. It is striking to compare the *Standing Nude* of 1905 (3), drawn with strokes that are obviously vigorous but still loose and continuous, with the monumental *Standing Nude* of 1911 (4), drawn with thick, broken strokes and vigorously stylized.

To Léger, as to all the best artists of his generation, Cézanne represented a decisive stimulus. 'Cézanne taught me the love of shapes and volumes; he made me concentrate on drawing,' acknowledged Léger. 'I realized then that drawing should be rigid and not at all sentimental.' In the cosmopolitan artistic community of La Ruche, he also watched Archipenko at work: 'I was greatly intrigued by contrasting materials. It seemed to me wonderful to bring wood and metal into play together.' The ruggedness of Cézanne, the wooden or metallic density of plane surfaces hewn to sharp ridges, and a manifest 'Primitivism' in vision and execution, characterize *The Seamstress* (1909, private collection, Paris), the first painting in his personal style, in which architectonic tension absorbs the intimate nature of the subject.

Although none of them refers directly to it, the geometrical nudes lead up to the first major composition, which was finished in spring 1910, the *Nudes in the Forest* (Rijksmuseum Kröller-Müller, Otterlo), an arrangement of cones and cylinders in a strange, muted light, the result of years of effort—in the painter's own words—to 'manipulate form for form's sake' and win 'the battle of volumes' before conquering colour. Colour asserted itself triumphantly in 1912 with *The Woman in Blue* (Kunstmuseum, Basle), a masterly composition of pure tones in areas defined by a system of rings, within which they were rhythmically applied.

The nudes in charcoal or pencil (14–16), dating from 1912 and 1913, are no longer simple sketches silhouetted against an abstract background, but large and elaborately detailed studies which reveal all Léger's graphic mastery, and his unique position at the heart of the Cubist movement. Volume is not broken up analytically into multiple facets, as it is in the works of Braque and Picasso at the same time, but reveals its constituent masses and inner cores by means of a network of contrasted straight lines and curves, light patches and shaded areas. These female nudes, placed in several relationships to the chair they are sitting on, are now set in a definite frame and create a rich, strong spatial articulation by means of the variations in the position of the arms and legs and the tilt of the head. The circle round the picture is a working-out of a traditional theme, morphologically and chromatically analogous to *The Woman in Blue* (in Basle) and

the *Nude Model in a Studio* (in the Guggenheim), of which we give here a very elaborate preparatory gouache (21) with strong inflexions; this constitutes the third category of nude drawings. For Léger, modernity did not consist in the choice of subject, as the Futurists naïvely thought, but in its interpretation. For, he said, 'with the most ordinary subject, the most often-used subject, a nude woman in a studio and thousands of others, you have a better alternative than locomotives and other modern machinery, which it is difficult to have brought to your home. All these things are materials; the only interest is in the way in which they are used.'

This declaration is found in the famous lecture 'Les Réalisations picturales actuelles', which he delivered and published in June 1914. In it he defined the artistic revolution which had just taken place—in terms of his own work—as the replacement of the old 'additive painting' by what he called 'multiplicative painting', which was governed by the basic principle that was to influence his work to the end: intensity of contrast. 'Take . . . the visual effect of round curls of smoke rising between buildings. You wish to render their plastic value; and here you have an excellent practical example on which to put into practice the results of this research into multiplicative intensities. Concentrate your curves with the greatest variety possible, short of disuniting them; frame them by means of the hard, dry relationship of the surfaces of the houses, dead surfaces which will acquire mobility by the fact that they will be coloured contrarily to the central mass and that they are in opposition to live forms; and you get the maximum effect.'

The drawing in Indian ink, *Smoke over the Roof* (13), to which there is definitely a corresponding painting, shows the general pattern of those little urban scenes which Léger executed between 1910 and 1912, at the same time as those of his friend Delaunay.

In his gouache studies (18, 19) and the paintings on sackcloth, Léger developed his revolutionary series of *Contrasting Forms* to the point of abstraction; because of their freedom of pure colours and contours, which separate to give a more dynamic rhythm to the surface, these remained the generative nucleus of his whole output. But for Léger, always faithful to reality, this was only a short experimental phase, and not the radical leap towards non-figurative art that Kandinsky and Delaunay were making at the same time. The subject re-emerges from the geometrical structure which dominates the studies for *Woman in Red and Green* (17, 20).

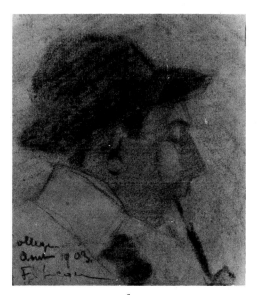

1

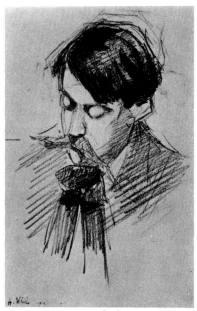

2

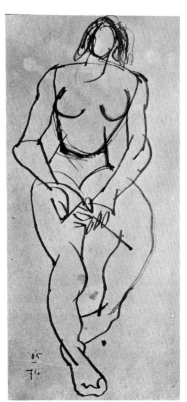

3

1 Portrait of André Mare 1903
 charcoal, 29.5 × 25 cm
 dated and signed lower left: *Collège*
 août 1903
 F. Léger
 Collection Mare-Vène, Paris

2 Portrait of H. Viel 1904
 charcoal, 18.5 × 12.5 cm
 inscribed lower left: *H. Viel (1904)*
 Musée National Fernand Léger, Biot

3 Study of Nude Woman, Standing 1905
 ink, 33 × 16.5 cm
 dated and signed lower left: *05*
 FL
 Musée National Fernand Léger, Biot

4 Study of a Standing Nude 1911
 ink, 33 × 25 cm
 dated and signed lower right: *11*
 FL
 Private collection

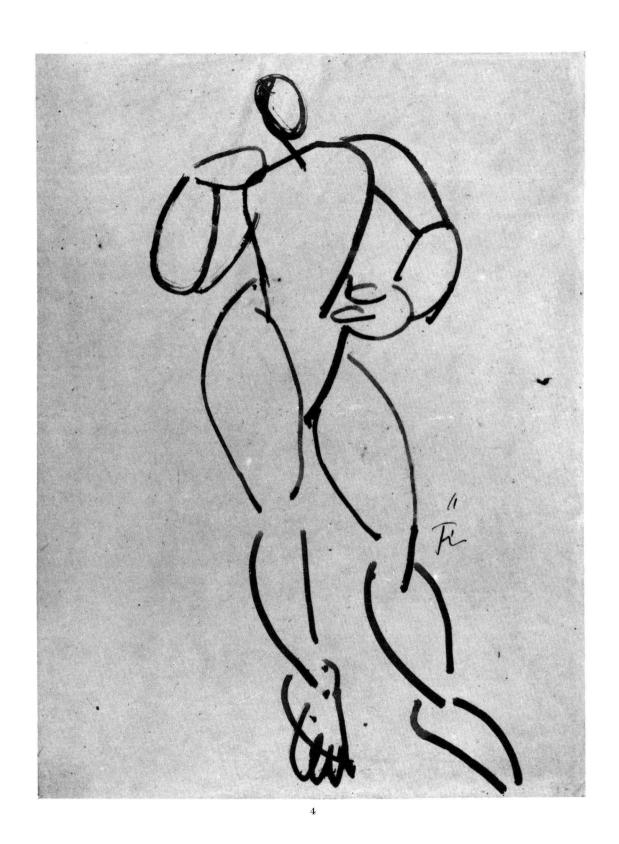

4

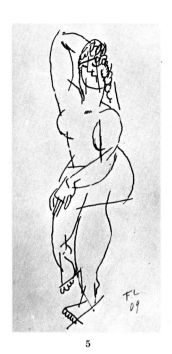

5

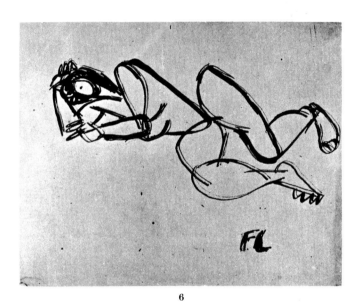

6

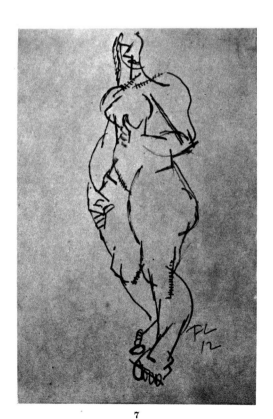

7

5 Study of Nude Woman, Standing 1909
ink, 24 × 12 cm
signed and dated lower right: *FL*
 09
Private collection, Paris

6 Reclining Nude
ink, 25 × 34 cm
signed lower right: *FL*
Private collection

7 Study of Nude Woman, Standing 1912
ink, 30 × 20 cm
signed and dated lower right: *FL*
 12
Musée National d'Art Moderne, Paris
(Presented by D. H. Kahnweiler)

8 Study of Nude Woman, Kneeling 1911
ink, 28 × 16 cm
dated and signed lower right: *1911*
 FL
Philadelphia Museum of Art, Philadelphia

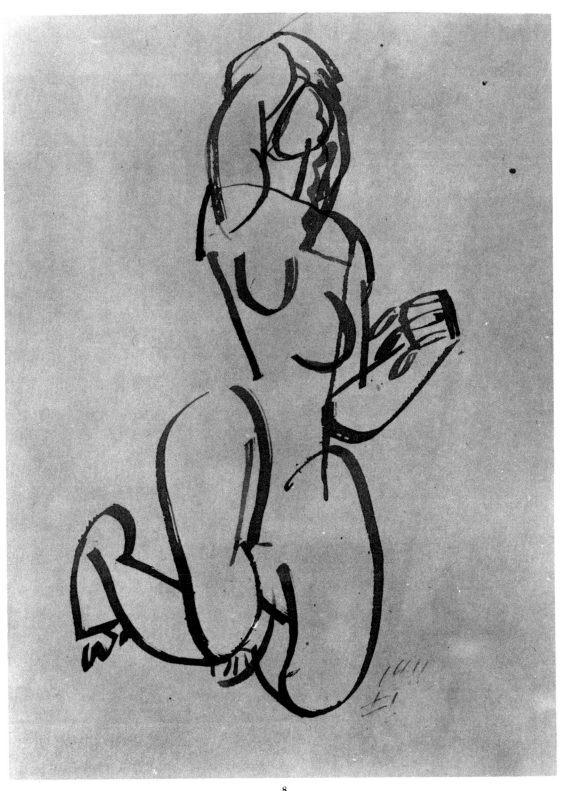

8

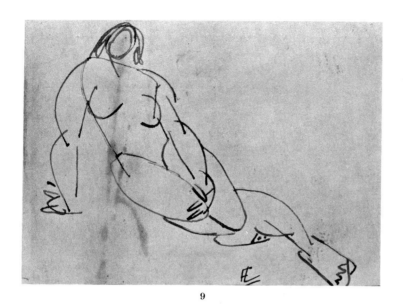

9

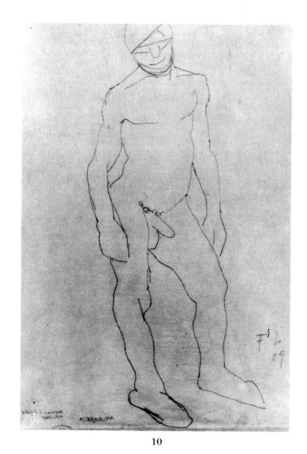

10

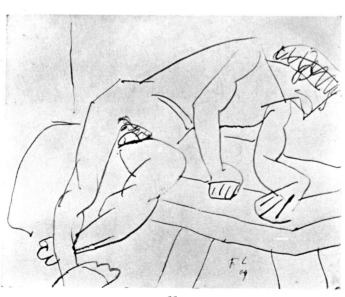

11

9 Study of Nude Woman, Reclining
 ink, 23 × 32.5 cm
 signed lower right: *FL*
 Collection Mare-Vène, Paris

10 Study of Male Nude
 pencil, 33 × 25 cm
 signed and dated lower right: *FL*
 09
 Musée National d'Art Moderne, Paris
 (Presented by D. H. Kahnweiler)

11 Study of Male Nude, Seated 1909
 ink, 25 × 34 cm
 dated and signed lower right: *FL*
 09
 Kunsthalle, Hamburg

12 Nude Woman, Standing
 ink, 32 × 22 cm
 signed lower right: *F L*
 Öffentliche Kunstsammlung, Basle

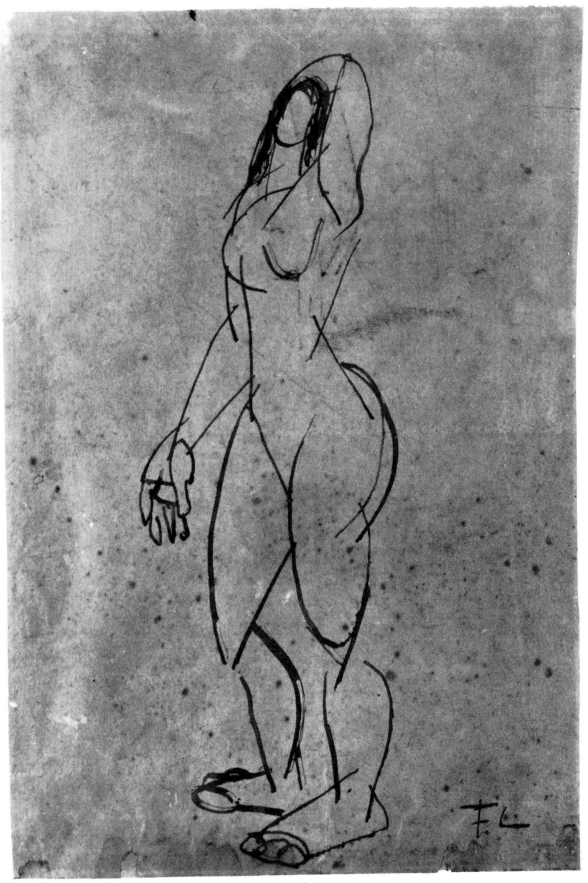

12

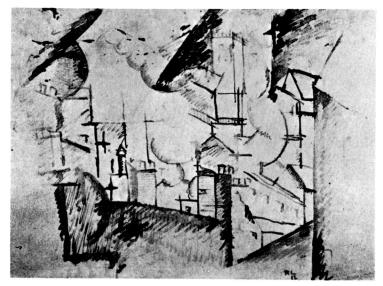

13

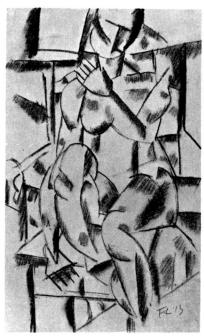

14

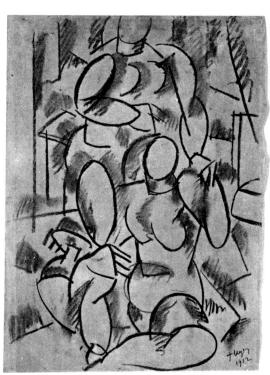

15

13 Smoke over the Roof 1912
ink, 20.5 × 29 cm
signed and dated lower right: *F L*
 12
Collection Mme Nadia Léger
To be compared with the paintings of 'Smoke over the Roofs' (particularly that shown below)

T 1

14 Nude Woman, Seated 1913
pencil, 49 × 32 cm
signed and dated lower right: *F L 13*
Private collection

15 Two Nudes 1912
charcoal, 51 × 37 cm
signed and dated lower right: *F. Léger*
 1912
Department of Prints and Drawings, Nationalmuseum, Stockholm
(Georg Pauli Bequest)

16 Nude Woman, Seated 1912
pencil, 64 × 49 cm
signed and dated lower right: *F L*
 12
Former Collection Marie Cuttoli
Collection Galerie Beyeler, Basle

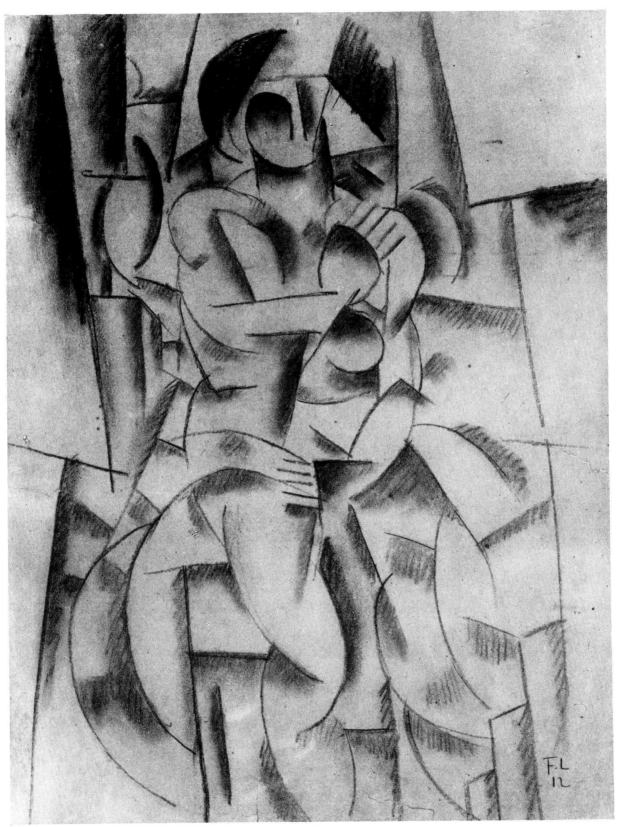

16

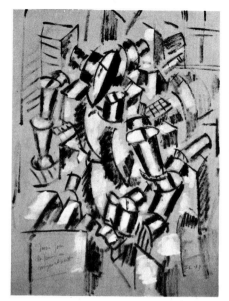

17

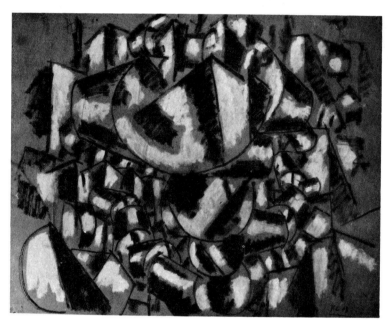

18

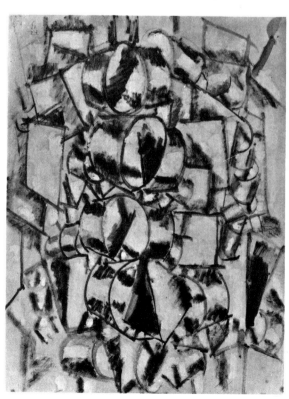

17 Study for *The Woman in Red and Green* 1913
black and white gouache, 62.5 × 48 cm
signed and dated lower right: *F L 13*
and inscribed lower left: *Dessin pour*
la femme
en rouge et vert
Collection Mme Nadia Léger
Drawings 17 and 20 should be compared with
the painting 'The Woman in Red and Green',
of 1913 (below)

T 2

18 Contrast of Forms 1913
black and white gouache, 49 × 63 cm
signed and dated lower right: *F L 1913*
Private Collection, Paris

19 Contrast of Forms 1913
wash drawing with gouache, 63 × 49 cm
signed and dated lower right: *F L*
13
Former Collection André Lefèvre

20 Study for *The Woman in Red and Green* 1913
black and white gouache, 62 × 47 cm
signed and dated lower right: *F L 13*
and inscribed above left: *Dessin pour*
la femme
en rouge et
vert
Philadelphia Museum of Art, Philadelphia

19

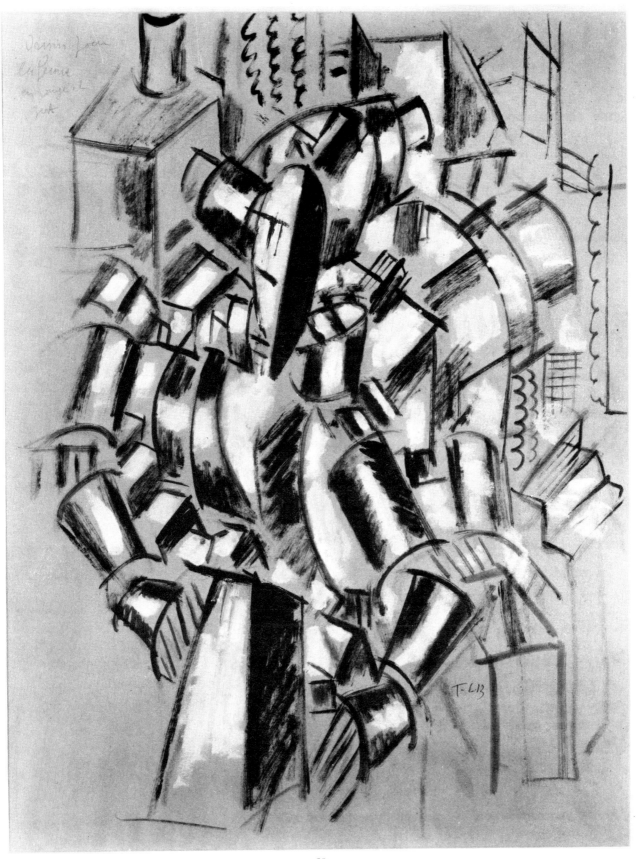

20

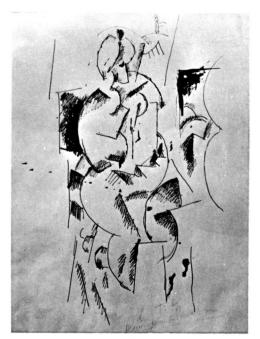

21

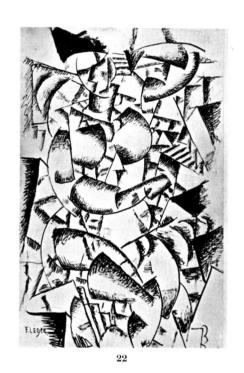

22

21 Drawing for the Nude Model 1913
 pencil and ink, 48 × 34 cm
 signed and dated lower right: *F L*
 13
 and inscribed: *Dessin pour le modèle nu*
 Private collection, Paris

22 Clown
 ink, 48.5 × 31.5 cm
 signed lower left: *F. Léger*
 Private collection, Germany

2 The War Years 1914–17

On the declaration of war, at the beginning of August 1914, Léger was mobilized as a sapper. He was sent to the Argonne Front, then took part in the whole of the battle of Verdun, where he was a stretcher-bearer for three months. He refused a transfer to the camouflage service, to which many painters were naturally assigned, in order to stay in the front line, with his comrades in the trenches. He was severely gassed on the Aisne Front in spring 1917, and both lungs were affected. He spent a long time in hospital at Villepinte, on the outskirts of Paris, before being invalided out of the army in January 1918.

He felt the horror of that war, but also its exhilarating power to lay bare both the true character of people and the marvellous nature of objects. It was a decisive experience, artistically and socially. 'I left Paris', he said, 'completely immersed in an abstract method, a period of pictorial liberation. Without any transition, I found myself on a level with the whole of the French people; once I was in the Engineers, my new friends were miners, navvies, workers in wood and metal. There I discovered the French nation. At the same time, I was dazzled by the breech of a 75 mm gun, open and with the sun shining on it, a magic spell of light on white metal. . . . The human wealth, variety, humour and perfection that I found in certain kinds of men around me, their just instinct for what was real and useful and how it might be adapted in the midst of this drama of life and death into which we had plunged—more than that, they were poets, inventors of everyday poetic figures of speech—I mean slang, which is so flexible and highly-coloured. Once I had bitten into this reality, the object was and remained essential to me.'

For some months, he seems to have neither painted nor drawn. But from July 1915 to December 1916 there appeared a rich

series of sketches, the only indications of his stylistic development at the time, which constitute an exceptional record by a great artist of the life of soldiers, in quarters and in the firing zone, during the First World War. Other good painters have conjured up the atmosphere at a distance, at the rear or even in the studio; but Léger's drawings are records made on the spot, with an intense immediacy. They were done in pen or pencil on any scrap of paper that came to hand. On top of a rapid pencil-sketch there is sometimes superimposed a more elaborate drawing, heightened with blue or black ink. A few drawings are heightened with gouache.

These drawings, dashed off during short halts or again in a moment of rest, are sometimes crude and elementary, sometimes finely detailed; quite often they have a date and even the name of a place, which allows us to classify them chronologically and geographically as well. The first group, done in the summer and autumn of 1915, were executed in Argonne, a wooded, hilly region, poor and difficult to penetrate. The inscription M.F. on several of them stands for *maison forestière* (forest ranger's house). There are landscape studies, sappers busy at work (28) and playing cards in their dugouts (39–41), views of field kitchens on the move (23, 29) and halting in a village where they blend their rounded and square forms with those of the houses. A powerful drawing (26), heightened with gouache and showing some of those wagons whose structure and articulation was ideally suited to his dynamic Cubist mode of expression, was dedicated to his Russian friends Larionov and Goncharova, the founders of Rayonnism, who had settled in Paris on the eve of the war.

The long and bloody battle of Verdun gave birth to hundreds of sketches, some of which are now in the Musée de la Guerre at Vincennes (31). Blaise Cendrars has told the story of how Jeanne, Léger's mistress, set out to join him in the lines, and came back from this escapade with 'a large haversack, bulging fit to burst with drawings and sketches', which she hung up 'in a dark corner of the studio' in the rue Notre-Dame-des-Champs. Some of them show aspects of Verdun when it was still intact, the station, the Place d'Armes with the signboards of its hotel and dye-works; others show houses gutted by shelling (35). *The Wrecked Aeroplane* (32) is one of three vigorous watercolours inspired by the arrival of French military aircraft.

'I never made any drawings of guns,' Léger said. 'I had them before my eyes. It was the war that brought me back to earth.' Yet there exist, on military postcards addressed to his friend Yvonne Dangel, at least two magnificent drawings of the huge

weapons—a 100 mm naval gun and a 220 mm howitzer—which were brought into action for the preparatory barrage of the French counter-offensive, begun on 24 October. From this historic day, there is a series of five drawings which do not show the murderous tumult itself but calmer secondary episodes; horses tethered on the Souville road, sappers at work on the Fleury road. The fifth and definitely the best, the only one with a tragic element, is *Two Men Killed on the Fleury Road* (33), which he sent to Yvonne Dangel with the following words: 'Perhaps this card will make a change from our big guns. In any case, it bears a famous date, that of the day we recaptured Douaumont. The sketch was made on the day, to the accompaniment of no mean barrage'. No rhetoric here, no excess of emotion, but, in the midst of the cruel daily turmoil, the matter-of-fact recording of an event.

During the war, material conditions prevented Léger from painting the pictures he dreamed of. In September 1915, during a peaceful interval in Argonne, he executed two or three small oil paintings on the lids of shell-boxes—card-players, horses in the support lines—to which he stuck pieces of paper to show the colours. These are his only known attempts at using collage, a technique his Cubist friends exploited in a revolutionary way.

In summer 1916, when he was on leave in Paris—in the course of which he discovered Chaplin and the fascination of the screen —he painted a single tall figure, the *Soldier with a Pipe* (now in Düsseldorf), an affirmation of the geometrical concentration of his style. Harmony is reduced to restrained, muted tones animated by a strong red note. The theme of the smoker had been in his mind for years; the two preparatory gouaches given here (37, 38), and dated 1914 without the month, seem, from their technique, dimensions and formal characteristics, to date from before the war.

During the last months of 1916, Léger thought about painting a picture on the theme of tunnelers at work, but after several quite detailed drawings (25), he gave up this project. At the end of 1917, at Villepinte, he completed *The Card Game* (Rijksmuseum Kröller-Müller, Otterlo), a major composition in which the soldier has become a part of his mechanical environment. It was the outcome of many large-scale, detailed drawings (39–41), made at the Front out of personal admiration for his fellow soldiers; 'while the lads were playing cards, I stayed behind them, watching them, making drawings and sketches—I wanted to portray them exactly. I was very impressed by those lads, and the wish to draw them came spontaneously. From that there later came *The Card Game*.'

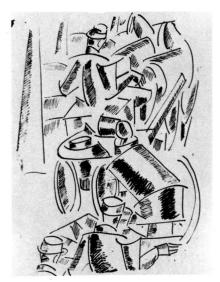

23

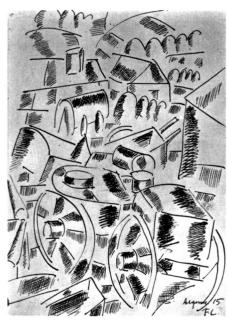

24

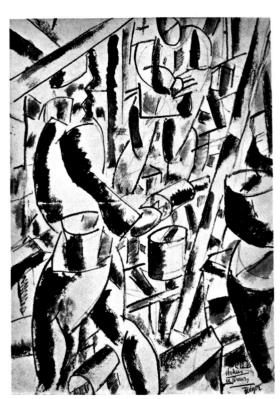

25

23 Front-line Drawing
ink, 20 × 15.4 cm
Musée National Fernand Léger, Biot

24 Argonne 1915
ink
dated and signed lower right: *Argonne 15*
 F L

Private Collection

25 The Tunnelers, Verdun 1916
ink and wash, 35 × 26 cm
dated, inscribed and signed lower right:
 12/16
 Verdun
 Les Foreurs
 F. Léger
The Museum of Modern Art, New York
(Frank Crowninshield Fund)
*This and other drawings are projects for a
painting which was not done.*

26 War Drawing
ink and gouache
inscribed above left: *A Larionov*
 à Gontcharova
 aux deux grands
 artistes russes
 leur admirateur
 et ami
 F. Léger

Private Collection

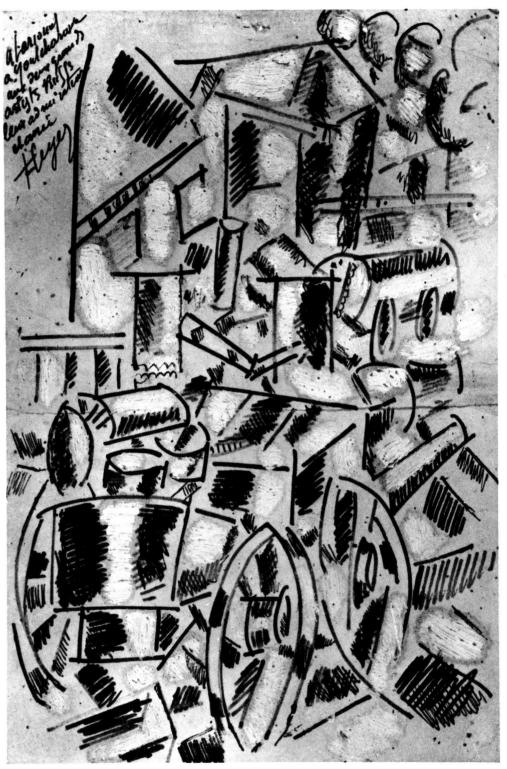

26

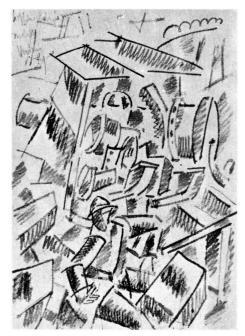

27

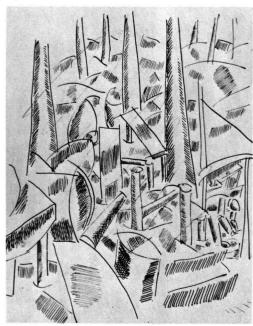

28

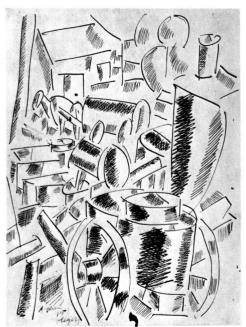

29

27 Hoisting a Mobile Mould
 wash, 19.5 × 14 cm
 inscribed and signed above left: *Hissage de*
 forme
 mobile
 Verdun
 F L
 Collection Mme H. Gomès, Paris

28 The Sapper
 ink, 20.2 × 15.8 cm
 (on the back of another drawing, 'Soldiers
 in a Dugout—1915')
 Collection Mme H. Gomès, Paris

29 The Field Kitchen 1915
 ink, 20 × 15.5 cm
 inscribed, dated and signed lower left:
 Argonne
 1915
 F. Léger
 Collection Mme H. Gomès, Paris

30 Verdun, Landscape with Figures 1916
 ink and wash, 34 × 24 cm
 inscribed, signed and dated lower right:
 Verdun
 F L
 16
 Private Collection, Paris

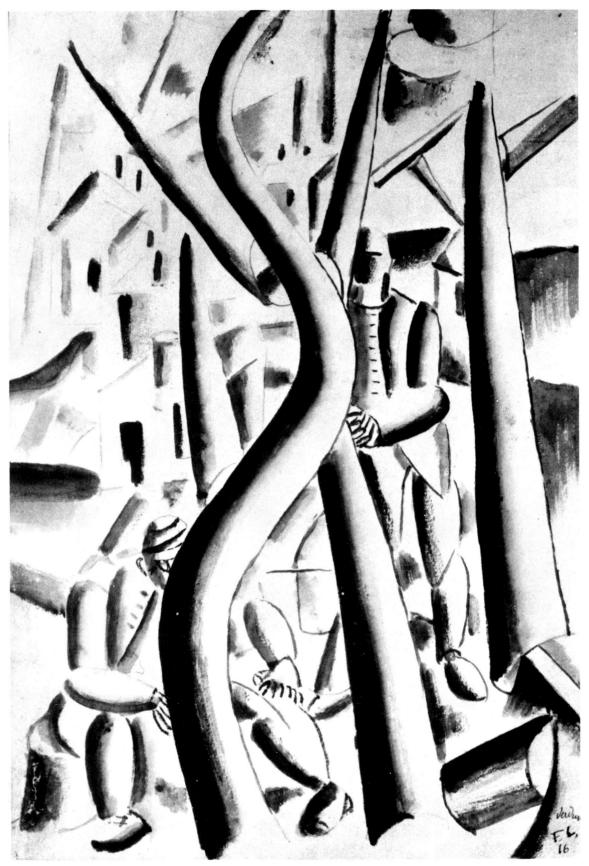

30

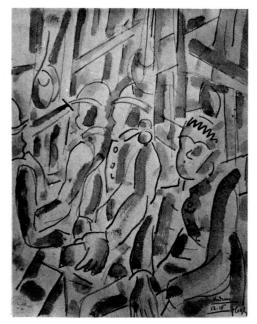

31

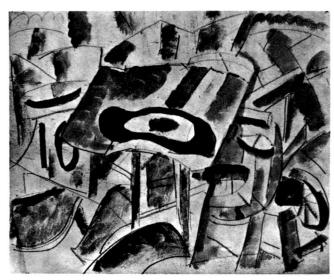

32

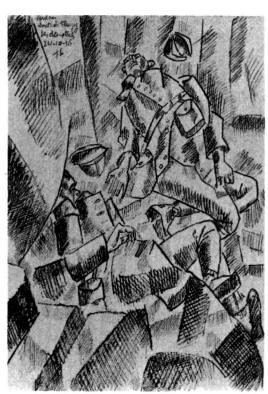

40

33

31 Verdun, Infantrymen at the Ravin de Bazile
1916
ink and wash, 19 × 23.7 cm
dated and signed lower right: *Verdun*
12–16
F. Léger
Musée de la Guerre, Vincennes

32 The Wrecked Aeroplane
watercolour, 23.5 × 29.5 cm
Collection Mme Nadia Léger

33 Two Men Killed on the Fleury Road 1916
ink, 12 × 8.7 cm
inscribed, dated and signed above left:
Verdun
Route de Fleury
Les deux tués
24/10/16
F L
Former Collection Dangel, Paris

34 Front-line Gouache 1916
gouache, 34.5 × 36.5 cm
dated and signed lower right: *16*
F L
Musée National Fernand Léger, Biot

34

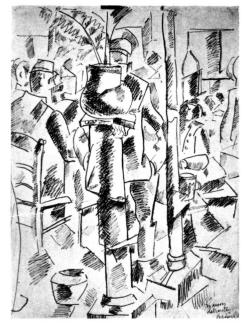

35

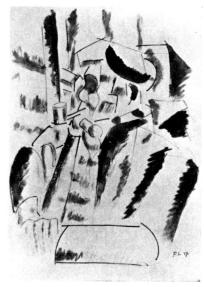

36

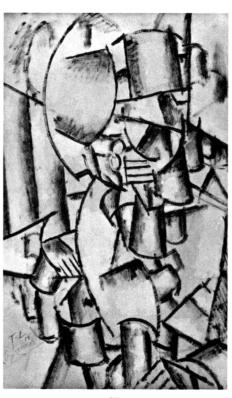

37

35 Verdun: House in Ruins 1916
ink, 33 × 22.5 cm
inscribed and dated lower right: *Maison*
détruite
Verdun 16
Collection Mme Nadia Léger

36 The Smoker 1917
ink and wash
signed and dated lower right: *F L 17*
Private Collection

37 The Smoker 1914
gouache, 65 × 50 cm
signed, dated and inscribed lower left:
F L 14
Le fumeur
Collection Mme Frigério, Paris

38 The Smoker 1914
gouache, 64.5 × 50 cm
dated, inscribed and signed lower right:
F L 14
Le fumeur
F L
Collection P. Bruguière, Paris
Drawings 36, 37 and 38 may be compared with
the painting 'The Man with the Pipe', of
1916 (below)

T 3

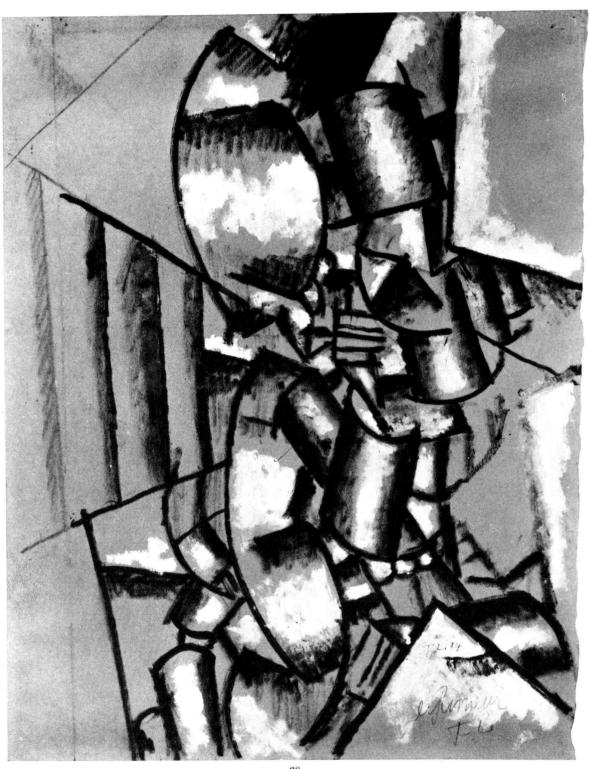

38

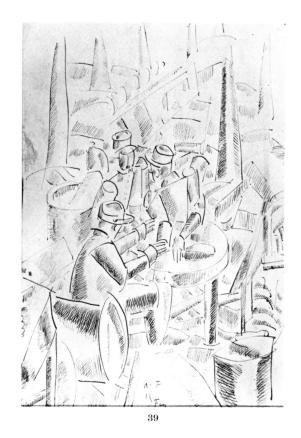

39

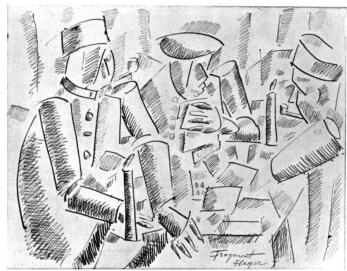

40

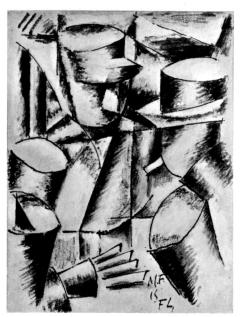

41

39 Soliders in a Dugout 1915
ink, 19 × 13.5 cm
dated and signed lower middle: *M.F*
 15
 FL.
('M. F.' stands for 'Maison Forestière',
Argonne)
Private Collection, London

40 Study for *The Card Game*
ink
inscribed and signed lower right: *Fragment*
 F Léger
and on reverse: *Osbert Sitwell*
 Cordialement
 F. Léger
Collection Mr Milton D. Ratner, Chicago

41 Soliders. Study for *The Card Game* 1915
black and white gouache, 14.7 × 11.2 cm
dated and signed lower middle: *M. F.*
 15
 FL.

Private Collection
*Drawings 40 and 41 are to be compared with
the painting 'The Card Game', of 1917 (below)*

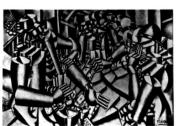

T 4

3 The Mechanical Period 1917–23

This period, in which almost all the drawings reproduced correspond to painted works, is extremely important for the understanding of the artist's creative process and the general characteristics of his mature style. The new tendency was already evident in several works done at the hospital at Villepinte. In the one seen here (45), the helical forms of *Propellers* (which was so greatly admired as early as 1914 at the 'Salon de l'Aviation' next to the 'Salon d'Automne') are combined with tubular forms, and introduce us to the contemporary world of speed and technical efficiency, with which Léger totally identified himself. 'On my return from the war, I continued to make use of what I had felt at the front for three years, I used geometrical forms; this will be called the mechanical period.'

The first phase, a strictly mechanical or mechanist one—involving industrial objects but no people—is represented here by a whole succession of marvellous drawings in black ink, some of them heightened in white, which are simply entitled *Compositions* or *Mechanical Elements*, the final synthesis of which, sketched in its entirety as early as 1917 (50), was not to be painted until 1923 (p. 55; Kunstmuseum, Basle). In a letter to D. H. Kahnweiler on 11 December 1919, Léger charted the progress of his work: 'I have used mechanical elements a lot in my pictures these last two years; my present method is adapting itself to this, and I find in it an element of variety and intensity. The modern way of life is full of such elements for us; we must know how to use them. Every age brings with it some new elements which should serve us; the great difficulty is to *translate* them into plastic terms and avoid the error of Futurism.'

He did not, in fact, copy the external appearance of machines, but transposed into his own terms the geometrical elements which signify their structure and workings. Examples include the ink

drawing, with dense black masses, which is significantly called *Chain of Motion* (42) and shows a transmission system using tie-rods; and a pencil study of great strength and delicacy which gives a multiple image of a wheel in motion (43). It was above all the synchronization of mechanical forms that preoccupied Léger in the architectonic organization of his drawings: the plans and sections govern the charges and impulses and determine the balance of the composition. 'The mechanical element is not a set purpose, an attitude, but a way of achieving a feeling of strength and power,' he said. For him, machinery was neither the quasi-mystic idol of Constructivism or Purism, nor the devilish monster denounced by the Dadaists and Surrealists, but a historical, functional instrument of modern society, and it had to be handled in artistic terms in accordance with the principle of *equivalence* and not that of *similitude*. 'I have never enjoyed copying a piece of machinery. I invent pictures of machines as others do, by using my imagination and views. . . . I try to create, with mechanical elements, a *beautiful object*.'

Two major paintings dominate the early stages of this mechanical period: in 1918 *The Discs* (Musée d'Art Moderne de la Ville de Paris), and in 1919 *The City* (Philadelphia), which is perhaps Léger's masterpiece. No definitive study for *The Discs* is reproduced here, but we may regard several drawings of circles or circular forms—observed from the viewpoint of mechanical articulation, not that of optical diffusion, as with Delaunay—as implicitly connected with this work. A full watercolour sketch with certain elements reversed (60), and a gouache (61), refer to *The City*, which combines in a dynamic way, like a cinematographic image on a well-defined, static screen, abstract plans, fragmented urban views and poster-advertisements with stencilled letters. 'The modern streets, with their multi-coloured elements and their printed words, helped me a lot (to me, it's raw material).' Shop-window dummies, and a few silhouettes or real human beings, are also visible.

More and more, Léger was reintroducing the human form, regarded 'not as a sentimental element, but solely as a plastic element', simplifying it as far as possible and making it take on the geometrical order which governs machinery and the urban environment. 'Modern man lives more and more in a predominantly geometrical order. All human creations which are mechanical and industrial are dependent on geometrical conceptions.' *The Printer* (46) is integrated into his workaday surroundings; he is physically a part of the tools and products of his trade. This work, painted in two versions, coincided with Léger's own typographical experiments, undertaken at this

time so that he could illustrate two books by Blaise Cendrars, *J'ai tué* (1918) and *La Fin du monde filmée par l'ange Notre-Dame* (1919). A theme which was to be taken up and amplified later made a brilliant first appearance in 1918: the *Acrobats* (76), with their carefully controlled contortions, and the actual décor of the *Circus* (77) of which they are a part, 'that strange architecture of coloured poles, metal tubes and criss-cross wires moving with the effect of the lights'.

In a series of *Compositions with Figures*, heightened with colour (66, 68–72), dating from 1919 and particularly 1920, the figures, still reduced to a geometrical diagram and simply substituted for the printed signs and big stencilled letters he had used previously, are caught up in a moving network of circular forms broken up by vertical or transversal bars to give stability.

This same rhythm, with its dominant curved lines, gives life to two fine gouaches of 1920, reproduced here with their bold and limpid colours: *Still-life with Green Table* (73) and *Still-life with Red Table* (74). Still-lifes, which were soon to constitute the larger part of his output, were rare at this date. In the contemporary gouache *Figure Leaning on Elbow* (78), the figure is leaning on a semicircular table of the same kind as in the other gouaches, balanced on the right by a high, vertical chair; here the density of the body has increased, and there is more detail in the drawing of the arms and hands, emphasizing the elbow's role as a pivot.

The return of the human form and its compact mass in the middle of this stylistically uniform but iconographically varied period marks the transition from a dynamic conception to a static, volumetric conception. 'I needed a rest, to breathe a little. After the dynamism of the mechanical phase, I felt as it were a need for the static quality of the large forms that were to follow. Earlier, I had broken up the human body. Now I began to put it together again, to find the face again. Since then I have always used the human form. Later it developed, slowly, towards a more realistic, less schematic representation.'

The series of *Landscapes with Figures* (81, 82) of 1921, to which may be added the theme of *The Fisherman* (83), represents a measure of rural relaxation after the bustle of the city; it proceeded with the same happy inventiveness as the fertile series of *Contrasting Forms* in 1913. Faithful to the spirit of Poussin and Corot, who were then being restored to their place of honour in the Louvre, Léger was successful, in his entirely personal fashion, in capturing the freshness of his native Normandy, its subtle variations of light, and the difficult but supreme accord between the human form, architecture and nature. Trees, houses, fields, clouds, men resting, domestic animals, were resolved into

analogous structures related by formal assonances, and orchestrated in a manner as supple as it was strictly controlled. The theme of *The Tugboat*, which developed over a number of years and produced some remarkable painted versions, obviously evokes a marine atmosphere, but it is situated architectonically in an urban setting with the framing forms and changes of level that are characteristic of docks and industrialized riverbanks. We have some examples here of rapid sketches (107, 108), more elaborate pencil-drawings (109) with black and white contrasts and shadings, and finished and brightly coloured gouaches (110, 114). 'When I transfer the subject of a drawing on to canvas, I simplify it; I subject its form to the overall conception of the painting; I get rid of the superfluous things which might be in the way; I clear it of all the parasites which would rob its appearance of purity.'

In an impressive group of compositions with human figures, which became increasingly larger in format, traditional domestic themes *à la* Vermeer led to a monumental and unprecedented crystallization of forms. Léger's great achievement here consisted in placing in the foreground motionless volumes, made up of rounded curves, spheres, ovals, ellipses and cylinders, against flat, uncompromisingly rectangular backgrounds. *Le Grand Déjeuner* (Museum of Modern Art, New York) is an exceptional masterpiece, which holds in balance the two styles that Picasso was then pursuing separately, synthetic Cubism and Neoclassical plasticity. Although depersonalized and subjected to a mechanical order, the human form is not reduced to the state of a robot, but takes on a universality, a hieratic majesty, that recalls the greatest epochs of art. The three pencil studies included to show the right-hand side (92), the left-hand side (93) and the whole (94), reveal a purity of design, a precision in the assembly, and a complex working-out of spatial relationships. 'I never put my work directly on to the canvas. I put my work together study by study, piece by piece, like an engine or a house.'

The imposing composite drawing (102) for the *Mother and Child* (1922, Basle) establishes, on an exact system of coordinates, contrasts and plastic rhythms, relationships between planes and depth, between internal and external space, and between human forms and things. The *Reading* (Musée National d'Art Moderne, Paris) is perhaps the figurative painting from this period in which the tightness of construction is most striking. There are preparatory drawings for each of the two figures (95, 96), and also corresponding painted versions, and an overall drawing (97) for the final work. There is no longer any hair, whether spiralling in waves or put up in sweeping curves, on the head of the woman

with the bouquet. 'Really,' said Léger, 'with the best will in the world, I could not give the woman any hair. In the place where her head was I needed a clear, round shape. I did not do it on purpose. I could not put any hair on.' Comparison between the *Woman with Bouquet* of 1920 (85) and that of 1923 (96) shows a broadening in style combined with increased concentration.

A woman on her own (100), women in groups (99, 101), or a woman with a child (102), are central to most of his compositions; but sometimes a man appears, either in interiors where robust furniture echoes his rugged, athletic nudity (103, 104) or in a suit in urban surroundings (105, 106). The three drawings in green ink (111) and pencil (112, 113) entitled *Figures in the City*, one of which is dated 1924, represent Léger and his dealer Léonce Rosenberg during their journey in Italy, in the course of which they particularly admired the Primitives and the mosaics of Ravenna. The two men are walking on a balcony overlooking the houses.

In order to recall Léger's contribution to the Ballets Russes and Ballets Suédois, which would justify a whole book in itself, this chapter ends with two scenery designs (115, 116) and an idea for a costume for *La Création du monde*, a ballet of 1923 with a scenario by Blaise Cendrars and music by Darius Milhaud. It was one of the rare instances when Léger was inspired by African art. 'I took as my point of departure some Negro statues from the great period. Original dances served as guides. Under the aegis of three Negro gods eight metres [27 feet] tall, we witness the birth of men, of plants and of animals.'

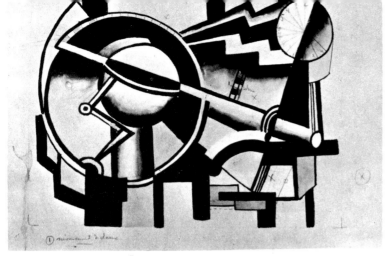

42

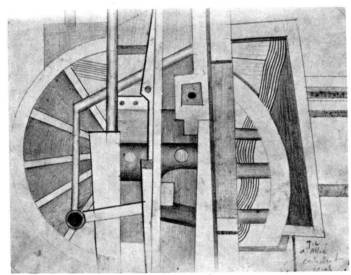

43

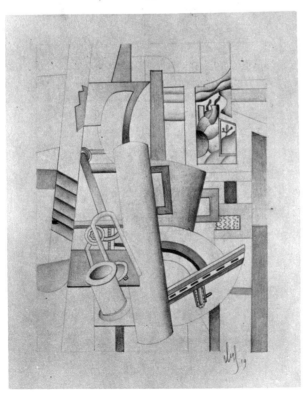

44

42 Study of Mechanical Elements
pencil and ink
inscribed lower left: *1 mouvement de chaîne*
Collection Mme Nadia Léger

43 The Wheel
pencil
dedicated and signed lower right:
 F.L
 à Allié
 cordialement
 F Léger

Private Collection
Georges Allié was the photographer instructed by Léger to photograph many works from his studio.

44 Composition with Mechanical Elements
 1919
pencil, 50.1 × 40.1 cm
signed and dated lower right: *F. Léger*
 19
Private Collection, Paris

45 Composition with Mechanical Elements
 1917
ink, 32 × 23 cm
signed and inscribed lower right: *F.L.*
 Hop.
 Villepinte
Drawn during Léger's stay in hospital. To be compared with the painting 'The Propellers', of 1918 (below)

T 5

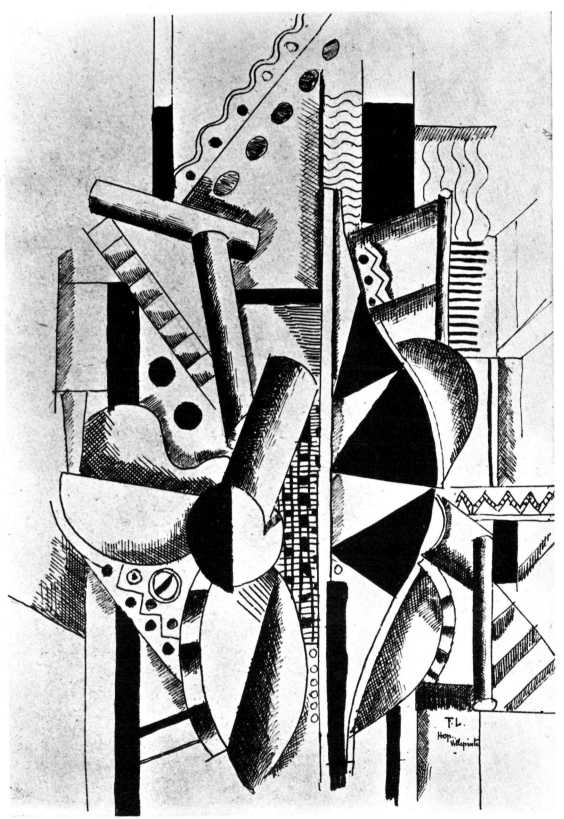

45

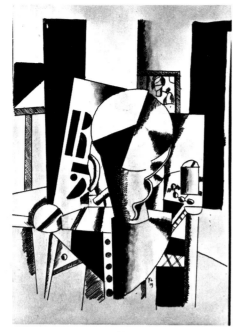

46

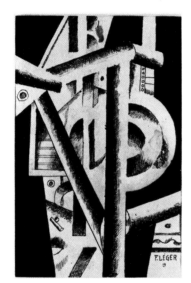

47

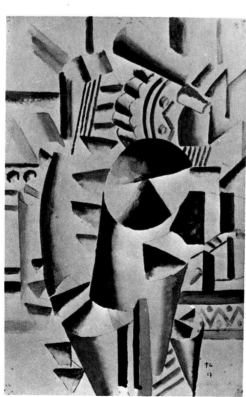

48

46 Study for *The Printer* 1919
ink and gouache, 39 × 28 cm
signed and dated lower right: *F L*
 19

Private Collection
*To be compared with the second version of the
painting 'The Printer', of 1919 (below)*

T 6

47 Scaffolding 1919
ink, 23 × 15 cm
signed and dated lower right: *F. Léger*
 19

Private Collection, Paris

48 Composition 1917
watercolour, 33 × 22 cm
signed lower right: *F.L*
 17
Moderna Museet, Stockholm
Acquired from the artist in 1919

49 Composition 1919
ink and watercolour, 40 × 30.5 cm
signed and dated lower right: *F.L*
 19

Private Collection, Paris

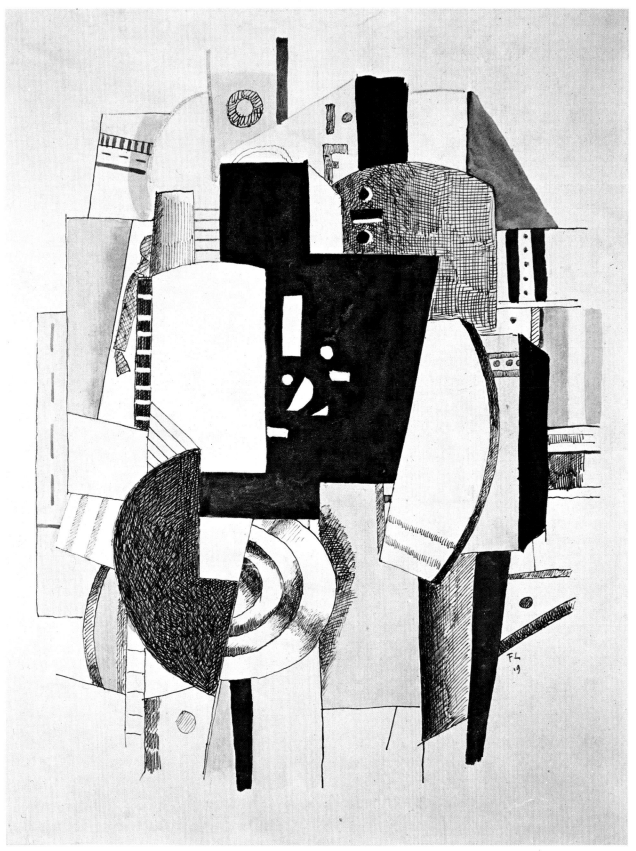

49

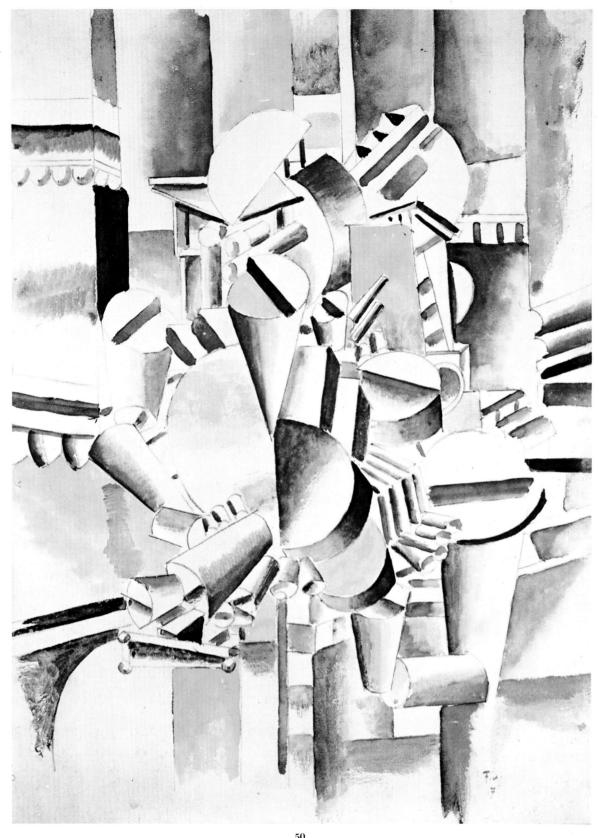

50

50 Mechanical Elements 1917
watercolour, 34 × 25 cm
signed and dated lower right: *F.L.*
 17

Private Collection

51 Mechanical Elements 1918
ink, 30.9 × 23.2 cm
signed and dated lower right: *F Léger 18*
Öffentliche Kunstsammlung, Basle
*Drawings 50 and 51 should be compared with
the painting 'Mechanical Elements', of 1918–23
(below)*

T 7

52 Mechanical Elements
watercolour, 35 × 23 cm
signed lower right: *F Léger*
Private Collection, Paris
*To be compared with the painting 'Still-life
with Mechanical Elements', of 1918 (below)*

T 8

53 Composition 1918
pencil and watercolour, 33.5 × 24 cm
signed lower right: *F.L*
 18
The Solomon R. Guggenheim Museum,
New York

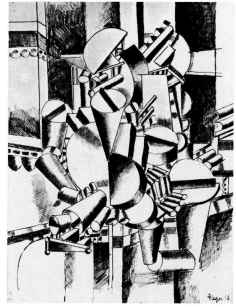

51

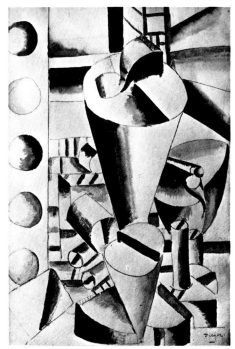

52

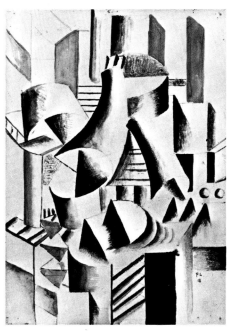

53

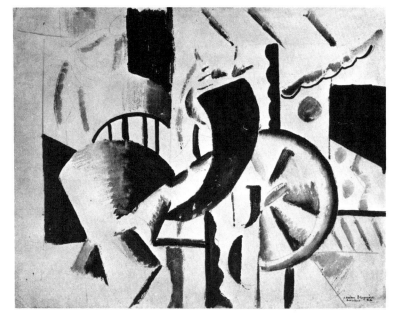

54

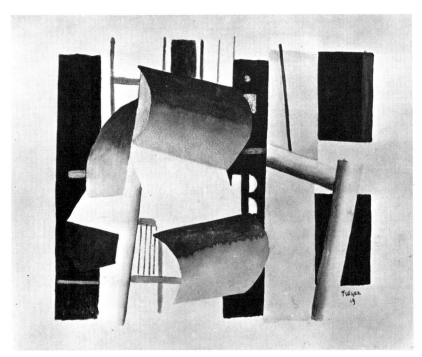

55

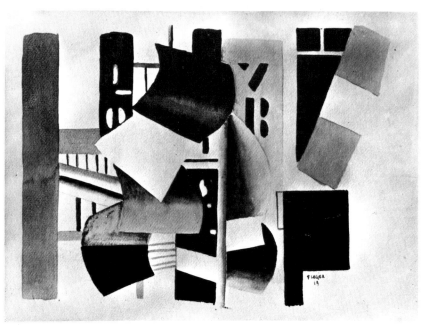

56

54 Composition
 water-colour, 26 × 34.5 cm
 inscribed and signed lower right:
 A Madame Bruguière
 Amicalement F.L
 Collection P. Bruguière, Paris

55 Composition 1919
 watercolour, 26 × 31 cm
 signed and dated lower right: *F. LÉGER*
 19
 Private Collection

56 Composition 1919
 watercolour, 30 × 37 cm
 signed and dated lower right: *F. LÉGER*
 19
 Private Collection, Paris
 These two works (55 and 56) should be com-
 pared with the painting 'The Armistice', of
 1919 (below)

T 9

57 Composition 1919
 watercolour, 36 × 43 cm
 signed and dated lower right: *F.L*
 19
 Private Collection
 To be compared with the painting 'The Ship's
 Deck' (below)

T 10

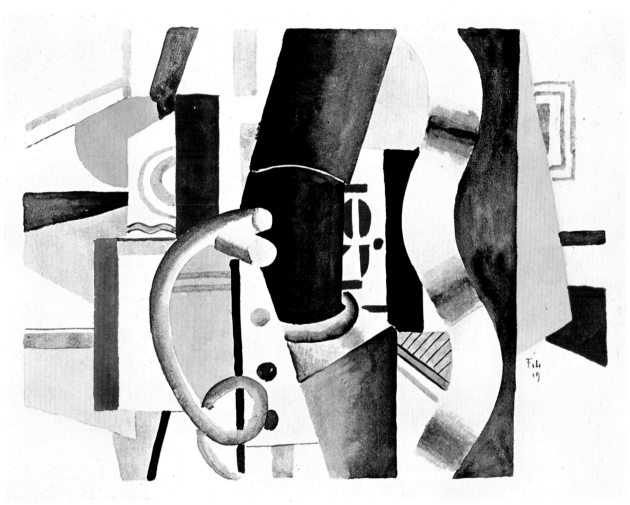

59

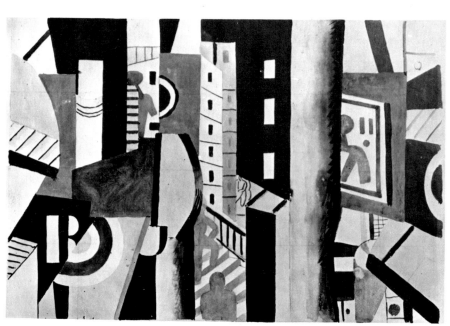

60

58 Composition
pencil and watercolour 43 × 34 cm
signed lower right: *F.L*
Musée de Peinture et de Sculpture,
Grenoble
To be compared with the painting 'In the Factory', of 1919 (below)

T 11

59 The Factory 1918
wash and gouache, 28 × 31 cm
signed and dated lower right: *F.L*
 18
Johnson International Gallery, Chicago

60 Study for *The City* 1919
watercolour, 54 × 76 cm
signed and dated lower right: *F.L 19*
Nationalmuseum, Stockholm
To be compared with the painting 'The City' (below)

T 12

61 Study for *The City* 1919
gouache, 38 × 28 cm
signed and dated lower right: *F.L. 19*
Collection P. Bruguière, Paris
Léger allowed the present owner of this work to choose between the two parts of a gouache on the subject of 'The City' (above). This drawing corresponds to the left part of the painting

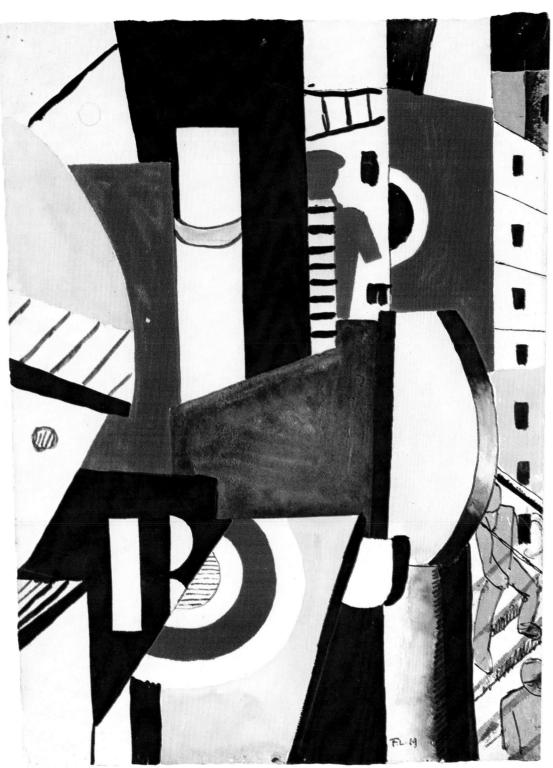

61

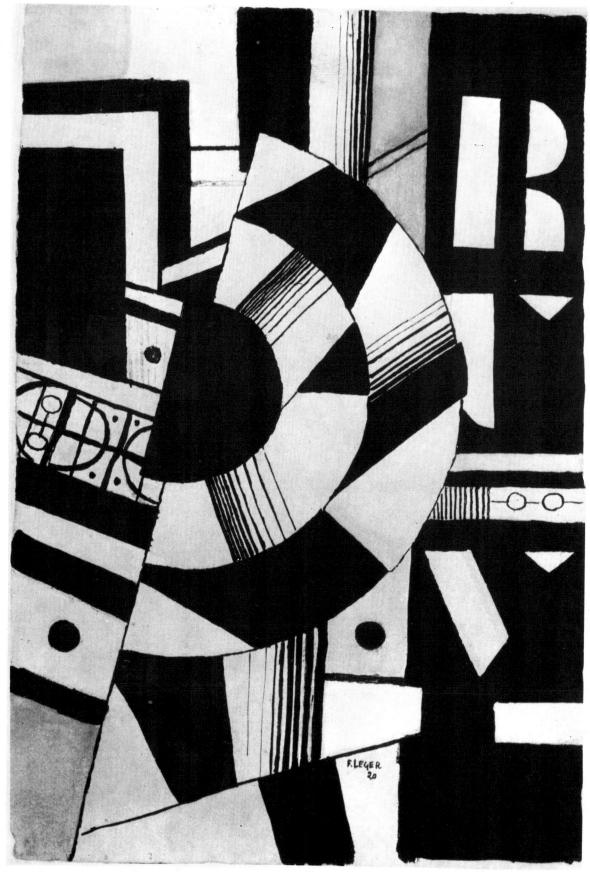

62

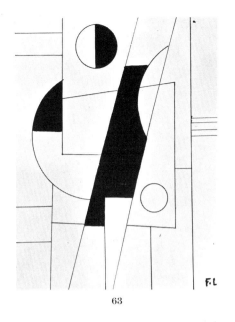

63

64

62 Composition 1920
 ink and gouache, 34 × 24.5 cm
 signed and dated lower middle: *F. LÉGER*
 20
 Private Collection, Paris

63 Mechanical Elements
 ink
 signed lower right: *F.L*
 inscribed on reverse: *1er état graphique,*
 project fresque 1922, exposé Salon Indép. 22
 Musées Royaux de Belgique, Brussels

64 Mechanical Elements 1920
 ink
 signed lower left: *F.L*
 Musées Royaux de Belgique, Brussels

65 Composition 1920
 ink, 35.5 × 25.1 cm
 signed and dated lower right: *F. LÉGER*
 20
 Öffentliche Kunstsammlung, Basle

65

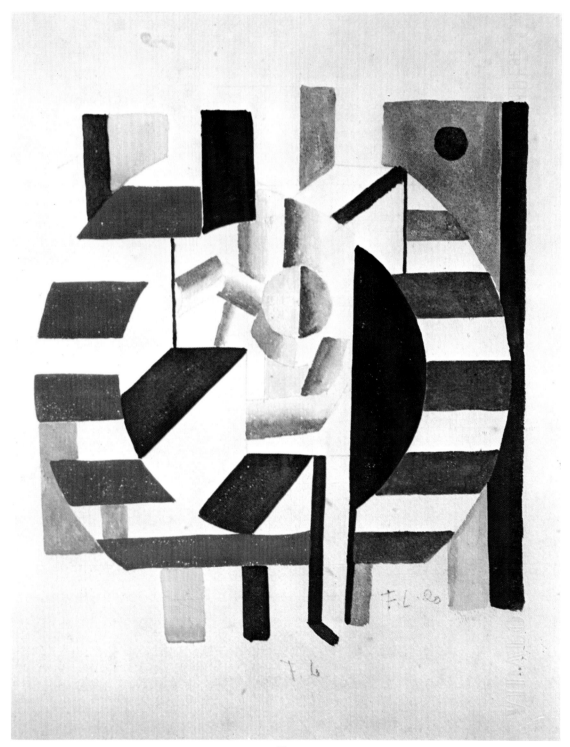

66

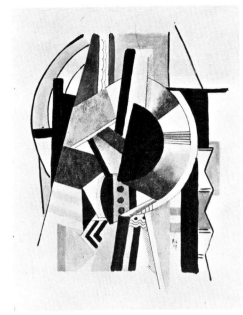

67

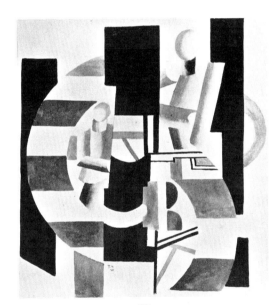

68

66 Composition with Figure 1920
watercolour
signed and dated lower right: *F.L. 20*
Private Collection

67 Mechanical Elements 1919
watercolour and ink, 31.5 × 25 cm
signed and dated lower right: *F L*
 19
The Solomon R. Guggenheim Museum,
New York

68 Composition with Two Figures 1920
watercolour, 30.5 × 27.5 cm
signed and dated lower centre: *F.L*
 20
Galerie Jeanne Bucher, Paris

69 Composition with Two Figures 1920

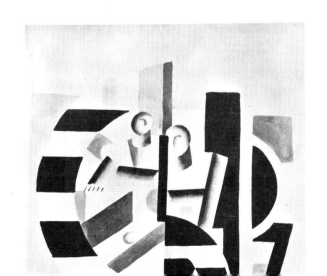

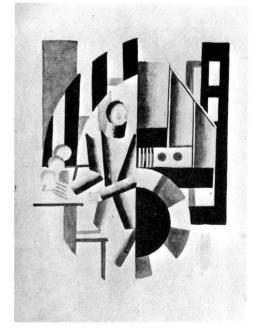

70

70 Composition with Figure
 gouache, 39 × 32 cm
 signed lower right: *F.L·*
 Private Collection
 To be compared with the painting 'Man with Pipe', of 1920 (below)

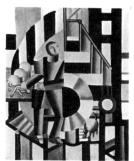

T 13

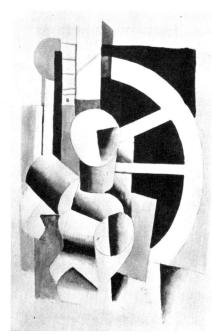

71

71 Composition with Figure
 gouache, 40 × 29 cm
 signed and dated lower right: *F.L.*
 19
 Private Collection

72 Composition with Figure 1920
 gouache, 37 × 29 cm
 signed and dated lower right: *F L*
 20
 Private Collection, Paris

73 Still-life with Green Table 1920
 gouache, 29 × 35 cm
 signed and dated lower right: *F L*
 20
 Private Collection, Paris

74 Still-life with Red Table 1920
 gouache, 29 × 34 cm
 signed and dated lower right: *F L*
 20
 Private Collection, Paris

 Drawings 73 and 74 should be compared with the painting 'Still-life with Red Table', of 1920 (below)

T 14

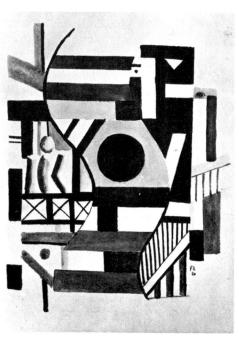

72

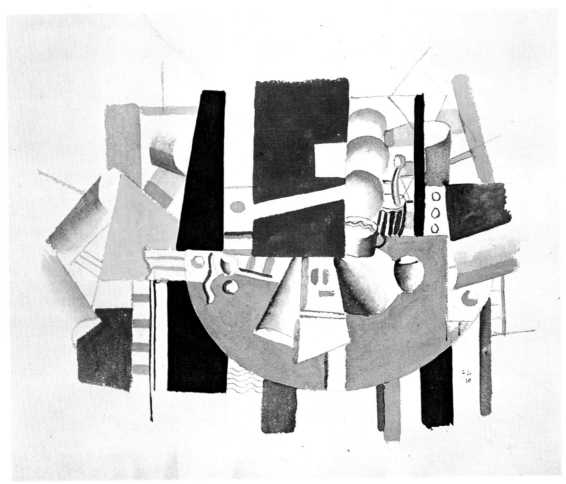

73

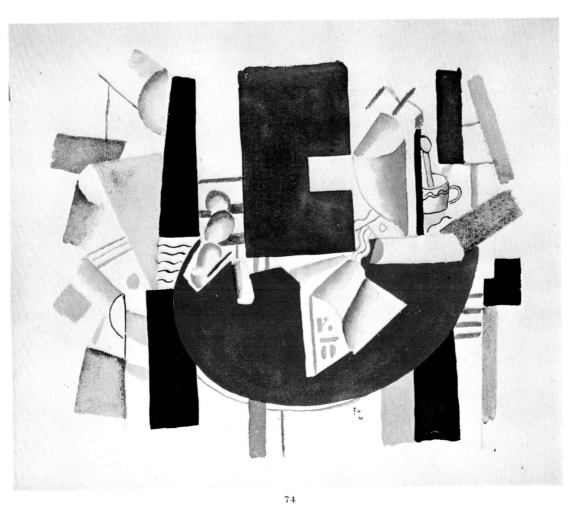

74

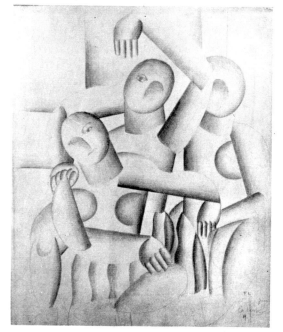

75

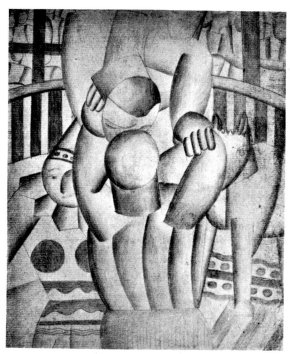

76

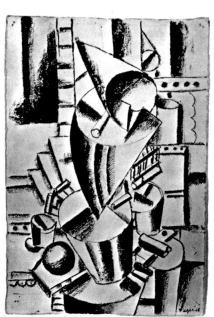

77

75 Three Women 1919
pencil, 37 × 30.5 cm
signed, dated and inscribed lower right:
 F.L
 étude pour
 la danse
 19
Private Collection, Paris

76 Acrobats
pencil, 39.5 × 33 cm
Collection Mme Nadia Léger
To be compared in particular with the painting
'Acrobats in the Circus' (below)

T 15

77 The Circus 1918
wash
singed and dated lower right: *F. Léger. 18*
Nationalmuseum, Stockholm
Acquired from the artist in 1919
To be compared with the painting 'The Circus',
of 1918 (below)

T 16

78 Figure Leaning on Elbow 1920
gouache, 33 × 25 cm
signed and dated lower right: *F.L*
 20
Private Collection, Paris
Léger wrote on the paper mount of this drawing:
'Étude pour le portrait de Monsieur L . . . M . . .'.
The painting was not executed.

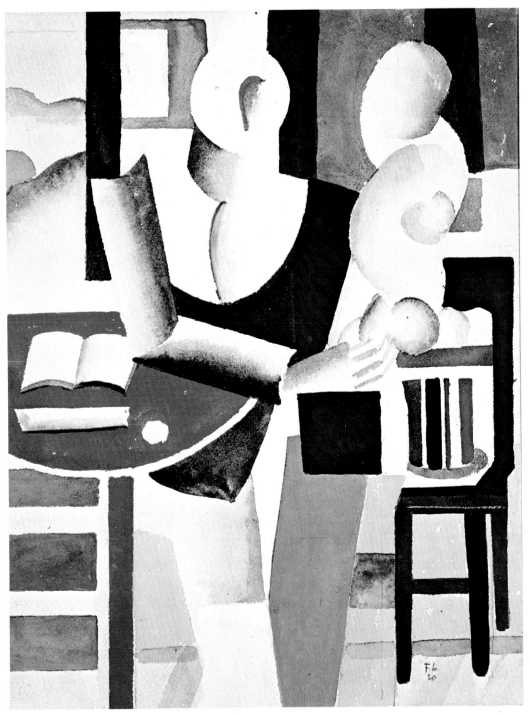

78

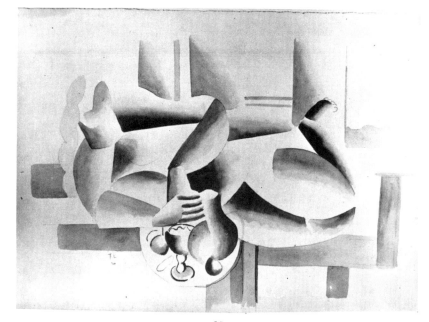

79

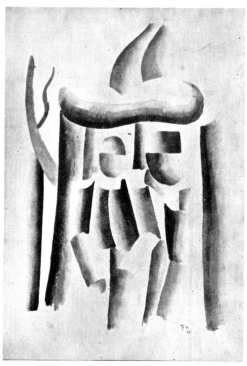

80

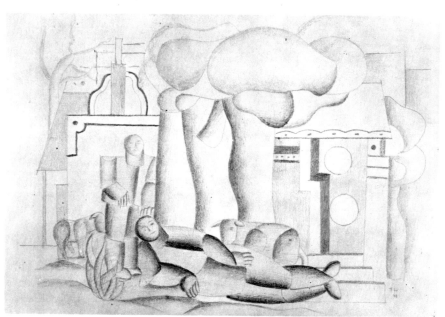

81

79 Reclining Woman 1920
watercolour, 32 × 49 cm
signed and dated lower left: *F.L*
20

Private Collection
To be compared with studies of reclining women which were the preparation for 'The Meal, Large Version' (see p. 75) and with the painting 'Two Women', of 1920 (below)

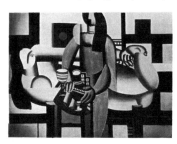

T 17

80 Figures 1921
watercolour, 37 × 26 cm
signed and dated lower right: *F L*
21

Private Collection

81 Repose 1921
pencil, 27 × 38 cm
signed and dated lower right: *F L*
21

The Museum of Modern Art, New York
(Gift of Mr and Mrs Daniel Saidenberg)
To be compared with the series of pictures 'Landscapes with Figures', and particularly the painting 'Repose', of 1921 (below)

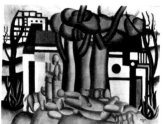

T 18

82 Reclining Figure 1921
watercolour, 26 × 37 cm
signed and dated lower right: *F L*
21

Private Collection
To be compared with the series of paintings 'Landscapes with Figures'

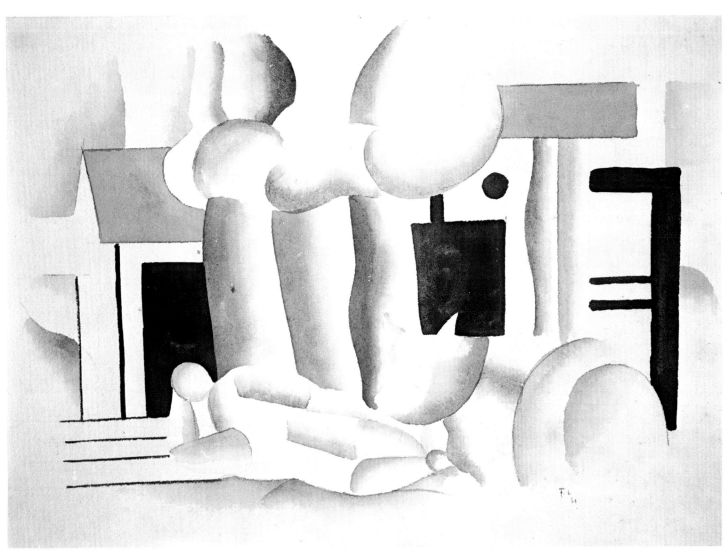

82

The answer is below.

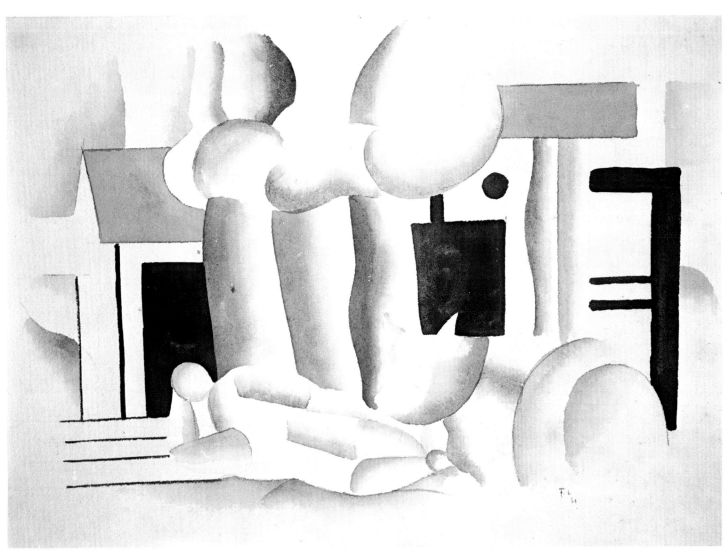

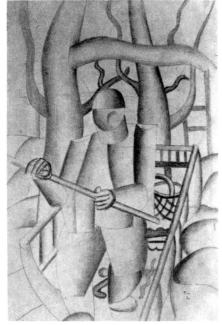

83

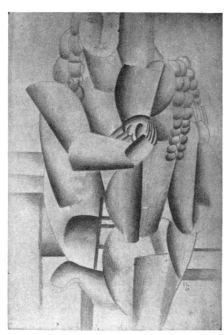

84

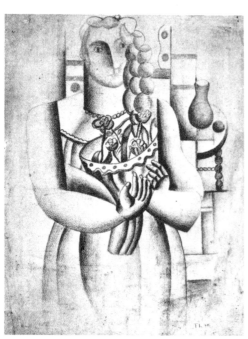

85

83 The Fisherman 1921
pencil, 39 × 27 cm
signed and dated lower right: *F.L*
 21
Marlborough Fine Art Ltd, London
To be compared with the central part of the painting 'The Fishermen', of 1911 (below)

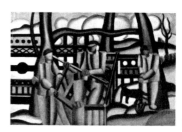

T 19

84 Two Women Dressing 1920
pencil
signed and dated lower right: *F.L*
 20
Private Collection
To be compared with the painting 'Two Women Dressing' (below)

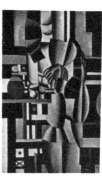

T 20

85 Woman with Bouquet 1920
pencil, 38 × 29 cm
signed and dated lower right: *F L 20*
Collection Mme Nadia Léger
To be compared with the painting 'Women with Bouquet' (below)

T 21

86 The Smoker
pencil, 31 × 24 cm
Collection Mme Nadia Léger

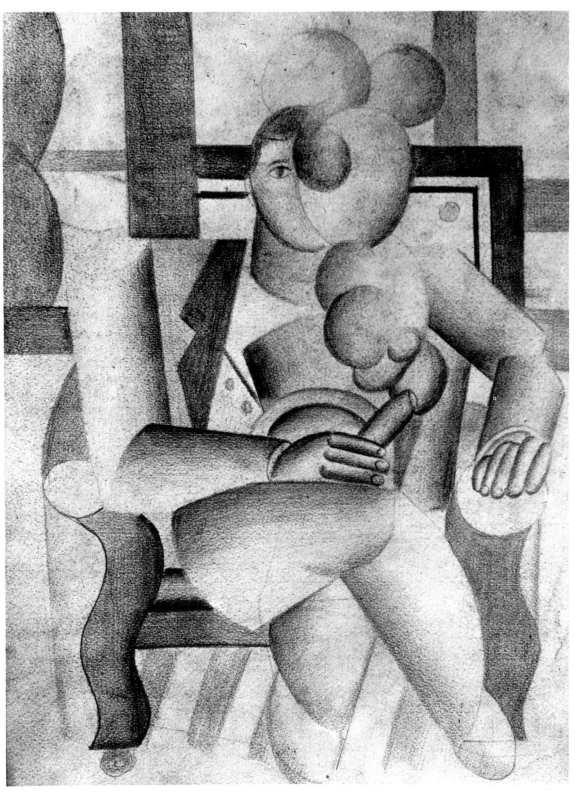

86

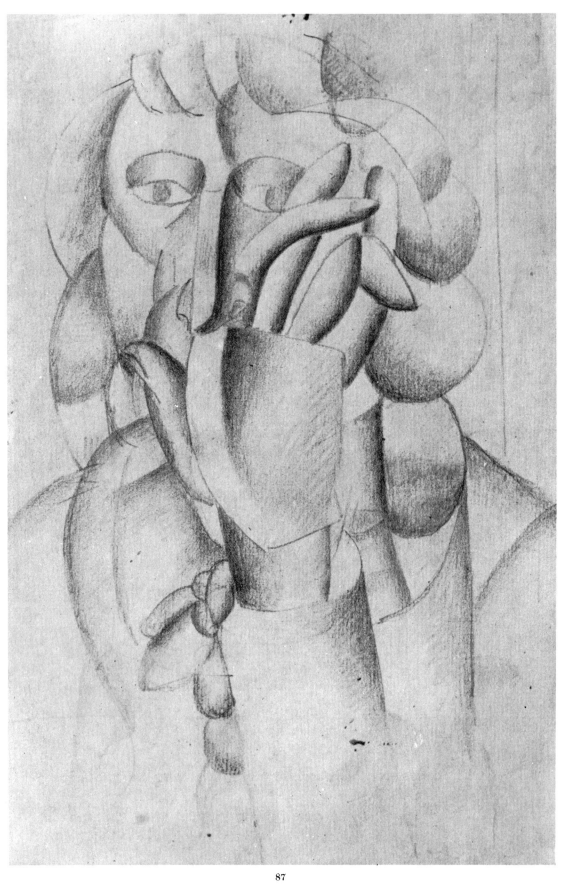

87

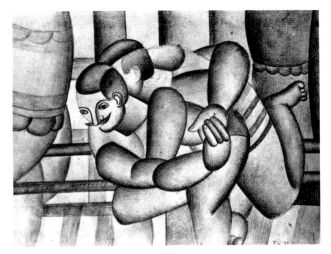

88

87 Head and Hand
 pencil, 31 × 20 cm
 Collection Mme Nadia Léger

88 The Wrestlers 1921
 pencil, 22.5 × 31 cm
 signed and dated lower right: *F.L. 21*
 Collection, Mr and Mrs Daniel Saidenberg,
 New York

89 Two Heads 1920
 pencil, 41 × 31 cm
 signed lower right: *F.L*
 20
 Galerie Claude Bernard, Paris

90 Reclining Woman
 pencil, 31 × 42 cm
 signed lower right: *F.L*
 Private Collection
 To be compared with the painting 'Reclining
 Woman', of 1922 (below)

89

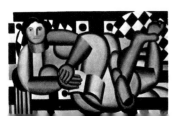

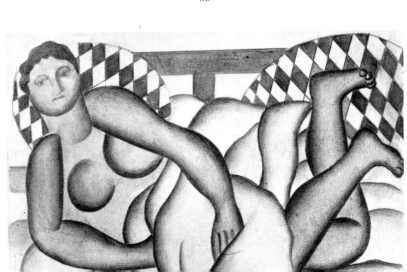

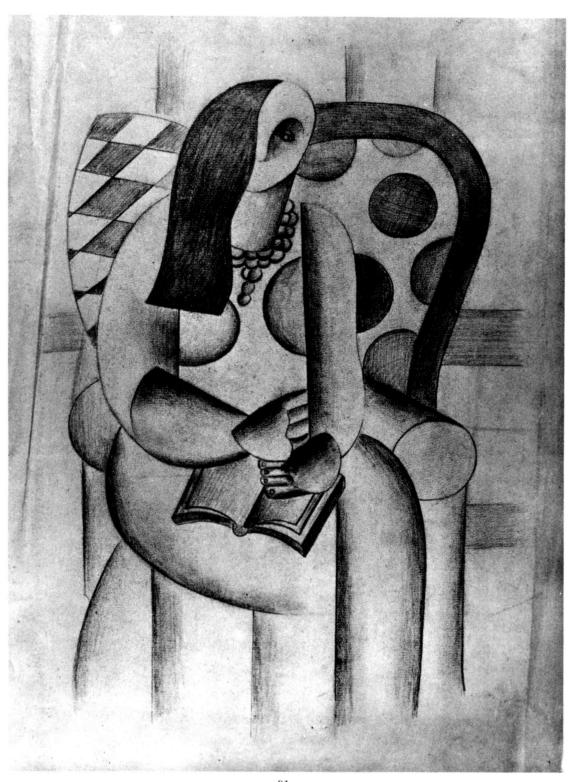

91

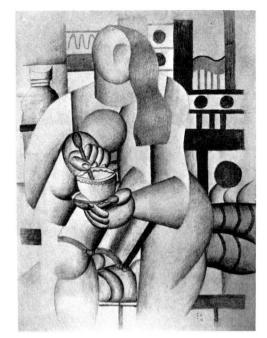

92

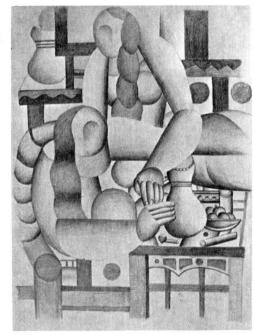

93

91 Seated Woman
pencil, 47.5 × 34.5 cm
Private Collection

92 Study for *The Meal (Large Version)* 1921
pencil, 47 × 35.5 cm
signed and dated lower right: *F.L*
21
Rijksmuseum Kröller-Müller, Otterlo,
Netherlands

93 Study for *The Meal, Large Version* 1921
pencil, 48.5 × 36.5 cm
signed and dated lower right: *F.L*
21
Rijksmuseum Kröller-Müller, Otterlo,
Netherlands

94 Study for *The Meal, Large Version* 1920
pencil, 37 × 51 cm
signed and dated lower right: *F.L*
20
Rijksmuseum Kröller-Müller, Otterlo,
Netherlands.
*Drawings 92, 93 and 94 should be compared
with the painting of 1921, 'The Meal, Large
Version' (below)*

T 23

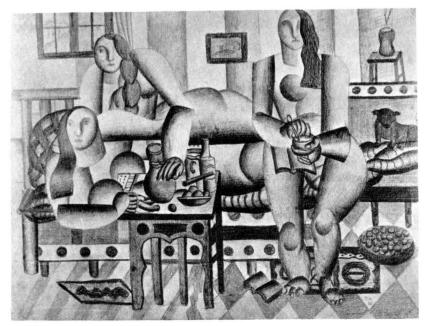

94

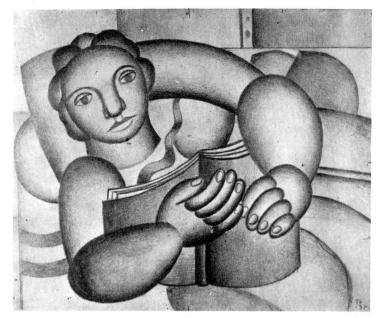

95

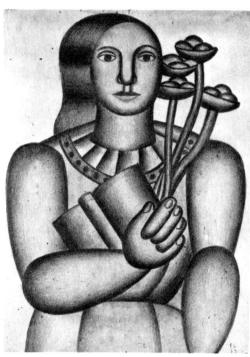

96

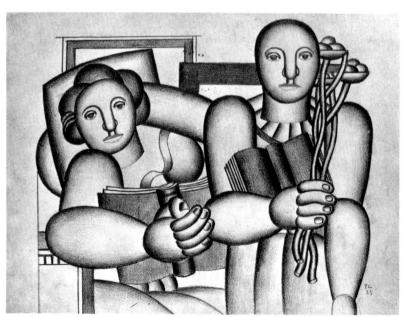

97

95 Woman with Book 1923
 pencil, 24.5 × 31.5 cm
 signed and dated lower right: *F L*
 23

 Private Collection, Paris

96 Woman with Bouquet 1923
 pencil, 32 × 23.5 cm
 signed and dated lower right: *F.L*
 23

 Private Collection, Paris
 To be compared with the painting 'Woman with Bouquet', of 1924 (below)

T 24

97 Study for *Reading* 1923
 pencil, 27 × 37 cm
 signed and dated lower right: *F L*
 23

 Private Collection, Paris
 Drawings 95, 96 and 97 should be compared with the painting 'Reading', of 1924 (below)

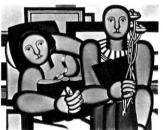

T 25

98 Three Women 1923
 pencil, 31 × 31 cm
 signed and dated lower right: *F L*
 23

 Private Collection, Paris
 To be compared with the painting 'Three Women' (below)

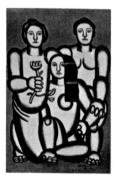

T 26

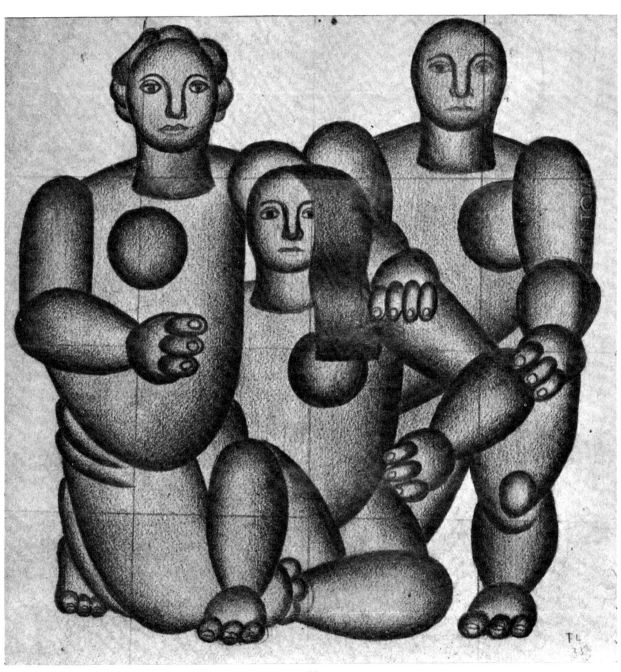

98

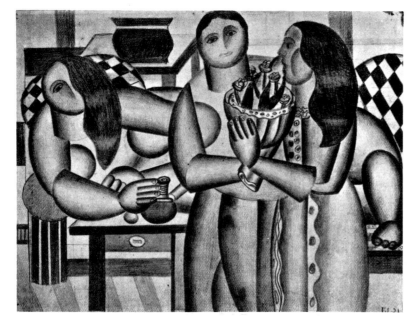
99

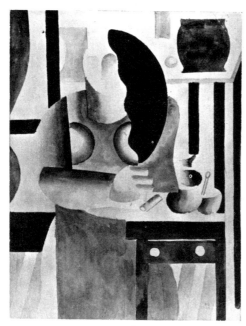
100

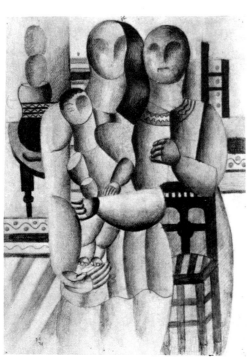
101

99 Three Women with Flowers 1921
pencil, 31 × 41 cm
signed and dated lower right: *F.L 21*
Private Collection
*To be compared with the painting 'Three
Women with Flowers', of 1920 (below)*

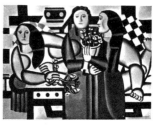
T 27

100 Woman at Table 1920
watercolour, 32 × 25 cm
signed and dated lower right: *F.L*
 20
Private Collection

101 Two Women and Child 1921
pencil, 40 × 31 cm
signed and dated lower left: *F L*

Collection Mrs Andrea Singer Pollack,
USA
*To be compared with the painting 'Mother and
Child', of 1921 (below)*

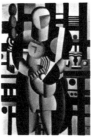
T 28

102 Mother and Child 1924
pencil, 30 × 39 cm
signed and dated lower right: *F L. 24*
Philadelphia Museum of Art, Philadelphia
*To be compared with the painting 'Mother and
Child', of 1922 (below)*

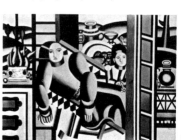
T 29

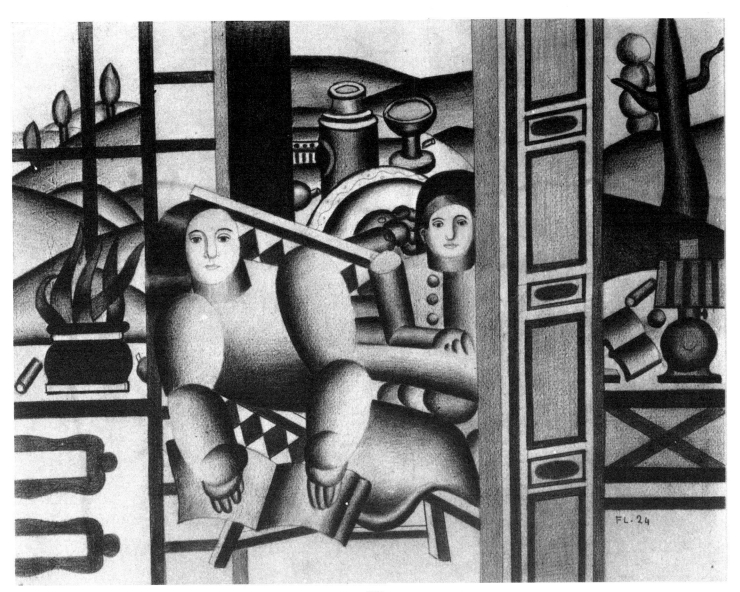

102

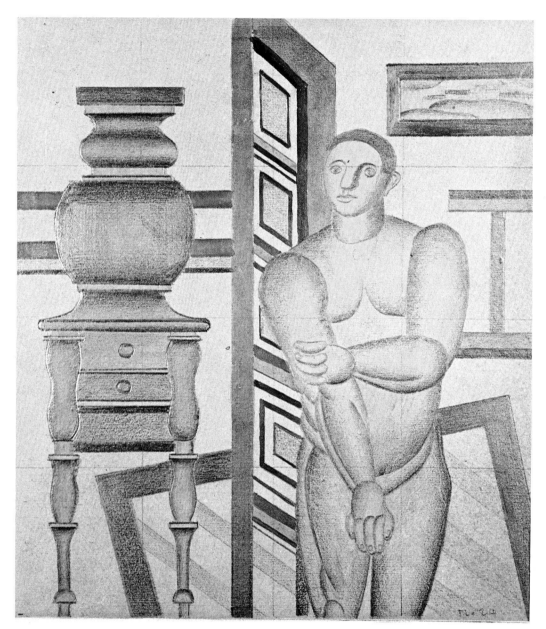

103

104

103 Figure 1924
coloured pencils, 23 × 20.5 cm
signed and dated lower right: *F L 24*
Private Collection, Paris

104 Figure
pencil, 26 × 31 cm
Private Collection

105 Houses 1922
pencil, 31 × 24 cm
signed and dated lower left: *F L*
22
Marlborough Fine Art Ltd, London
To be compared with several paintings on this
theme, and in particular with the painting 'View',
of 1925 (below)

T 30

106 Man in Sweater 1923
pencil, 27 × 38 cm
signed and dated lower right: *F.L*
23
Saidenberg Gallery, New York
To be compared with the painting 'The Man in
a Sweater', of 1923 (below)

T 31

105

106

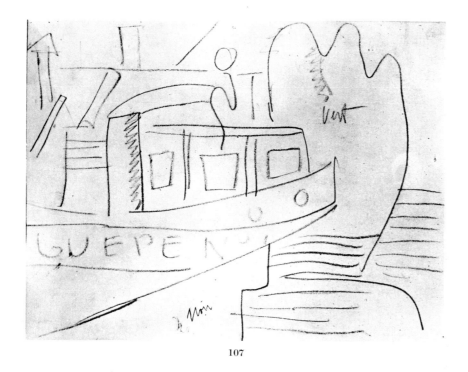

107

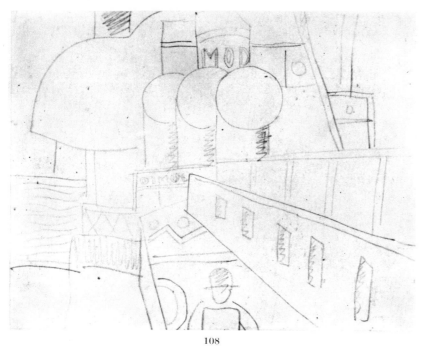

108

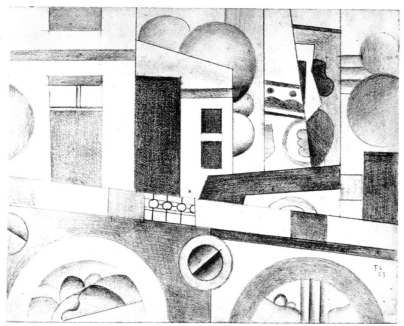

109

107 Sketch for a Tugboat
pencil, 25 × 32 cm
inscribed with colour notes: *vert, noir*
Former Collection Lefebvre-Foinet

108 Sketch for a Tugboat
pencil, 25 × 32 cm
Former Collection Lefebvre-Foinet

109 Study for a Tugboat 1923
pencil, 25 × 32.5 cm
signed and dated lower right: *F.L*
 23
Private Collection

110 architecture 1922
gouache, 25 × 32 cm
signed and dated lower right: *F.L*
 22
Private Collection
These four drawings relate to the theme of the tugboat, which led to several paintings. The gouache 110 in particular should be compared with the painting 'The Deck of the Tugboat' (below)

T 32

110

111

112

113

111 Figures in the City
green ink, 20.5 × 27 cm
Former Collection Lefebvre-Foinet

112 Figures in the City 1924
pencil, 21 × 25.5 cm
dated and signed lower right: *F.L 24*
Collection Louis Clayeux, Paris

113 Figures in the City
pencil, 22 × 25 cm
Musée National Fernand Léger, Biot

114 In Port 1922
gouache, 26 × 32 cm
signed and dated lower right: *F.L*
 22
Private Collection, Paris
*Drawings 111–13 seem to show Fernand
Léger and Léonce Rosenberg during a journey in
Italy, and are the origins of several paintings on
this theme. One, 'Landscape with Figures',
of 1924 (below), incorporates the motif of the
boat seen in gouache 114.*

T 33

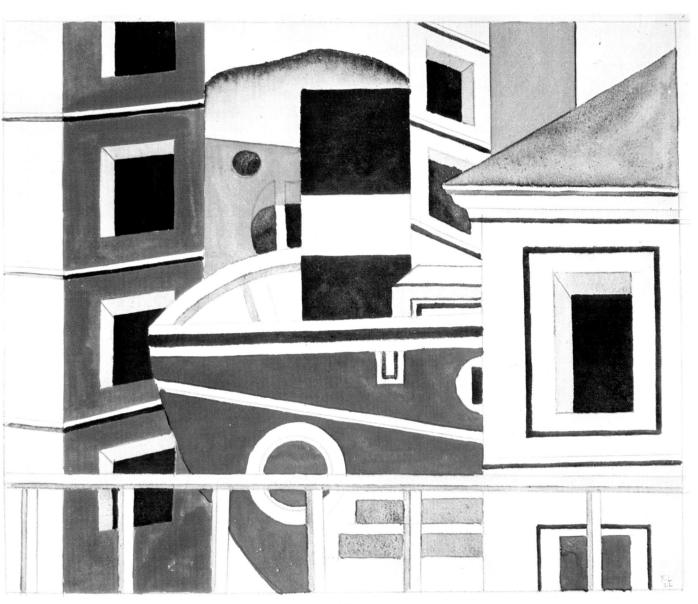

114

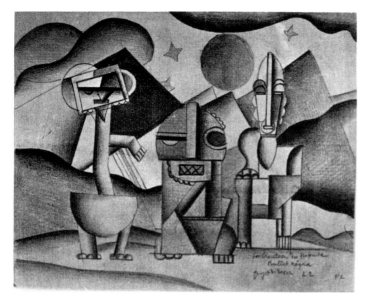

115

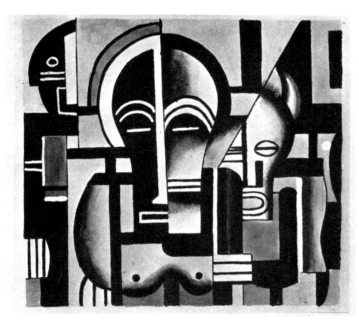

116

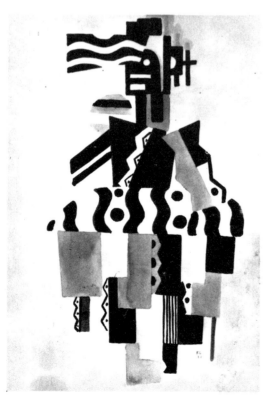

117

115 Set Design for the Ballet *La Création du Monde* 1922
pencil, 21 × 27 cm
inscribed, signed and dated lower right:
La Création du Monde
Ballet nègre
Projet de décor 22
F L
The Museum of Modern Art, New York
(Gift of John Pratt)

116 Set Design for the Ballet *La Création du Monde*
gouache, 25.5 × 29.5 cm
signed lower right: *F.L*
Private Collection, Paris

117 Costume Design for the Ballet *La Création du Monde* 'The King' 1921
gouache, 46 × 32 cm
signed and dated lower right: *F.L*
21
Private Collection, Paris

4 The Purist Phase 1923–26

Apart from an abstract gouache conceived as a mural (134), all the drawings of the years 1923–26 grouped here obviously belong to the category of still-lifes, though in a new way. Their style is an extension of that of the mechanical period, with a tendency towards starkness and stiffness which is often called Purist. Léger was in contact with Mondrian and those who produced the Dutch review *De Stijl*, in which one of his drawings had in fact been published as early as 1919, and well informed of the research carried out at the Bauhaus and by the Russian Constructivists; his main links were with Ozenfant and Jeanneret (alias Le Corbusier), the founders of *Esprit nouveau*, though he kept his distance from a movement which claimed to be a systematic distillation of Cubism; its doctrinal narrowness was incompatible with his down-to-earth, robust instincts. 'Purism did not appeal to me. Too thin for me, that closed-in world. But it had to be done all the same; someone had to go to the extreme.'

The preference for still-life and the cult of the object had the same doctrinal importance for the Cubist generation as the preference for landscape and the cult of nature had for the Impressionist generation. 'In 1923–24,' he said, 'I completed paintings whose important elements were objects set right outside any kind of atmosphere and unconnected with anything normal —objects isolated from the subjects I had abandoned. The subject in painting had already been destroyed, just as the avant-garde film had destroyed the story-line. I thought that the object, which had been neglected and poorly exploited, was the thing to replace the subject.'

This course had been imposed on him, like a revelation, by a twofold visual experience: the appearance of the streets, with their shop-windows and displays, and the growing impact of the

cinema. He saw Chaplin as 'a sort of living *object*, clear-cut and mobile, black and white'; Abel Gance's *La Roue* (1921) showed in his view the wonderful triumph of 'the actor-object', and prompted him to create *Ballet mécanique* in 1924, a film without a story which was concerned with the fragmentation and rythmic repetition of objects. 'The close-up, which is the real cinematographic invention, was useful to me in putting together this film. The fragment of an object has its own power. By isolating it, you give it character.'

Vase in a Window (118), a still-life set against a landscape background, and adhering to the same schema, with human forms eliminated, as the *Mother and Child* (102), provides a link with the last chapter. The central object is a vase which, with its sculpted base and fluted contour, reminds us of a Doric capital. The same theme, executed first of all as a working drawing in pencil (119) and reconsidered two years later in a less rigid gouache (120), was to undergo variation before reaching the final stage, that of the painting. Solid, curved volumes—the apples, the soup-tureen and the fruit-dish—are grafted uncompromisingly on to dominant rectangular planes. There is a contrast on several levels between the planes, which are 'more quickly comprehended as structures', and the forms in relief, 'which slow the eye down'.

In other structurally complex drawings, vertical (121, 126) or horizontal (129) in shape, pencil is used, not just for the sake of tension in the line but also to bring out the richness of the texture, and to show the clear, strongly-defined relationships between black, white and grey areas without gradations. These areas combine with the precision of contour to form an arrangement as rigid as that of the *Composition with Umbrella and Bowler Hat* (124). There is absolute harmony between the reality of the object and the purity of style, between what Léger called 'the code of realism' and 'the code of invention'.

The ruler, the set-square and the compasses, instruments which were necessary to the painter's precise manner of working, also appear as objects in his works. Thus, the compasses, fully in view or with only one point visible, dominate one composition in pencil (122) and two gouaches (123, 125). They are depicted together with a human eye or a rose, and this brutal contrast between form and matter sharply underlines the strange nature of each object. The compasses form a link between straight line and circle; and, in Léger's words, 'every object that has the circle as its basic form is always sought as an attractive force . . . roundness satisfies the human eye: it is complete, there is no break in continuity. The ball, the sphere are enormous plastic

values.' Hence his predilection for curved masses and cylinders (126–28), which yield all the more readily to the demands of plane or angular surfaces.

When he elected to depict a musical instrument, it was not the noble guitar or violin of his Cubist friends, but rather the popular instrument par excellence, the accordion, which he loved to hear in suburban dance-halls full of atmosphere and true rhythm. 'The band is simple,' he said: 'an accordion with bells tied to the player's ankle.' A gouache with the precision of a technical cross-section (132) shows an accordion with its inner parts unveiled.

In the multiple-register still-lifes, in which each separate article divides the space into compartments, printed letters sometimes occur as unexpected plastic signals; and so, sometimes, do objectivized human profiles, growing architectonically in one version (133), and shrinking, in another, between a green plant with two spirals and a line of vases arrayed like balusters (130). The disproportion in scale, and the paradoxical contrast between whole objects and fragments of objects, are among the most original of Léger's devices for intensifying form and activating composition.

At the 1925 'Exposition des Arts décoratifs', Léger decorated, with Delaunay, the hall of a model embassy constructed by Mallet-Stevens, and Le Corbusier invited him to display some examples of his mural painting in the *Esprit nouveau* pavilion. It was an opportunity for him to distinguish and contrast two kinds of plastic expression: easel painting, 'a firm value in itself, made up of concentration and intensity', which reacted against the wall through its dense, uncompromising structure, and ornamental painting, 'dependent on architecture, a firmly relative force, giving way to the necessities of its setting'—whose live surfaces it respects, while neutralizing the dead surfaces. Because of this function, it therefore needs abstract planes and pure colours, the volumetric masses being provided by the architecture and the spectators enclosed in it. During this short period, Léger composed ten or so entirely abstract decorative paintings, directly related to the contemporary realistic still-lifes whose static, monumental dignity they amplify. They are, to use his own term, 'wall illuminations'; one of the preparatory gouaches, vertical in form and forthright in colouring, is reproduced at the end of the chapter (134).

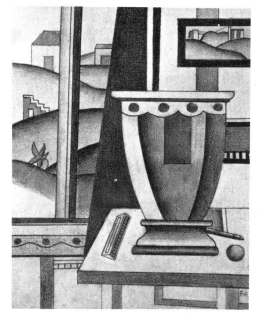

118

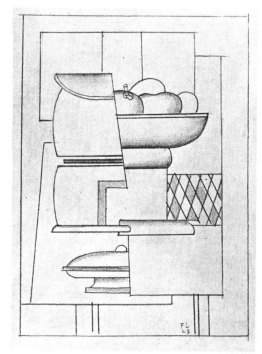

119

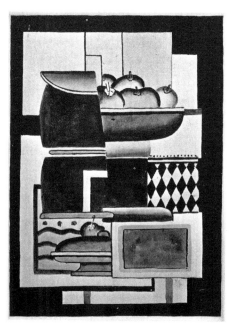

120

118 Vase in Front of Window
pencil, 22 × 18 cm
signed lower right: *F.L*
Saidenberg Gallery, New York

119 Still-life 1923
pencil, 30 × 21 cm
signed and dated lower right: *F.L*
 23
Private Collection

120 Still-life 1925
gouache, 27 × 19 cm
signed and dated lower right: *F.L*
 25
Philadelphia Museum of Art, Philadelphia
(A. E. Gallatin Collection)
*Léger often worked on the fruit-bowl theme at
this time. This gouache may be compared in
particular with the painting 'The Fruit-bowl',
of 1925 (below)*

T 34

121 Still-life 1924
pencil, 27 × 20 cm
signed and dated lower right: *F.L*
 24
Private Collection, Paris
*To be compared with the painting 'Still-life',
of 1924 (below)*

T 35

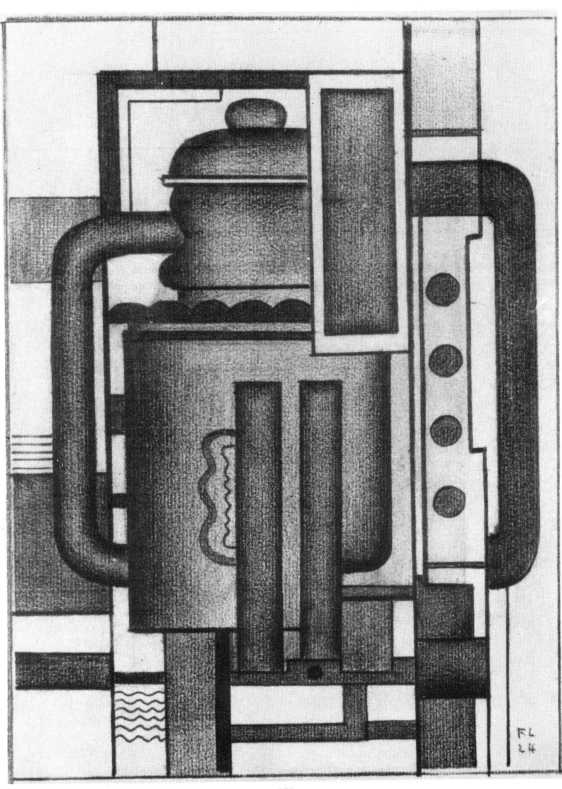

121

122

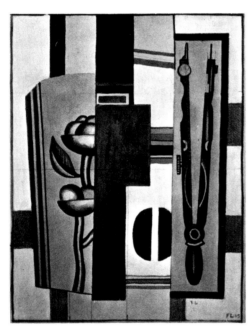

123

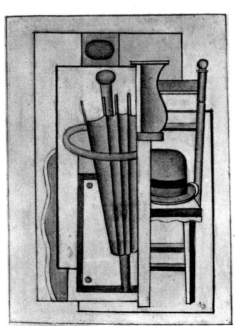

124

122 Composition with Compasses 1925
pencil, 33 × 65 cm
dated and signed lower right: 25
 F.L
Private Collection, Paris

123 Rose and Compasses 1925
gouache, 30.5 × 23.5 cm
signed and dated lower right: F.L
 F L 25
Saidenberg Gallery, New York
*To be compared with the painting 'Rose and
Compasses', of 1925 (below)*

T 36

124 Composition with Umbrella and Hat 1925
pencil, 30.5 × 23 cm
signed and dated lower right: F.L
 25
Private Collection, Paris
*To be compared with the painting 'Umbrella
and bowler', of 1926 (below)*

T 37

125 Composition with Compasses 1925
gouache, 35.6 × 25 cm
signed and dated, lower centre: F.L 25
Private Collection, Paris

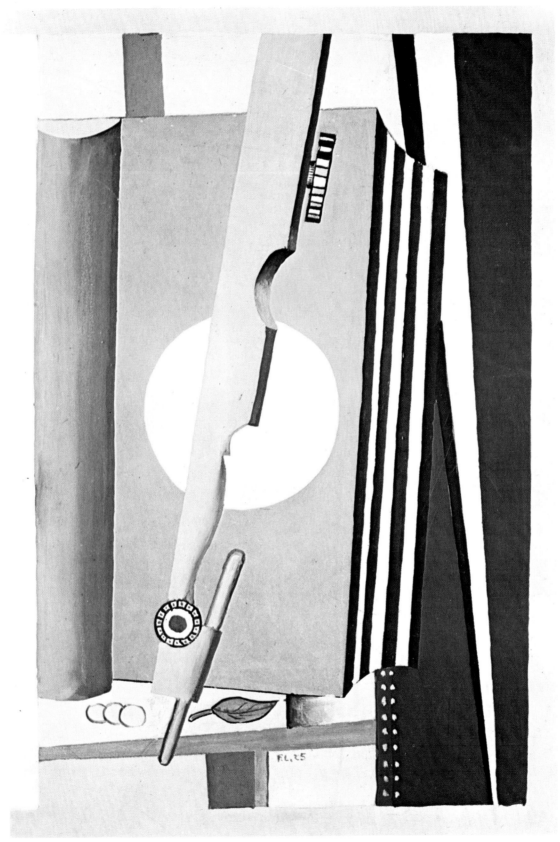

125

126

127

128

126 Still-life 1923
pencil, 30 × 21 cm
signed and dated lower right: *FL. 23*
Private Collection

127 Still-life 1924
gouache, 24 × 20 cm
signed and dated lower right: *F.L 24*
Philadelphia Museum of Art, Philadelphia
(A. E. Gallatin Collection)

128 Still-life with Bottle 1927
gouache, 27 × 21 cm
signed and dated lower right: *F.L. 27*
Collection, Mr and Mrs Daniel Saidenberg,
New York
*To be compared with the painting 'Still-life
with bottle' (below)*

T 38

129 Still-life on a Table 1925
pencil, 30 × 38 cm
signed and dated lower right: *FL. 25*
Collection Louis Clayeux, Paris
*To be compared with the painting 'Still-life', of
c. 1925 (below)*

T 39

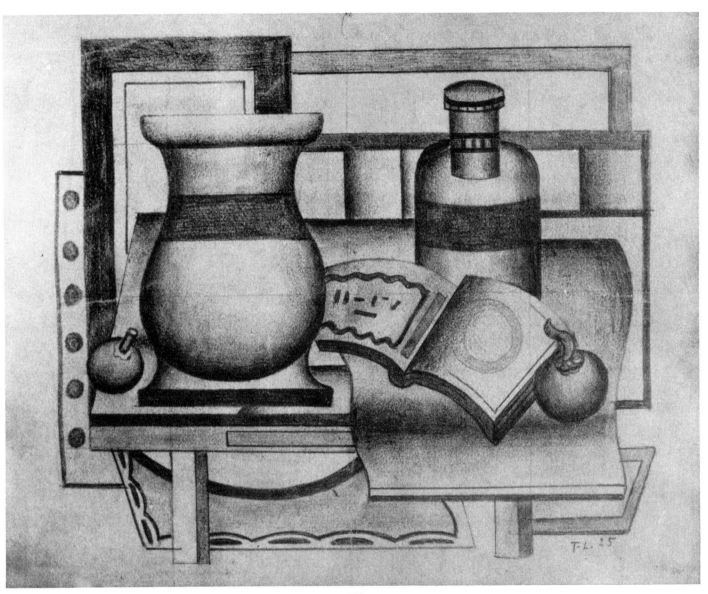

129

130

130 Study for *Composition with Two Profiles* 1926
gouache, 33.5 × 23.5 cm
signed and dated lower right: *F.L. 26*
Private Collection, Paris
To be compared with the painting 'Composition with Two Profiles' (below)

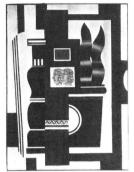

T 40

131 Study for *The Ball-bearing* 1926
gouache, 52 × 46.5 cm
signed and dated lower right: *F.L. 26*
Private Collection, Paris
To be compared with the painting 'The Ball-bearing' (below)

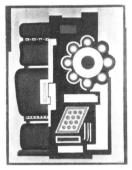

T 41

132 Study for *The Accordion* 1926
gouache, 33 × 25 cm
signed and dated lower right: *F.L. 26*
Philadelphia Museum of Art, Philadelphia
To be compared with the painting 'The Accordion', of 1920 (below left)

133 Study for the *Composition with Profile* 1926
gouache, 33.5 × 25 cm
Private Collection, Paris
To be compared with the painting 'Composition with Profile', of 1926 (below right), of which this is a reversed version

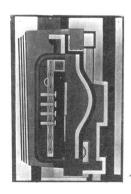

T 42 T 43

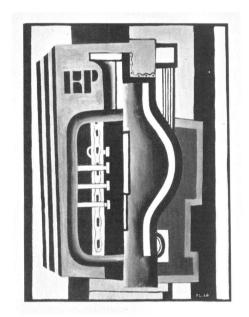

131

132

133

97

134

134 Project for a Mural Decoration 1924
gouache, 35 × 16 cm
signed and dated lower right: *F L 26*
Former Collection Marie Cuttoli
Private Collection
To be compared with the 'Mural Painting', of
1926 (below)

T 44

5 Objects in Space 1928–32

This chapter, which includes only one example of gouache, corresponds to one of the rare times when Léger practised drawing for its own sake and not in connection with a painting. It opens with three compositions of *Mechanical Elements*; their date, theme and style look backwards, but their rhythm and spatial organization prefigure his interest in 'objects in space'. The pencil drawing of 1922 (135), with its many overlappings of forms and planes, is the first forerunner of the more concise painting of 1924. The gouache of 1925, which is a preparatory stage for the painting which again simplified it (137), gives the impression of a machine throbbing into motion.

The drawings which follow (138–41) still seem related to those in the last chapter, whether by a vertical arrangement (141), by the difference in scale between a huge hand and two tiny heads (139), or by the use again of compasses, human profiles and painted letters, either spaced out or superimposed as in a Chinese ideogram (138). But the architectonic structure is no longer there: the orthogonal supports, particularly the table, have disappeared, so that the objects are now isolated in space, and no longer have the natural interrelationships which Braque and Picasso were preserving, and which make even the most inventive still-life a familiar organism, i.e. a subject. Léger's objects have escaped from the domination of the subject, as they have from the pull of gravity; they invert or reject perspective, loom up and recede in the air, with the power and mystery of pictures in slow motion.

This decisive change, the abrupt turning from a static, frontal, solemn order to a fluid and playful freedom, corresponds to the painter's internal dialectic. He justified the change as follows: 'I put my objects in space in order to be sure of them as objects. I felt that I could not put my object on a table without diminishing its force as object.' It was therefore in order to accent the

autonomy and entity of the object in itself, detached from the imprisoning subject, that he broke with the vertical structure and the Cubist principle of concentration, and inaugurated his own revolutionary principle of dispersion. 'I took the object and did away with the table; I put the object in the air, without perspective or support.' The result of this was a new spatial medium, a sort of ether in which the ordinary relationships between objects are dissolved, but which retains an indispensable environmental quality. In an article in *Cahiers d'art*, 'L'Importance de l'objet dans la peinture d'aujourd'hui', Christian Zervos noted in 1930, that is, at the very time which concerns us: 'The space in which Léger situates his objects allows of an atmosphere; Léger, in opposition to those who abolish it entirely, claims that the object needs a certain atmosphere in order to keep its plastic state. Atmosphere, for Léger, is a matter of the quantity of values. Thus, two values do not form an atmosphere; this is created with three or more. Nevertheless, the number of nuances must remain very small, if one wishes to attain to a true synthesis. Strong things always require a very bare, austere atmosphere.'

This change of attitude led Léger to extend his iconographic repertoire, to include in his aerial space, in which relationships became extremely delicate, flexible structures opened out, for example a shell and its convolutions (138), a leaf and its veins (140, 141), a rope and its strands (146), a belt and its coils (149); and to join the multifarious scattered objects with connecting threads and bands (148). Several of these are ink drawings, and they were no longer executed in such a clear and restrained manner as the ink drawings of the mechanical period. Drawn with a fine pen, and mostly for their own sake, independently of his paintings, they display a profusion of decoration and an unreal grace seldom found in Léger's works (147–49). Pencil was used for a number of severe, more clearly defined studies: a *Pair of Spectacles* (142) integrated into a complex whole and made to stand out with its circles and frame; a *Bunch of Keys* (145) suspended alone in space and in striking relief. When associated with other objects, such as an umbrella (144), or with female dancers with tendril-like limbs (151), these keys become the symbol or emblem of this strange period. They appear in several famous paintings, notably the one Léger considered to be the most ambitious of his works from the point of view of contrast. He told of its inception thus: 'One day, I had done a bunch of keys on a canvas, my bunch of keys. I did not know what I was going to put beside them, I needed something which was the absolute opposite of the keys. Then, when I had finished working, I went out. I had hardly gone a few steps, and what did I see in a window?

A postcard of the *Mona Lisa*! I realized right away. That was what I needed; what could be a greater contrast with the keys? And so I put the *Mona Lisa* on the canvas. After that, I also put in a tin of sardines. That made a really sharp contrast.'

It is easy but pointless to delve into the Freudian implications of such combinations; Léger's reactions were stimulated only by the physical reality of objects, and he was influenced only by plastic requirements, by the laws of rhythm and contrast which ruled his self-ordained world. He was quite closely acquainted with the Surrealist movement (as with all the other artistic currents of his time), and sometimes immersed himself in its atmosphere; but his positive, concrete method was decidedly opposed to the iconoclastic Romanticism of the disciples of Lautréamont, who were fascinated by the incongruous and the unconscious, and contemptuous of the machine-based civilization in which Léger never lost faith.

Female nudes treated as plastic elements make a new appearance; and joyously take part in the spatial ballet, alone or in couples, surrounded by subsidiary objects which revolve round them (151, 152) or giving order on their own to the infinite space created and diversified by their majestic, concerted choreography (150–53). Sometimes their heads are bald and round as a ball; sometimes their hair hangs down in long tresses or in long waves linked with the movement of the drapery.

A final series of pencil drawings, denser and with a classicism akin to that of Ingres (154–57), restores stability to their bodies, while keeping the flowing rhythm, and lays emphasis on the hands and fingers which partly mask the face, in which there are great pensive eyes, wide open. A female dancer in space comes back to earth and becomes a crouching bather (154) or an expectant reader (157), firmly set down in all her nobility of form and gesture.

135

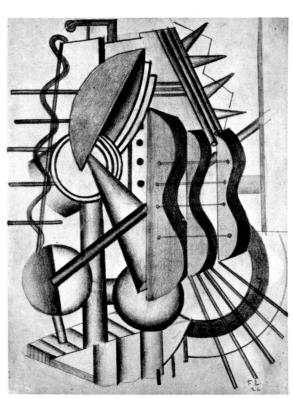

136

135 Mechanical Elements 1922
pencil, 32 × 24.5 cm
signed and dated lower right: *F.L. 22*
Private Collection, Paris
*To be compared, in particular, with the painting
'Mechanical Elements', of 1924 (below)*

T 45

136 Composition 1924
pencil, 31 × 24 cm
signed and dated lower right: *F L*
 24
Private Collection, Paris

137 Composition
gouache
inscribed and signed lower right:

*à M. Léonce
Rosenberg
avec son meilleur
souvenir
F L*

Private Collection, Paris
*To be compared with the painting 'Composition',
of 1925 (below)*

T 46

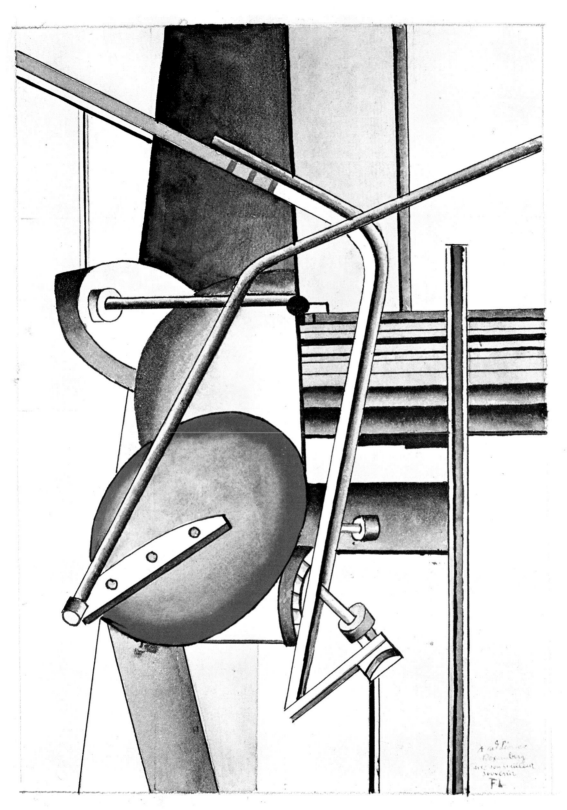

137

138

139

140

138 Shells and Profile 1928
 ink, 31 × 23.5 cm
 signed and dated lower right: *F.L. 28*
 Private Collection, Paris

139 Composition with Compasses 1929
 ink, 29 × 22 cm
 signed and dated lower right: *F.L 29*
 Musée de Peinture et de Sculpture,
 Grenoble

140 Composition
 pencil, 37.5 × 26 cm
 signed lower right: *F L –29*
 Galerie Henriette Gomès, Paris

141 Composition with Leaf
 ink, 45 × 37 cm
 signed lower right: *F.L.*
 Private Collection, Paris
 *On the reverse is another drawing, a study of
 hands, signed F.L.*

141

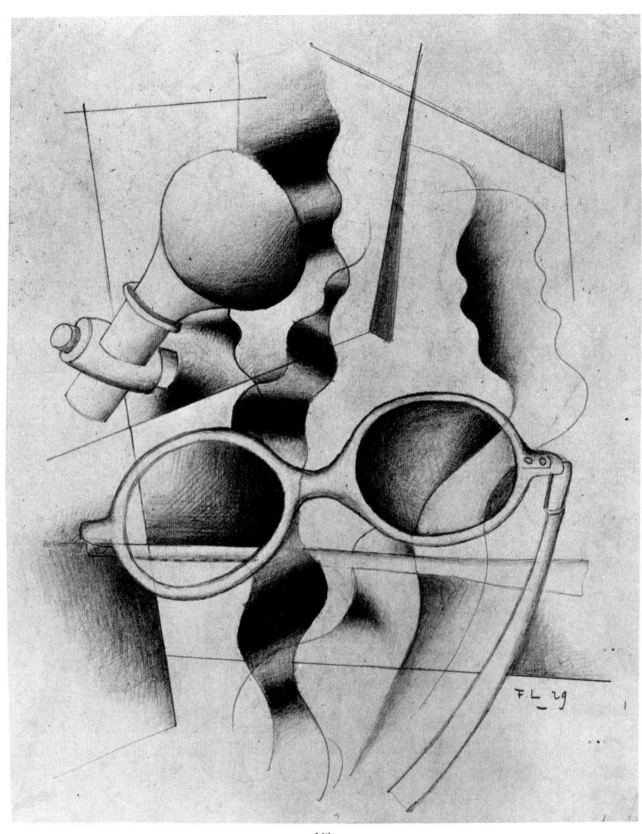

142

142 The Spectacles 1929
Pencil, 27 × 21 cm
signed and dated lower right: *F.L 29*
Private Collection, Paris

143 Pen Nibs and Objects in Space
ink
Present owner unknown; photographed by
Georges Allié in Léger's studio
*To be compared with the right-hand part of the
painting 'Contrasting Objects', of 1930 (below)*

144 Umbrella, Keys and Objects in Space
ink
Present owner unknown; photographed by
Georges Allié in Léger's studio
*To be compared with the painting 'Umbrella
and Keys' (below)*

T 47

145 Keys 1929
pencil
The photograph used has the date and the
signature of F. Léger on the back
Present owner unknown; photographed by
Georges Allié in Léger's studio
*The motif of the bunch of keys is to be found
most notably in 'The Mona Lisa with Keys',
of 1930 (below)*

T 48

143

144

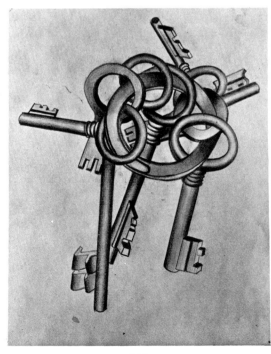

145

146

147

146 Composition with Rope
ink, 40 × 31.5 cm
Galerie Louise Leiris, Paris

147 Woman and Rose
ink
Private Collection
Compare the painting 'The Rose', of 1931
(below)

T 49

148 Composition 1930
ink, 31 × 24 cm
signed and dated lower right: *F.L*
 30
Private Collection

149 Composition with Profiles, Belt and
Umbrella 1930
ink, 35.5 × 26 cm
signed and dated lower right: *F.L. 30*
Private Collection, Paris

148

149

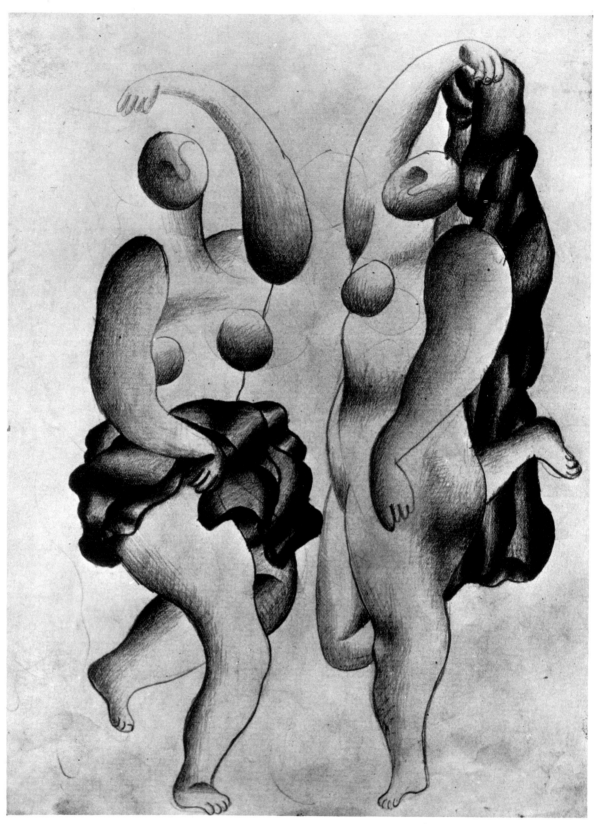

150

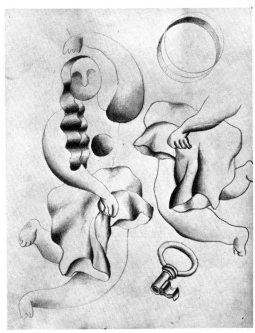

151

150 Two women
pencil
Present owner unknown; photographed by
Georges Allié in Léger's studio
*To be compared with the painting 'Two
Women', of 1928 (below)*

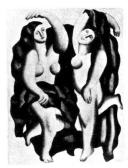

T 50

*The woman on the right may be compared with
the painting 'Contrasting Objects', of 1930
(below)*

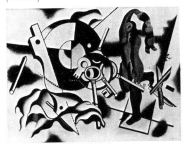

T 51

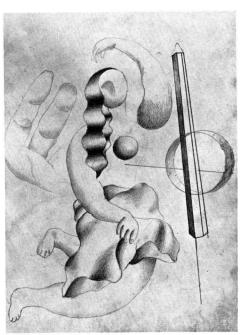

152

152 Woman and Objects in Space
pencil
Present owner unknown; photographed by
Georges Allié in Léger's studio

152 Woman and Objects in Space
pencil
Present owner unknown; photographed by
Georges Allié in Léger's studio

153 Two Women
pencil
Present owner unknown; photographed by
Georges Allié in Léger's studio

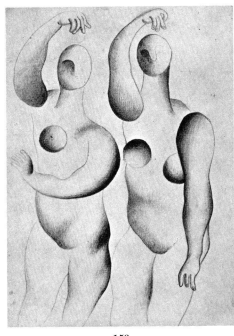

153

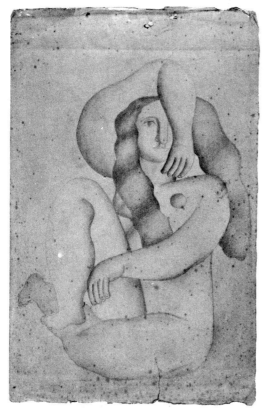

154

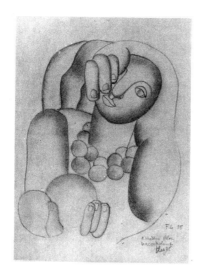

155

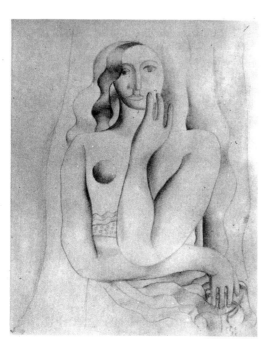

156

154 Study for *The Bather*
pencil, 49 × 31.5 cm
signed lower right: *F.L.*
Private Collection
*To be compared with the painting 'The Bather',
of 1931 (below)*

T 52

155 Woman Holding a Ball
pencil, 27 × 21 cm
inscribed, signed and dated lower right:
 *F.L. 35
 à madame Bloc
 très cordialement
 F. Léger*
(The date of execution is anterior to this.
The above dedication did not appear in a
photograph published in 1929.)
Collection Mme André Bloc

156 Seated Woman 1932
pencil, 38 × 31 cm
signed and dated lower right: *F.L*
 3²
Private Collection, Paris

157 Reading 1931
pencil, 52.5 × 61 cm
inscribed, signed and dated lower right:
 *La lecture
 F L 31*
Private Collection, Paris

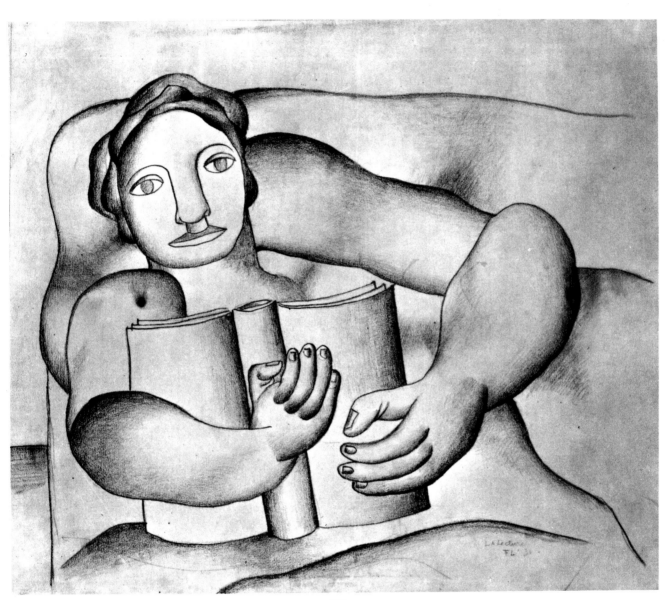

157

158

159

158 Composition on Black Ground 1930
 50 × 65 cm
 signed and dated lower right: *F.L. 30*
 Private Collection

159 Composition with Corkscrew
 pencil, 48 × 63 cm
 Private Collection

6 The Fascination of the Object 1928–34

A new series of drawings which extended from 1928 to 1934 again depicts objects, or parts of the human body treated as objects. It is thus a continuation of the two preceding series, but has certain distinctive characteristics which confirm that there was a continuous evolutionary force. Léger was now breaking away from the world of machines and turning towards natural forms which were essentially vegetable, mineral, animal—towards the human body and the clothes which bear its imprint. From the phase of dispersion in space, he kept the principle of using a neutral background in depth, against which the objects were grouped. But most often he detached a single object and set it down with the precision of a scholar and the fervour of a poet, using a resolutely classical style.

Standing between earth and sky, stable and yet full of movement, totally self-sufficient, the tree has always fascinated artists. Klee compared the creative function to a tree in growth, and the same image often suggests itself with regard to Léger. Reverdy said, 'I liked to picture him to myself as a great tree with a hard, generous bark, firmly outlined against a rolling horizon—a tree that shed its leaves upon the night, where they now shine like dazzling stars.' The tree was to remain one of Léger's favourite themes; his love of contrast led him to use it as an antidote to the machine. 'I adore trees. I can't rest when there are trees round me. I'm enormously tempted to paint them, but I know that I shall never be able to paint them as I see them. How could I ever give them more expressiveness than they have? I know I'm beaten before I start.' He liked them particularly because of their roots and their smooth trunks. 'I am greatly attracted by trees, but only when they have no leaves.' Roots (161) spread out their tentacles around a central stump. Logs (160) are placed at intersecting angles, and trunks which are smooth (163), or have nerve-like branches (162), go to make up

amazing geometrical bundles. Pear-tree roots drawn in ink or with gouache grow in force and starkness. These are no longer convulsed, fibrous lines, but extended segments with a rather bony look. Thus, they can be compared with the contemporaneous studies of flint (170, 171), in which the compact, shadowy mass of the mineral is lightened by holes.

'Everything that can be painted, from a stone to a man, has a universal aspect': Léger showed the truth of this idea of Goethe's in a concrete manner. At the same time he revealed both his strong attachment to his native soil and his kinship with one of his illustrious fellow-countrymen. In Pierre Courthion's words: 'He went back home to his Normandy as a peasant, happy to revisit the place where his father used to raise cattle. As he walked slowly along the road, turning over some ideas of his own in his mind, he saw some stones on the roadway, picked them up and took them away with him. He painted them as a Naturalist would have, without realizing that he was following, after three centuries, another Norman, Nicolas Poussin, who used to bring back from his walks around Rome a stock of pebbles and leaves to make his rocks and trees. These realistic analogies with infinitely small things studied in magnified close-up are (Léger insists on my saying this) only *documents*.'

Apart from the holly-leaf (164), whose sharp points seem to have been cut out of metal, leaves had a texture that was too yielding, too impressionistic, to interest him. When he isolated and contemplated a piece of mahogany (165), part of an armchair (166), or a fragment of a glass window (167), carefully detailing the grain, the twisting lines, the facets, he was exploring the material world with the help of his experience with films, and revealed himself to be a precursor of Pop art. 'Magnifying an object, or a small part of an object, gives it an identity which it has never had before, and so it becomes the vehicle for an entirely new kind of lyrical power.' Everyday clothes, with the creases and folds made by their wearers—a pair of trousers (172), a belt (173), gloves (174), or some drapery (175)—are drawn with the intensity of technique and the Primitivist vision of Dürer or Van Eyck. Quarters of beef, which appealed to Soutine because of their corruptible flesh and to Léger because of the regular divisions made by the ribs, are contrasted with parts of machines (179), or, by means of rhythmic affinities, with natural components, a ladder, a stool, some branches (176). The poet Francis Ponge, who was as obsessed with objects as Léger was, described a piece of meat as 'a sort of factory: mills, bloodpresses and pipes are found next to power-hammers and greasepads'

During the long time he spent as a teacher, Léger never failed to stress the primordial importance of drawing. 'Draw first,' he taught his pupils. 'An exact drawing with lines, lines and nothing else. Small parts first: hands, feet, then human forms, and next comprehensive compositions.' He himself offered practical demonstrations of what he meant by quickly producing with his pen the *Back of a Nude Man* (180), with its carefully-detailed muscles shown by close-set lines like the network of lines in an engraving; hands and a foot together (181), with their clearly-marked, convex nails; an open hand with a closed fist (182); part of a face masked by a hand (183), in which we can see a tremulous eye and mouth; and by using his pencil like a chisel to produce pure, continuous strokes, studies of flexible and delicately-modelled hands (184–86), which are taking, gripping or holding different things. 'One becomes aware that *everything* is equally interesting, that the human form, the human body, are not more important, from the plastic point of view, than a tree, a plant, a fragment of rock or a rope.'

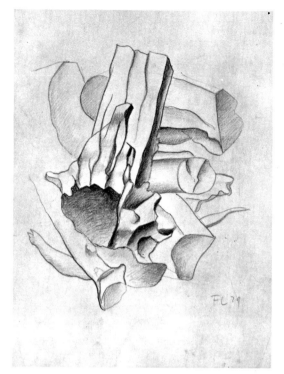

160

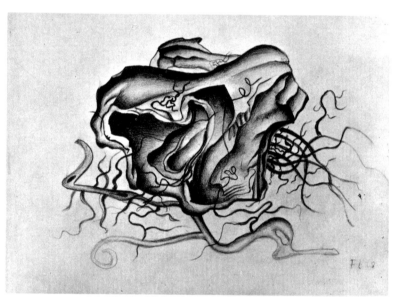

161

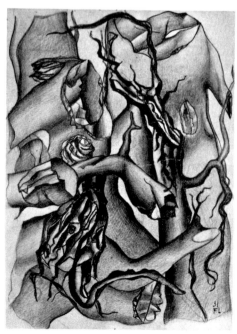

162

160 Logs 1929
pencil, 36 × 27 cm
signed and dated lower right: *F.L 29*
Private Collection

161 Root 1928
pencil, 27 × 37 cm
signed and dated lower right: *FL. 28*
Galerie Claude Bernard, Paris

162 Study for *Tree Trunks* 1931
pencil, 30 × 22 cm .
dated and signed lower right: *31*
 F.L
Galerie Claude Bernard, Paris
To be compared with the painting 'Tree Trunks',
of 1931 (below)

T 53

163 Trees 1931
pencil
inscribed, dated and signed lower right:
 Les Arbres
 Ramgut 31
 F L
Former Collection Lefebvre-Foinet, Paris

163

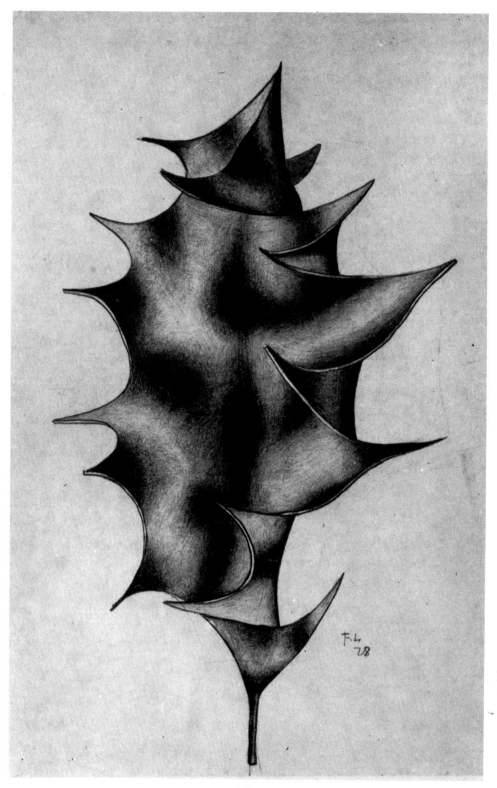

164

165

166

164 Holly Leaf 1928
 pencil, 32 × 21 cm
 signed and dated lower right: *F.L.*
 28
 Private Collection, Paris

165 Fragment of Mahogany 1933
 ink
 inscribed, signed and dated lower right:
 fragment d'acajou
 F.L 33
 Former Collection Lefebvre-Foinet, Paris

166 Part of an Armchair
 ink, 36.5 × 31 cm
 inscribed lower right: *élément de fauteuil*
 Private Collection, Paris

167 Fragment of Leaded Glass
 ink, 34 × 29 cm
 De Menil Collection, Houston, USA

167

168

169

170

168 Pear-tree root 1932
ink
inscribed, dated and signed lower right:
Racine de poirier
sept. 32 F L
Former Collection Lefebvre-Foinet, Paris

169 Pear-tree root 1932
gouache
inscribed, dated and signed lower right:
F.L. 32
Racine de
poirier
Philadelphia Museum of Art, Philadelphia
(A. E. Gallatin Collection)

170 Two Flints 1932
ink
inscribed, dated and signed lower right:
Les deux silex
sept. 32 F L
Former Collection Lefebvre-Foinet, Paris

171 Flint 1932
ink and white gouache on yellow paper,
68 × 48 cm
inscribed, dated and signed lower right:
Silex
sept. 32 F.L
Galerie Louise Leiris, Paris

SILEX
Sept. 32 _ F·L

171

172

173

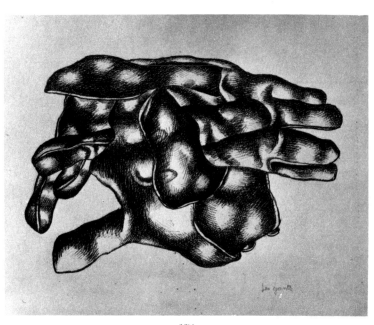

174

172 Pair of Trousers 1933
ink, 36.5 × 29.5 cm
signed and dated lower right: *F.L.*
 33
Collection Louis Clayeux, Paris

173 Belt 1930
pencil, 26.5 × 18 cm
signed and dated lower right: *F L*
 30
Private Collection, Paris

174 Gloves
ink, 32 × 29 cm
inscribed lower right: *Les gants*
Private Collection

175 Study of Drapery
pencil, 27 × 21 cm
signed lower right: *F.L*
Galerie Claude Bernard, Paris

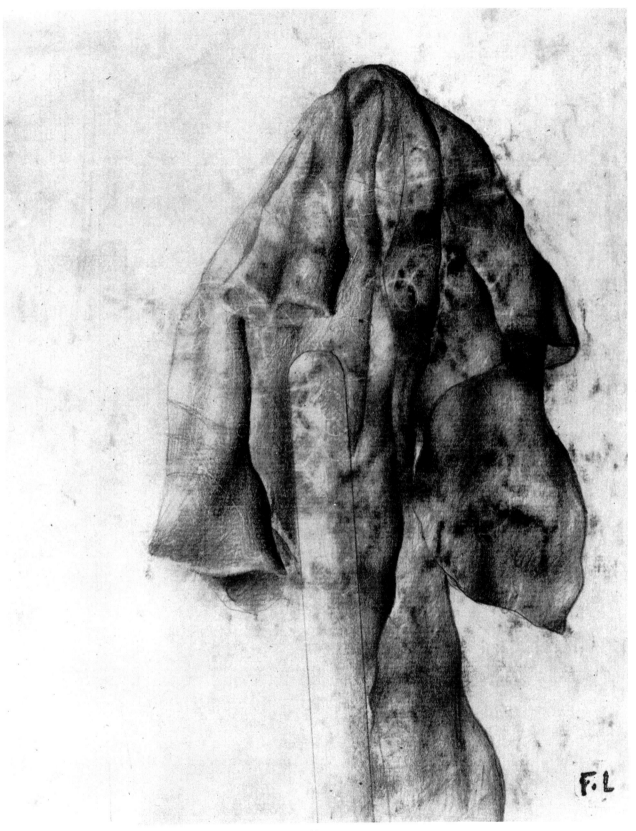

175

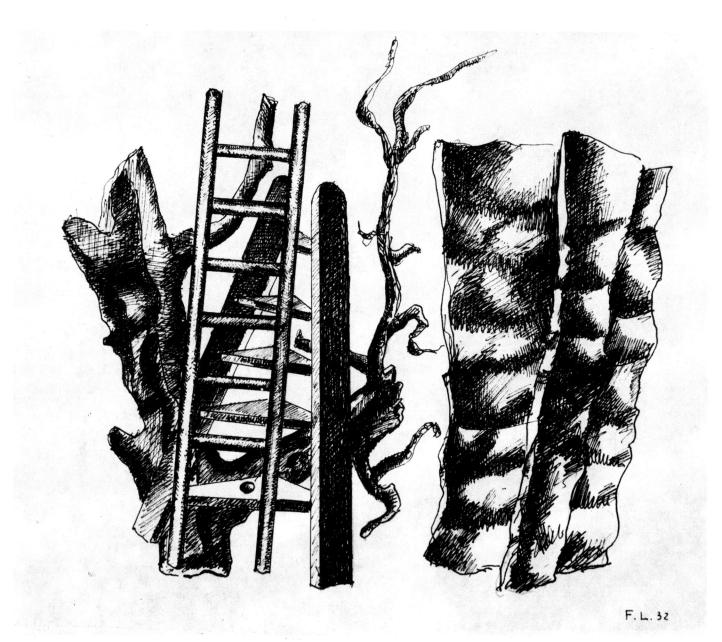

F.L. 32

176

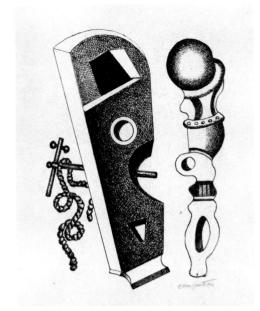

177

178

176 Ladder, Steps, Root and Quarter of Beef 1932

ink, 31.5 × 39 cm
signed and dated lower right: *F.L. 32*
Private Collection, Paris

177 Composition
ink, 32 × 24 cm
inscribed in pencil, lower right: *composition*
The Museum of Modern Art, New York
*Léger mounted this drawing in the same frame
as no. 181*

178 Composition with Jacket 1934
ink, 32 × 38 cm
signed and dated lower right: *F.L 34*
Collection Mme Nadia Léger

179 Quarter of Beef with Geometrical Elements
1943
ink, 31.5 × 22.5 cm
signed and dated lower right: *FL : 34*
Private Collection, Paris

179

180

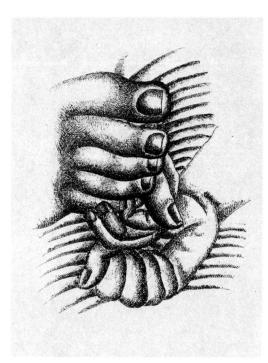

181

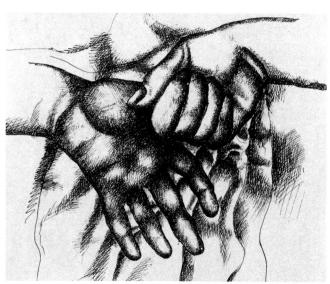

182

180 Back of Nude Man
 ink
 Private Collection

181 Foot and Hands 1933
 ink, 32 × 24 cm
 inscribed, signed and dated lower right:
 pied et mains
 F L 33
 The Museum of Modern Art, New York
 Léger mounted this drawing in the same frame
 as no. 177

182 Two Hands 1933
 ink, 29 × 36 cm
 entitled, signed and dated lower right:
 Les deux mains
 F L 33
 Former Collection Marie Cuttoli
 Öffentliche Kunstsammlung, Basle

183 Fragment of Face 1933
 ink, 31.5 × 24.5 cm
 entitled, signed and dated lower right:
 fragment de
 figure
 F L 33
 Former Collection Marie Cuttoli
 Private Collection, Paris

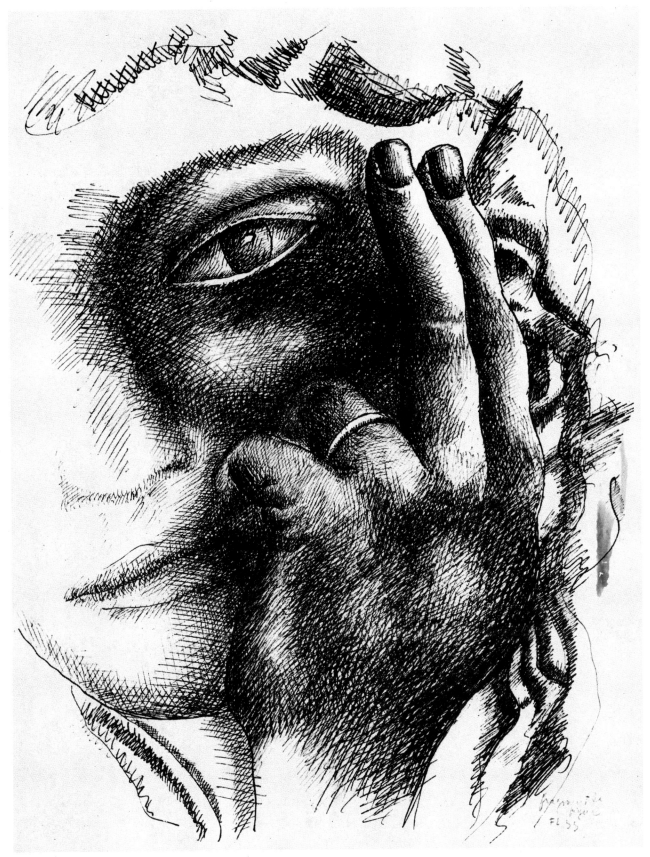

183

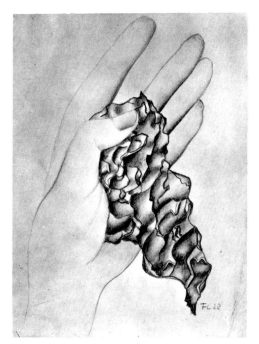

184

185

186

184 Hand Holding Object 1928
pencil, 32 × 24.5 cm
signed and dated lower right: *F L 28*
Private Collection, Paris

185 Hand Holding Rope 1932
pencil, 31.5 × 23.5 cm
signed and dated lower right: *F L 32*
Private Collection, Paris

186 Hands Holding a Box of Matches
pencil
Present owner unknown; photographed by
Georges Allié in Léger's studio

7 Gouaches 1936–38

This short chapter deals with seven drawings from the years 1936–38 which are closely related, due to the use of a common technique, that of gouache, and to a broad, flexible style which marks a clean break with the Purist severity of the earlier drawings.

Landscapes, a theme abandoned since 1921, now recur, but without human figures, with vegetable life, rather than architectonic values, striking the dominant note (187). Smooth trees with radiating branches give emphasis to the uniform space between fields and clouds (188).

In the strange *Flame* (189), the flame has the dimensions and outline of a tropical plant, beside which a snake-like form, a favourite of Léger's, unwinds its coils, all against a black background. The *Composition with Flower* (182) brings into opposition the schematic silhouette of a small human figure and a huge, circular flower, like a starfish. ('Never a flower as a flower, but solely when its presence beside another object forms an unexpected contrast.') In a third composition (193), vertical elements, to which an apple is connected by its long tail in the form of a necklace, rise in front of a sort of screen. The apple, with its sinuous appendage waving in the space where powerful rhythmical signs are suspended and condensed, reappears in two still-lifes (190, 191) in which Léger reintroduced the table as a support.

The gouache sometimes has an autonomous status—as is obviously the case in the *Composition with Flower*—though usually, after the preparatory drawings in ink or pencil, it constituted the final stage in the evolution towards the painting, which was then either a straight or an inverted transposition. This technique, which integrates pure colour with spontaneous drawing, was much more suited than watercolour—which is too harmonious—to the clear-cut style which Léger adopted more and more towards the end of his life.

187

188

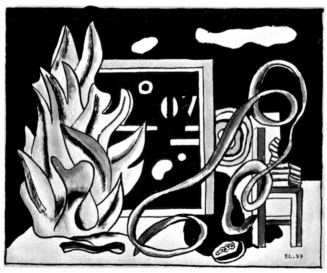

189

187 Landscape 1937
gouache, 31 × 24 cm
entitled, dated and signed lower right:
Paysage
37
F L
Former Collection Lefebvre-Foinet, Paris
*To be compared with the painting 'The Black
Tree', of 1937 (below)*

T 54

188 Landscape with Figures 1936
gouache, 65 × 50 cm
signed and dated lower right: *F.L. 36*
Private Collection, Paris
*To be compared with the painting 'Landscape
with Figures', of 1937 (below)*

T 55

189 Flames
gouache, 28 × 35 cm
signed and dated lower right: *F.L. 37*
Former Collection Marie Cuttoli
Private Collection

190 Composition 1938
gouache, 26 × 37 cm
signed, dated and inscribed lower right:
A Mazenod F.L. 6. 38
Amicalement F. Léger
Collection Lucien Mazenod, Paris

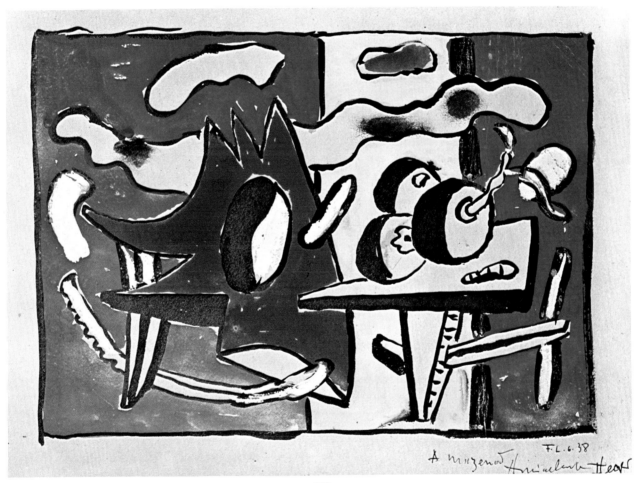

190

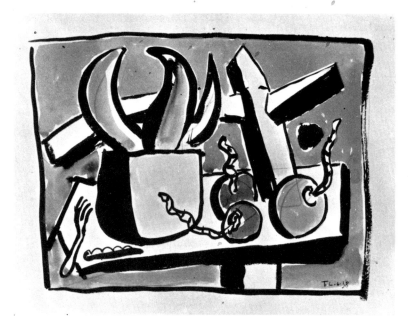

191

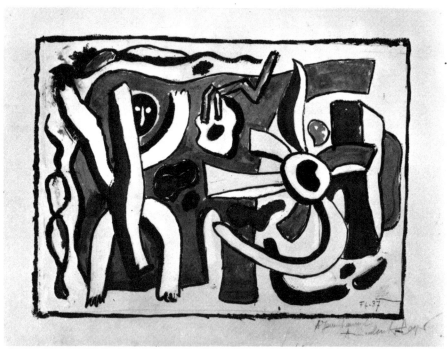

192

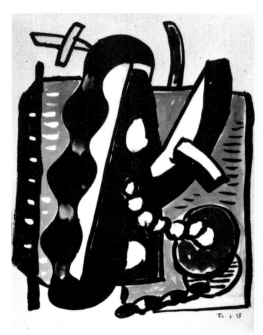

191 Still-life 1938
gouache, 30.5 × 24 cm
signed and dated lower right: *F L. 6. 38*
Former Collection Lefebvre-Foinet, Paris

192 Study for *Composition with Flowers* 1937
gouache
signed, dated and inscribed lower right:
 F.L 37
 A Jeanne Laurent
 Amicalement F. Léger
Collection Mlle Jeanne Laurent, Paris

193 Composition 1938
gouache, 26 × 19.5 cm
signed and dated lower right: *F.L.7.38*
Private Collection, Paris

193

8 The First Large Compositions 1935–39

Apart from the decorative section at the end, this chapter revolves round two major compositions incorporating the human form. It begins with a transitional series. Three drawings, one of which dates from 1932, are interpretations, using different techniques—pencil (194), pen (195) and 'pastel gouaché' (196)—of the theme of two women, naked, half-length front views. Our attention is drawn to their busts and the movement of their crossed hands, but their heads are barely sketched in, or are hidden by the waves of their hair. A fourth drawing, in ink (197), dating from 1935, takes up the same subject after an interval of a few years, but with a different approach: the two women are now more generously proportioned, and stand full-length, with a monumental poise. Their arms, their feet, their facial features, and the whole of their bodies, are defined by a strong line, with shaded sections giving relief. One of them inclines her head, and the other is holding in her right hand the same branching flower which can be seen in the preceding drawings, and which was for Léger both an emblem and an adjustable compositional device. Isolated and without context in the middle of the sheet of paper, these two women stand out from the neutral background like a bas-relief.

This drawing is definitely a study for the painting of *The Two Sisters* (private collection, Paris), a link in an imposing series of compositions fixed in undefined space and without any other scale than the accuracy of the relationships represented. The final synthesis of this series was, on the eve of war, the *Composition with Two Parrots* (Musée National d'Art Moderne, Paris), a work whose final composition was the result of a long process of trial and error extending through many drawings. Léger placed it, in his view of his work, at the opposite extreme from *The City*, on account of its articulation of movement and depth. He stressed

its importance (in New York in 1942) as follows: 'The evolution of my present creative process (towards people in space) began in Paris in 1936–37 with the picture entitled *The Parrots*. Three years of work preceded its completion.' We can, in fact, read beside his signature the date 35–39. The theme is that of two female acrobats or circus dancers, whose lithe curves are rhythmically complemented by their partners, a standing man and a crouching woman, who are supporting them. The partners are holding, one on an arm and the other on a hand, the two famous parrots, which were introduced last of all to serve as colour focuses and compositional counterweights. Drapery, plants and strong geometrical elements, ladders, gates and posts, counterbalance human pyramids outlined by the undulating forms of the clouds, and with an arabesque of interweaving ropes in front of them. Of the drawings reproduced here, some are anterior to the composition: studies in ink or pencil, sometimes on squared paper, of female acrobats (198–201), in which arms and legs balance each other skilfully. Others are later reconsiderations: the variations in ink (202–04), dating from 1940, and the final brainwave of the parrots, with contrasting details of hands, feet and ropes.

Another composition with human beings, no less strictly controlled, is that of *The Three Musicians* (Museum of Modern Art, New York). '*The Three Musicians* is perhaps something different. It is based on a drawing made in 1925, which I always wanted to translate into oils.' The pencil drawing in the Purist style (205), bearing the date 1920—but we know that Léger often dated his works a long time afterwards, without worrying about whether the date was exact—is no doubt the study he was referring to, or in any case is one of the initial group. In 1925, he did in fact publish, in the *Bulletin de l'effort moderne*, an extremely remarkable article showing his interest in the popular dances that he liked to go to, and where he could analyse the plastic forces of the scene: 'It is in these kind of places that the source for a new French choreography must be sought. It is nowhere else.' 'The dances are slick and lively, augmented by imaginative turns in perfect harmony.' Each and every musician 'is a perpetual innovator who loves his trade'. Two drawings from that period (208, 209), each having a different style and technique, show in detail the trio of instrumentalists, with the most important of them standing out to the fore, bareheaded and younger than the others: the accordionist, who was the subject of separate studies, either full-length, with the bend of his leg following the rhythm (210), or half-length and in close-up (211), with his busy fingers spread out on the keys of his instrument. A very fine

charcoal drawing on coloured paper (212) combines in a masterly arrangement the static theme of the musicians, with their feet on the ground, inseparable from their instruments and their seats, with the hectic theme of the *Acrobats*, with their involved gyrations.

The chapter ends with a few projects for designs connected with the world of entertainment, or on the scale of mural work, which Léger loved so much. In 1934, he designed some little figures (214–16) for the use of his pupil Jacques Chesnais, a puppet-master, who executed the designs for a production on the theme of boxing, presented on 17, 19 and 25 December at the Archives internationales de la Danse in Paris, with a *musique concrète* accompaniment. In the following year, 1935, he was commissioned to draw up some plans for the mural decoration of one of the rooms in the French pavilion at the 'Exposition Universelle' in Brussels. Two of his brilliant preparatory gouaches (217, 218) are reproduced in colour here. They evoke, with a tension peculiar to the gymnasium, the rhythm of the objects arranged in a space which is defined by rigging, ladders, dumbbells, the unwinding of the knotted rope, and the athlete's arms raised towards the ball. The announcement of the Paris Exhibition in 1937 fired the artist's imagination, though none of his many ideas were taken up. One of them was to have monuments and façades of houses cleaned and whitewashed by the unemployed, and then lit up by powerful coloured spotlights placed on the Eiffel Tower. The drawing on squared paper of the Eiffel Tower wound about with a weird snake-like shape (213) was made on this occasion. The only official commission he was finally offered was that for an enormous mural for the Palais de la Découverte celebrating the glory of science and electricity, *The Transmission of Power*. The large preparatory gouache (219) shows its spectacular design, with the contrast between the huge rainbow, the accumulation of natural power, and the tall metal structures which canalize the current. Another forceful and dynamic monumental design (220) was a project for the decoration of an air-force officers' mess two years later.

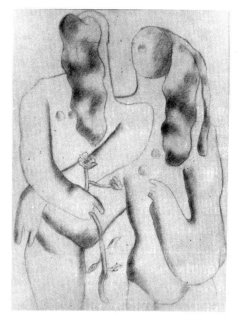

194

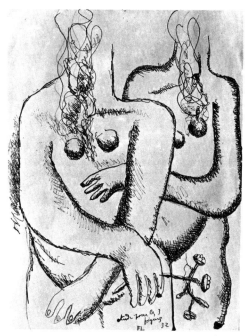

195

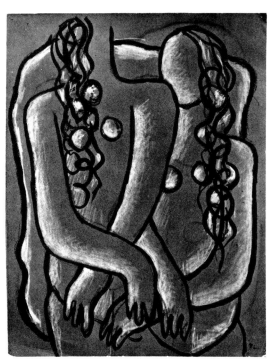

196

194 Two Women
pencil
Former Collection Lefebvre-Foinet, Paris

195 Two Women 1932
ink, 37 × 30.5 cm
inscribed and signed lower centre:

> *étude pour les 3*
> *figures*
> *F.L 32*

Private Collection
*Léger's title, 'Study for the Three Figures',
is misleading; this drawing bears no relation to
the painting of that title (1932) now in the
Musée National d'Art Moderne*

196 Two Women
gouached pastel, 40.5 × 31.5 cm
signed lower right: *F.L.*
Private Collection

197 Two Women 1935
ink, 50 × 33 cm
signed lower right: *F.L. 35*
Private Collection, Paris
*To be compared with the painting 'The Two
Sisters', of 1935 (below)*

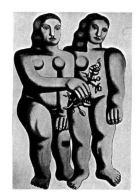

T 56

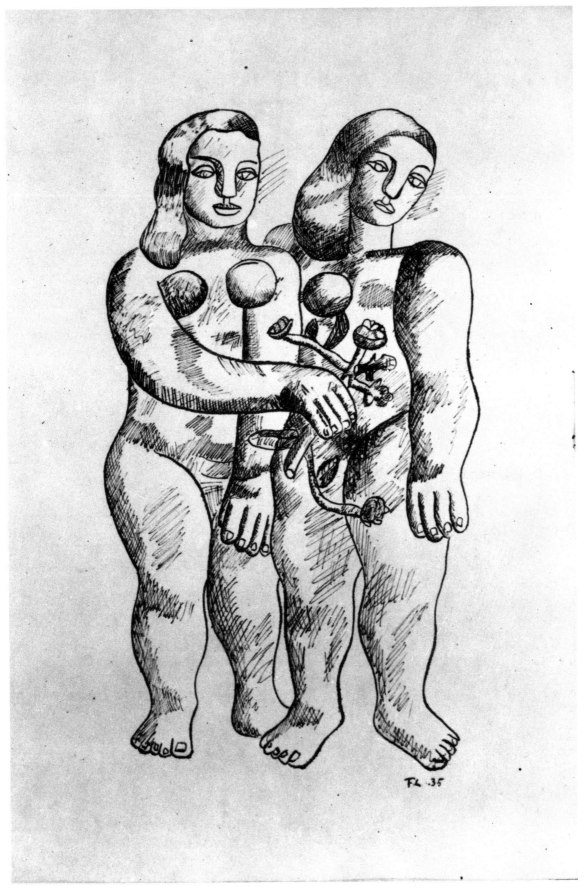

197

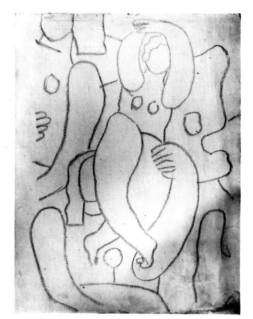

198

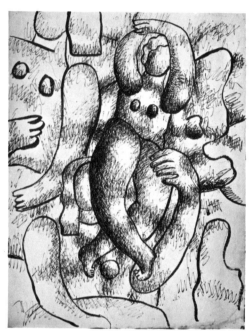

199

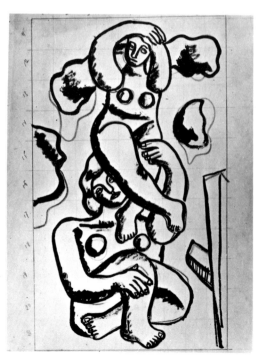

200

198 Female Acrobats
 pencil
 Private Collection

199 Female Acrobats
 ink
 Private Collection

200 Female Acrobats
 pencil and ink on squared paper
 Private Collection
 *To be compared with a painting of 1937
 (below), itself a study for the 'Composition
 With Two Parrots' (see p. 143)*

T 57

201 Female Acrobats 1937
 ink
 signed and dated lower right: *F.L. 37*
 Private Collection

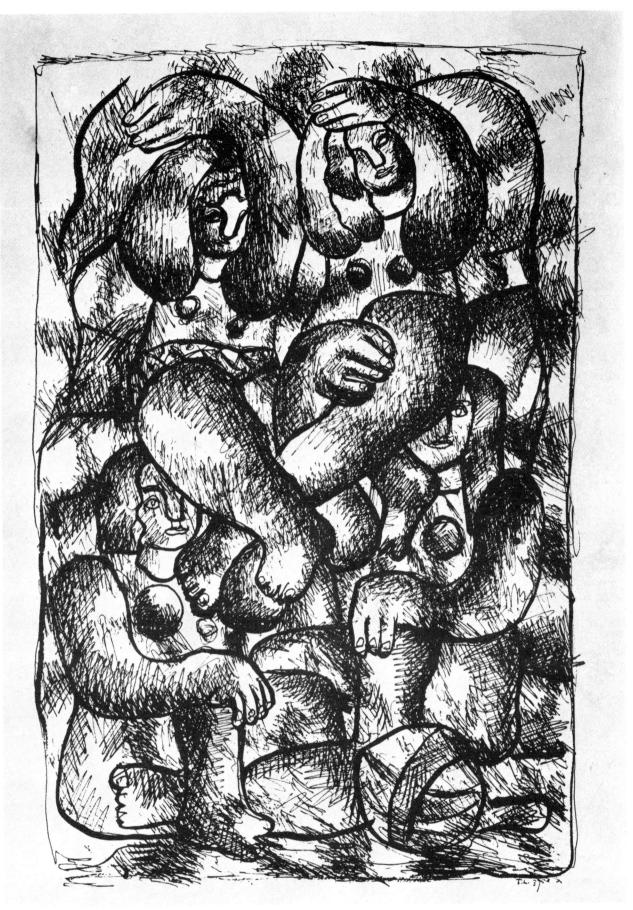

201

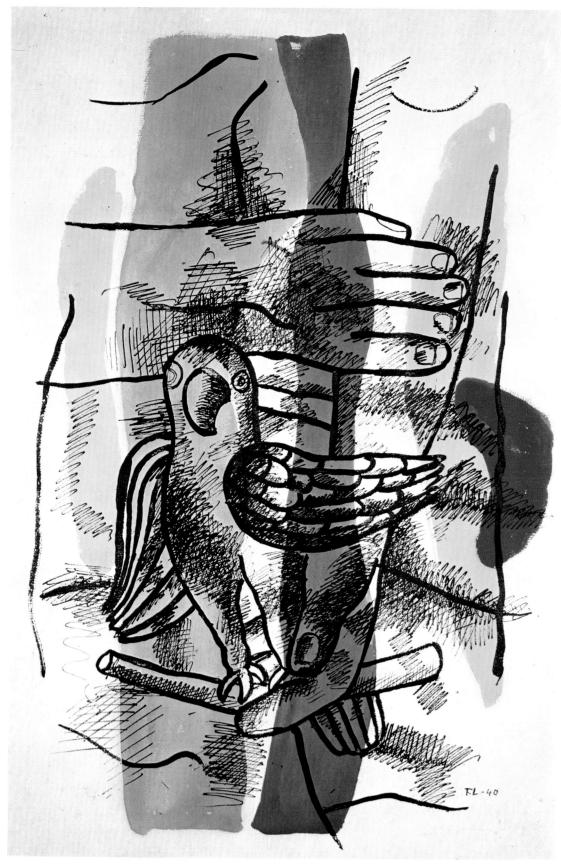

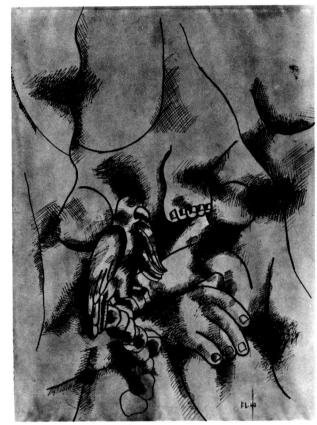

203

202 Drawing Inspired by the *Composition with Two Parrots* 1940
ink and gouache
signed and dated lower right: *F.L. 40*
Private Collection, Paris

203 Drawing Inspired by the *Composition with Two Parrots* 1940
ink, 61 × 46 cm
signed and dated lower right: *F.L. 40*
Collection Louis Carré, Paris

204 Drawing Inspired by the *Composition with Two Parrots* 1040
ink
signed and dated lower right: *F.L. 40*
Private Collection, USA
Drawings 201–04 should be compared with the painting 'Composition with Two Parrots', of 1935–39 (below)

T 58

204

143

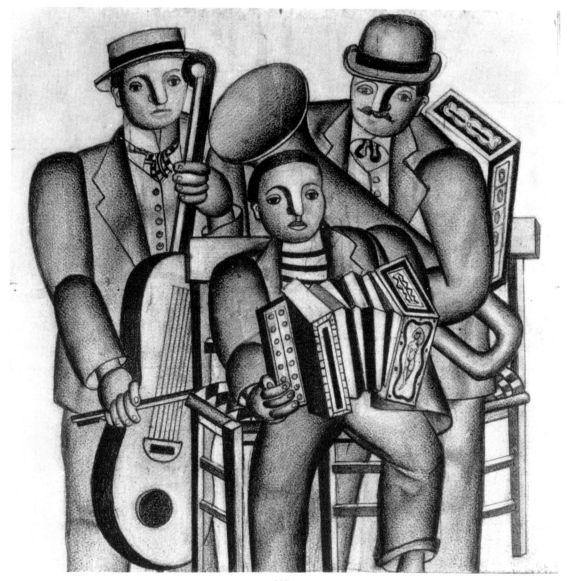

205

206

205 The Musicians 1925
pencil, 35 × 36 cm
signed and (wrongly) dated lower right:
F.L. 20
Collection Lionel Prejger, Paris
*The large number of drawings on the theme of
musicians, which were made at different times,
may be compared with the painting of 1944
(below), of which Léger wrote during his stay
in the United States: '"The Three Musicians"
is perhaps a special case. It is based on a drawing
made in 1925 which I had always hoped to
translate into oils, but only found the oppor-
tunity to do so after I arrived here.'*

T 59

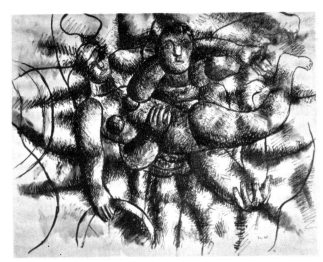

207

206 Composition with Acrobats 1940
ink and gouache
signed and dated lower right: *F.L. 40*
Private Collection, USA

207 Acrobats 1940
ink, 44 × 58 cm
signed and dated lower right: *F.L. 40*
Collection Louis Carré, Paris

208 The Musicians 1940
ink heightened with gouache, 60 × 49 cm
signed and dated lower right: *F.L. 40*
Collection Louis Carré, Paris

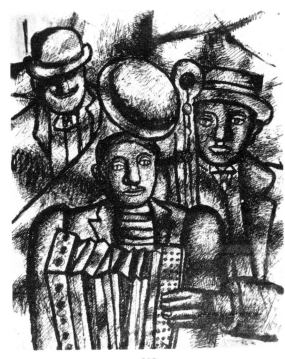

208

145

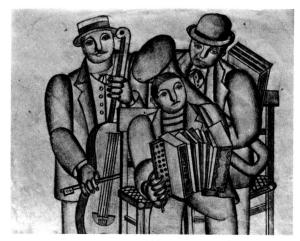

209

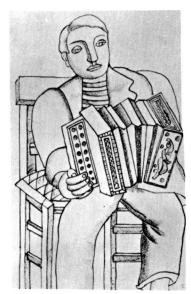

210

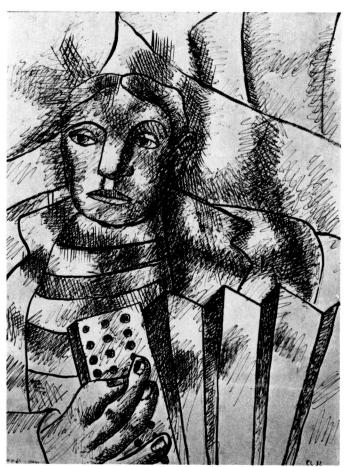

211

209 The Musicians
pencil, 21 × 27 cm
Collection Mme Nadia Léger

210 The Accordionist 1932
ink, 37 × 29 cm
signed and dated lower right in pencil:

FL 32

Private Collection

211 The Accordionist 1932
ink, 65 × 50 cm
signed and dated lower right: *F.L. 32*
Collection Mme Nadia Léger

212 Circus Performers 1940
charcoal on coloured paper, 99 × 86 cm
signed and dated lower right: *F.L.*

40

Collection Mr and Mrs Daniel Saidenberg,
New York

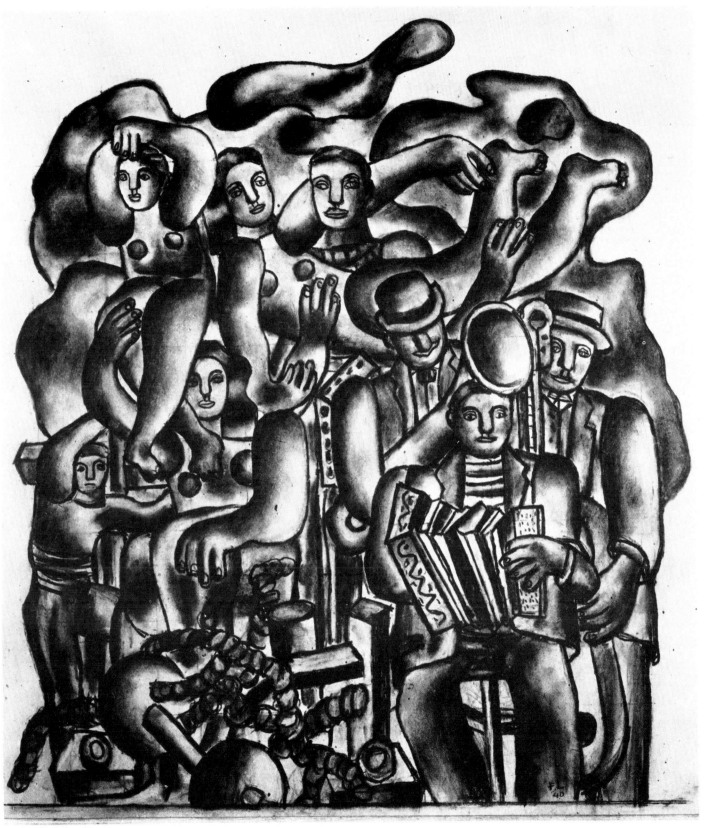

212

213

214

215

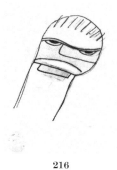

216

213 Project for the Decoration of the Eiffel Tower
pencil, 65 × 50 cm
signed lower right: *F.L.*
Private Collection
In 1936, Léger was commissioned to work on a decoration for the Eiffel Tower, and he worked out several projects in detail, none of which was carried out.

214 Boxing: Three Designs for a Marionette
215 Show 1934
216 pencil
Collection Jacques Chesnais, Paris
Léger designed these figures for Jacques Chesnais' show 'La Boxe'; below is a photograph of the three marionettes made by Chesnais from the drawings

T 60

217 Project for a Mural Decoration for a Gymnasium
gouache, 17 × 30 cm
Collection Mlle Jeanne Laurent, Paris

218 Project for a Mural Decoration for a Gymnasium
gouache, 17 × 30 cm
on the paper mount is the inscription:
 Fernand Léger 35
 Projet pour une décoration de salle de culture physique
Private Collection, Paris

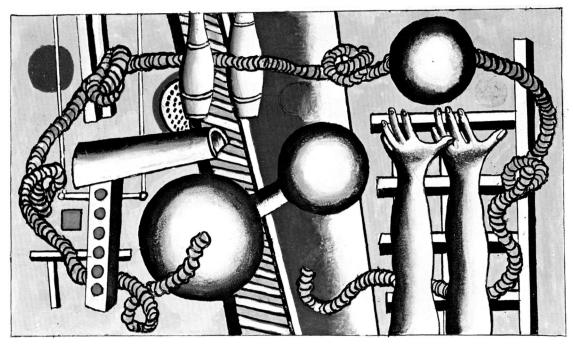

217

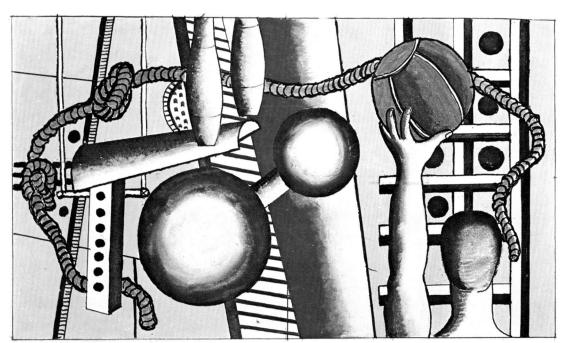

218

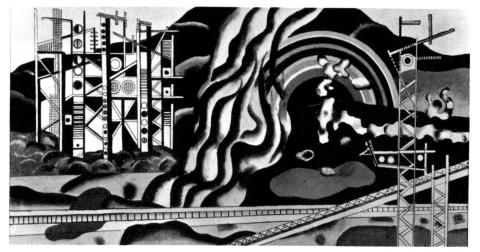

219

220

219 The Transmission of Power
gouache, 62 × 101 cm
Musée National Fernand Léger, Biot
Study for the mural composition 'The Trans-mission of Power', of 1937 (below)

T 61

220 Aeroplanes in the Sky 1939
gouache, 28 × 44 cm
signed and dated lower right: *F.L. 39*
Private Collection

9 The Years in America 1940–45

In September 1940, Léger arrived in the United States of America—which he loved, and where he had already stayed several times since 1931—and he remained there till December 1945. On the quayside in Marseilles, he watched some young dockers diving and bathing in the Mediterranean light. 'I was immediately impressed', he said, 'by the trajectory of their bronzed bodies in the sunlight and the water. A wonderful, fluid movement. It was those divers who set off all the rest, the acrobats, the cyclists, the musicians: I became more supple, less stiff.'

Once arrived in a continent where space and numbers are not measured as they are in Europe, he went one day to a swimming-pool. 'What did I see? There were divers there, not five or six, but two hundred at once. One could not tell any more which hand belonged to whom, whose was that leg, or those arms. So then I dispersed the limbs in my painting, and I realized that in so doing I was much more true to reality than Michelangelo when he concentrated on every muscle.'

Léger's evolution was thus governed by his inner logic, and by the external visual stimuli which confirmed it, or set it working. The theme of acrobats flying through the air, separated from their immobile partners, and that of great moving, wall-high roots (228)—red and black abstract shapes intertwined—with their blue backgrounds, are synthetically related to the theme of divers, which produced a series of large paintings in which the interaction between the figures and the mobile background is achieved by having black as a dominant, or sunlight, or several colours. 'It is a dynamic cycle,' noted Léger as he was executing these works, 'which forces me to project groups of human beings into space. I don't think anyone has yet been able to solve this problem.'

Thus the human form became the climax of the works dealing with the object in space, but on a monumental scale and in an original way, to which neither the Renaissance rules of anatomy nor the solutions of the Baroque ceilings could be applied, for it was a question of conjuring up 'the movement of water, the human body in the water, and the play of sensuous, enveloping curves'. Apart from one detail study of parts of feet and hands in close-up (223), the drawings all show more or less dense clusters of human bodies, all entangled in a swirling medium which is defined by their ascending and descending motion, and by the pulsating rhythm between the foreground and the background. The technique is varied, often composite: ink with white silhouettes and black patches (226), ink and pencil in a fluid sketch with a slower movement (224), ink heightened with gouache for a diffused effect (222), flat colours clearly outlined (227), gouache with thick outlines and bright colours (225).

The theme of cyclists inspired Léger to produce several paintings with a rich working-class flavour, in which the grouping was once more a frontal view, rectangular and static. He was fascinated by the metallic shine of the machine, the perfect shape of its wheels, whose spokes he sometimes left out to stress the strong circular form, and the fine physique and picturesque clothing of the American girls in their shorts and sweaters, 'dressed like circus acrobats', as he said. The eight drawings reproduced make a fairly homogeneous group in that they have the same date (1944), but there are differences in technique and subject. Some of them are strictly linear on a neutral background; others are heightened with white gouache and have a detailed setting (230, 231). All the groups are immobilized as if posing for a photograph, and with its skilfully composed grandeur the composition has the simplicity of an Epinal print. Drawn once in ink only (232), and once in ink with gouache (229), *The Team Resting* has four male figures, strongly outlined between a bicycle and a chair with a dog lying on it. *The Handsome Team*, drawn in ink (233) and again in gouache with a few additional elements (235), has two couples and two bicycles; one of the men is sitting down with his arms and legs crossed to form perpendiculars, and another holds a flower. *The Beautiful Cyclists* (234), five in number and linked by the touch of their hands, radiate joy and good health. *Leisure* (236) is an admirable working drawing for the final painting of the same title, which was finished in 1949. It bears the sub-title *Homage to Louis David*, the painter of great subjects, in whose works Léger liked the realistic tension and classical straightness of line. It is an arrangement of four vertical lines, broken transversally by the curved

shapes of the bicycles and horizontally by the reclining girl, one of whose legs is lengthened unnaturally in order to give the scene compositional stability. The six people, including the children, stare out at the spectator and communicate with one another by means of an uninterrupted tactile circuit which delicately reflects the artist's sensibility: the girl's fiancé touches her arm; her fingers touch the child she wants to have; her foot touches the mother she would like to be.

'A work of art is the end-product of an inner state,' affirmed Léger, 'and ought to owe nothing to the external picturesque; but when one is living in a country not one's own, one must follow the rhythm of that country and make use of it, though at the same time still using one's potential.' Without really modifying his evolution, his stay in the United States accelerated 'the multiplying forces', amplified the dramatic impact between nature and machinery, between the waste lands outside the cities and the remains of machines thrown out for scrap. Several drawings exploit the theme of the wheel: broken up (237), broken off (239), attacked by plant life (241, 242); that of the *Reaper* which rears its dismembered carcass like a symbol of war and death (240). The revealing gouache *American Landscape* (243), which heralded the painting *Goodbye New York* of 1946, is based on a circular rhythm and the contrast between flowers and scrap iron. 'I have been called the Primitive of the modern age, and it is true,' acknowledged Léger. 'I have interested myself in cyclists, machinery, scrap iron. Scrap iron is an invention of my time, and, as I was in tune with my age, I painted it, I put it in the foreground. Just like that, instinctively.'

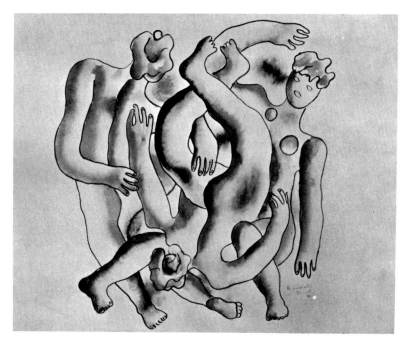

221

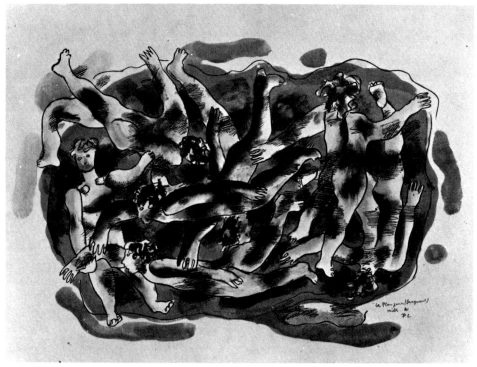

222

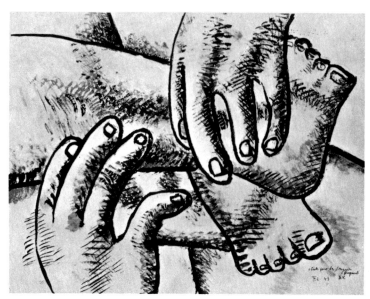

223

221 The Acrobats 1941
ink and wash, 41 × 60 cm
inscribed, signed and dated lower right:
les acrobates
F.L.S.F.
41

Collection Louis Carré, Paris

222 The Divers (Fragment) 1941
ink and gouache, 45.5 × 61 cm
entitled, dated and signed lower right:
Les Plongeurs (fragment)
Mills 41
F.L

Private Collection

223 Study for *The Divers* 1943
gouache, 31 × 41 cm
entitled, signed and dated lower right:
étude pour les plongeurs
fragment
F.L. 43 N. Y.

224 The Divers 1941
ink and pencil, 30 × 45 cm
inscribed, signed and dated lower right:
FL 41
Mills
les Plongeurs

Collection Louis Carré, Paris

154

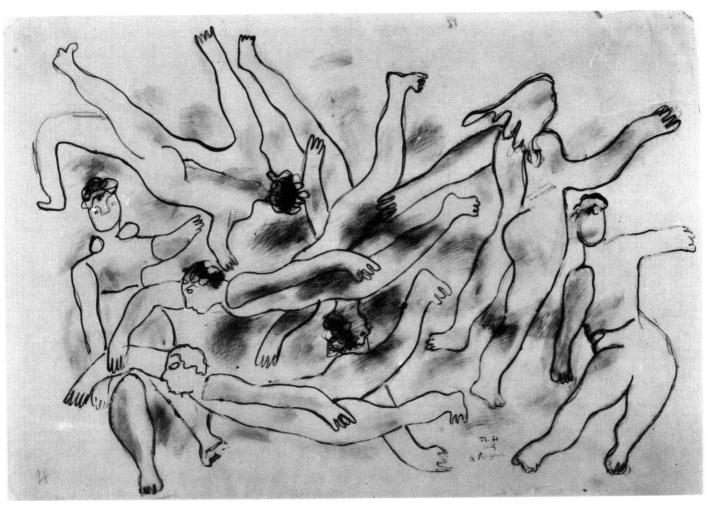

224

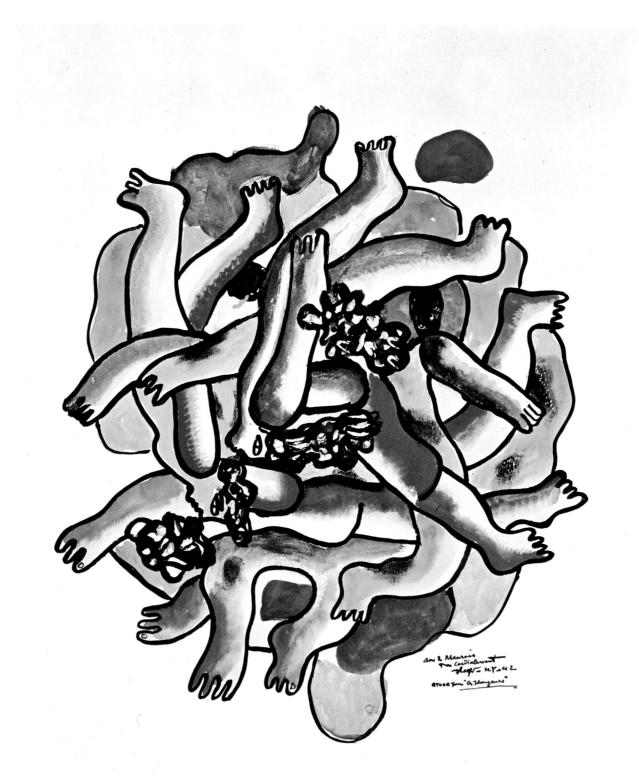

225

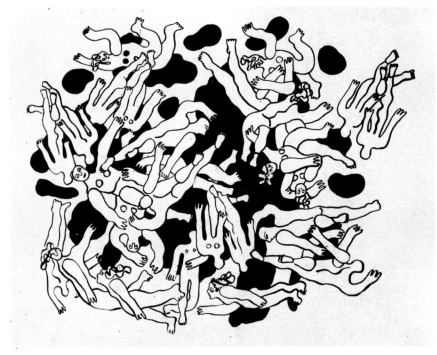

226

225 The Divers 1942
gouache, 41 × 47 cm
inscribed, signed and dated lower right:
 aux 2 Maurois
 très cordialement
 F. Léger N Y 42
 Etude pour "les plongeurs"
Collection Gérald Maurois, Paris

226 The Divers 1942
ink, 69 × 110 cm
signed lower right: *F L 42*
Collection Mme Nadia Léger

227 Study for *The Divers* 1941
ink and gouache, 43 × 38.5 cm
entitled, dated and signed lower right:
 Etude pour les Plongeurs
 S.F. 41
 F L
Private Collection, Italy

228 Project for a Mural Composition 1941
gouache, 40 × 26 cm
signed and dated lower right: *F L 41*
Private Collection
All these drawings should be compared with the
paintings of 'Divers', and in particular with
'Divers on a Yellow Background', of 1941
(below)

T 62

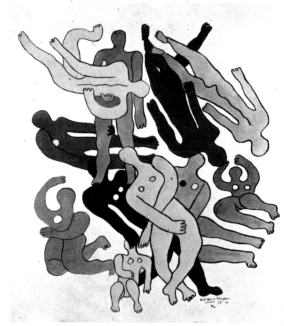

227

228

157

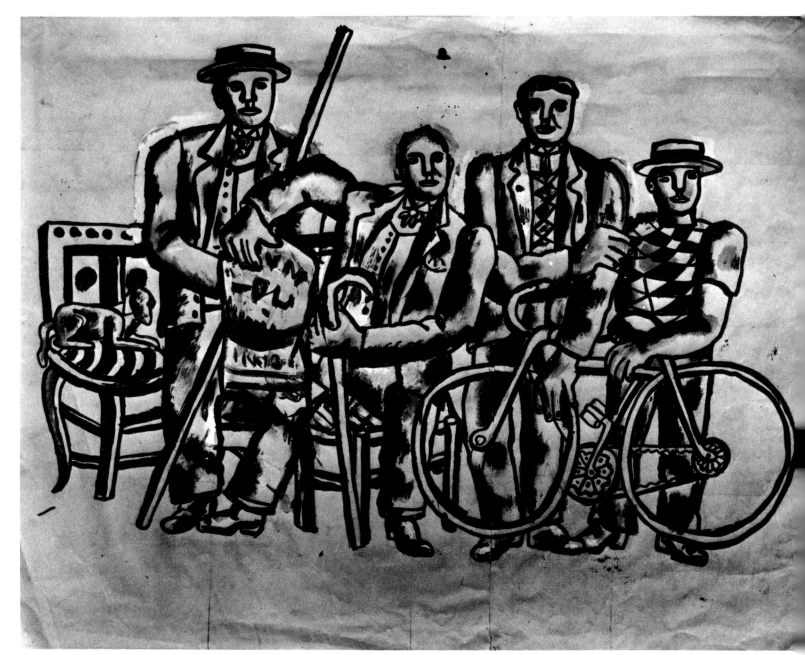

229

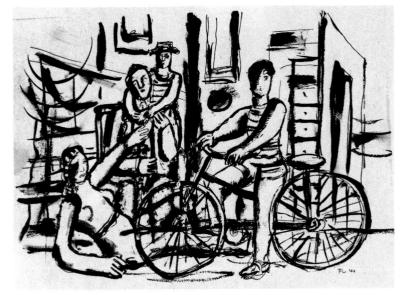

230

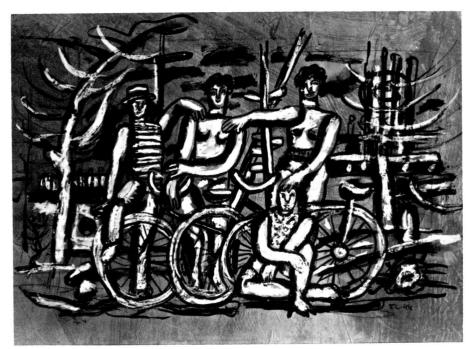

231

229 The Team Resting
ink and white gouache, 60 × 78 cm
Private Collection

230 Leisure Activities 1944
ink and white gouache, 30 × 45 cm
signed and dated lower right: *FL. 44*
Collection Louis Carré, Paris

231 The Cyclists 1944
ink and white gouache
signed and dated lower right: *F.L. 44*
Collection Louis Carré, Paris

232 The Team Resting 1944
ink, 32 × 44 cm
signed and dated lower right: *F.L. 44*
Collection Louis Carré, Paris

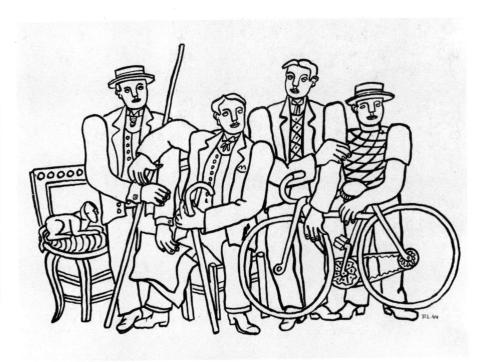

232

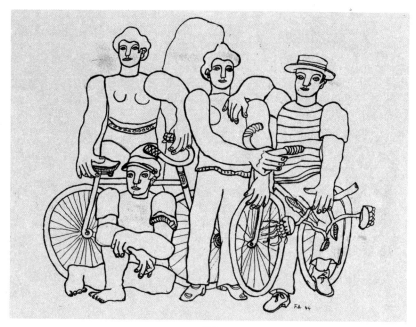

233

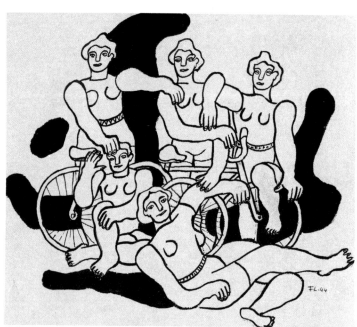

234

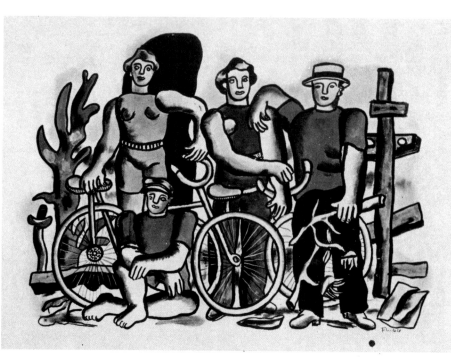

235

233 The Handsome Team 1944
ink, 30 × 39 cm
signed and dated lower right: *F.L. 44*
Collection Louis Carré, Paris

234 The Beautiful Cyclists 1944
ink, 33.5 × 41 cm
signed and dated lower right: *FL. 44*
Collection Louis Carré, Paris

235 The Cyclists 1944
gouache, 37 × 53.5 cm
signed and dated lower right: *FL. 44*
Collection Gérald Maurois, Paris

236 Leisure 1944
ink, 30 × 44 cm
signed and dated lower right: *FL. 44*
Collection Louis Carré, Paris
These works led to the painting 'Leisure', of 1948–49 (below)

T 63

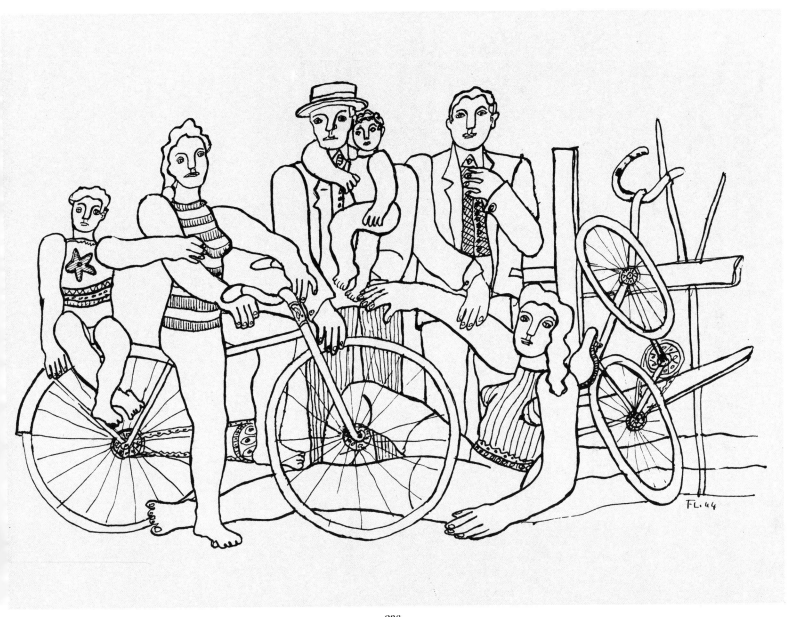

236

161

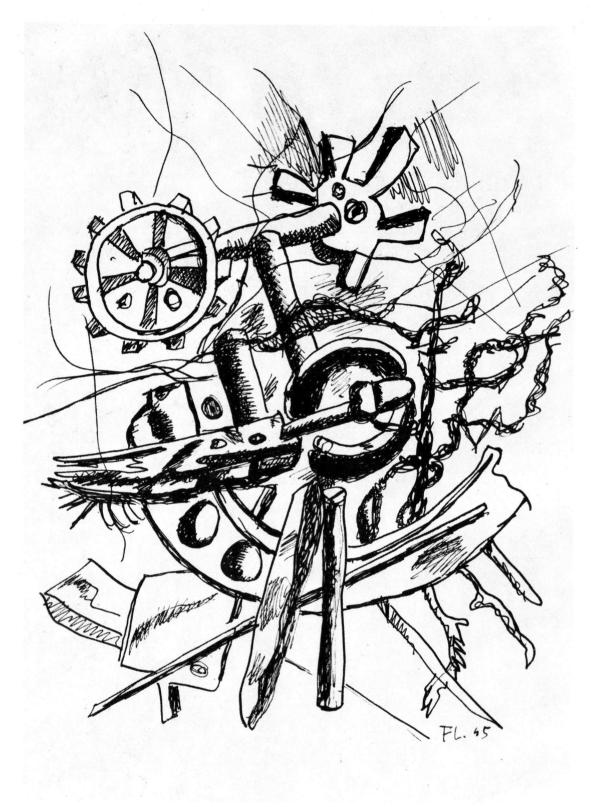

237

238

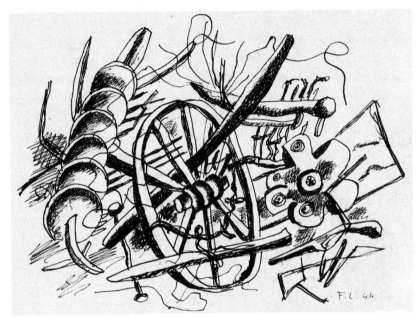

239

237 The Broken Wheel 1945
 ink, 30 × 22.5 cm
 signed and dated lower right: *FL 45*
 Collection Louis Carré, Paris

238 Composition 1943
 ink, 22 × 17.5 cm
 signed and dated lower right: *F.L. 43*
 Galerie Claude Bernard, Paris

239 Composition with Wheel 1944
 ink, 22.5 × 30 cm
 signed and dated lower right: *F.L. 44*
 Private Collection

240 Composition with Reaper 1945
 ink, 30 × 22.5 cm
 signed and dated lower right: *F.L. 45*
 Collection Louis Carré, Paris

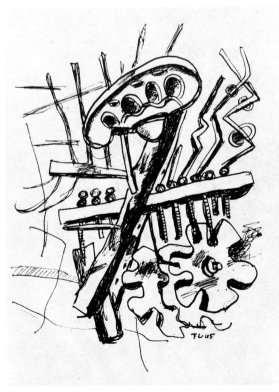

240

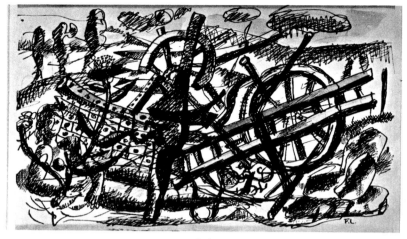

241

242

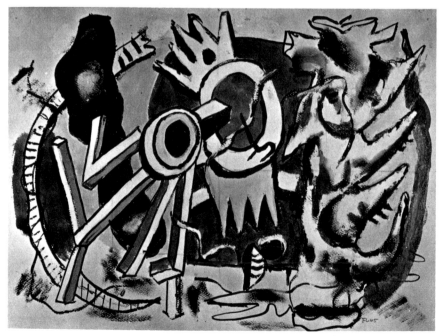

243

241 Woman in Landscape
ink and watercolour on paper, 13 × 23 cm
signed lower right: *F.L.*
Galerie Henriette Gomès, Paris

242 Wheels 1945
ink and white gouache, 30 × 45.5 cm
inscribed, dated and signed lower right:
> *[illegible]*
> *A J. Bazaine 45*
> *très cordialement*
> *F. Léger*

Private Collection, Paris

243 American Landscape 1945
gouache, 30 × 38 cm
signed and dated lower right: *F.L. 45*
Galerie Beyeler, Basle
To be compared with the painting 'Goodbye New York', of 1946 (below)

T 64

10 Still-lifes, Landscapes, Portraits 1948–53

Most of the post-war drawings relate to the last big, carefully-detailed compositions; but this chapter offers a selection from the traditional genres: landscapes, still-lifes, female heads. Ever careful to adapt his tools to the contrasting demands of his style and development, Léger abandoned the hard pencil and incisive pen he had used for so long in gouache—to which he gave increasing importance, sometimes reverting to it after the completion of the definitive oil painting—and most often drew directly with the brush, using broad, sure lines which combined with powerful splashes of colour to give a satisfying flexibility.

In the first series of still-lifes, we find several themes which were already familiar, but which were now reconsidered in terms of this broad, flexible manner. The bicycle (245), now fully equipped with brakes, headlamp and bell, is no longer part of a group of people, but part of a group of objects; it stands out, with its mechanical structure, among indoor plants, and can be seen from an upper window looking out on to a garden. The interior of a Norman farmhouse (244)—with its slanting perspective in which the dog that was lying down in *The Team Resting* reappears—opens out in the same way on to a space in the open air, with a rhythm formed by moving arabesques of cloud. This finer, more linear drawing is one of the rare examples where the pencil was still used together with the pen. Arranged against a neutral background (250), or bathed in light from a window, other indoor still-lifes, in which a number of domestic items substantially and formally apprehended are put together on the table or on the ground, show Léger's vigorous facility: *Still-life with Knives* (248) and *Still-life with Guitar* (250) have a horizontal rhythm, *Still-life with Doll* (249) and *Still-life in the Kitchen* (251) are set up vertically by slanting angles and enlivened by the majestic presence of the coffee-pot and the pitcher.

Two drawings, executed a year apart, and in differing styles, succeed in combining aspects of both the still-life and the landscape: one rugged (246), the other more fluid (247), they bring us back to one of his favourite themes, the association of trees and rope. 'If I isolate a tree from a landscape, and I go up to that tree, I see that its bark has an interesting design, plastically formed, and that its branches have a dynamic violence which should be noticed, and that its leaves are decorative. That is what I call the "objective value" of the tree. When it is enclosed in the subject, that is not brought to the fore.' In one drawing, Léger concentrates on the bark of a twisted dead tree-trunk, round which the rope winds itself like a snake (246); in the other, star-shaped leaves burst from the smooth, living branches and act both as expressions of energy and as ornamental punctuation. 'According to what laws do some trees go straight upwards, whereas others, on the contrary, are all twisted and twined? I know that trees have an animal strength. Moreover, if birds hide themselves in the trees, that is because there is an affinity between them. Trees have something in common with animal life. And what variety of expression!'

Four drawings done in 1951, two in gouache (253, 255) and two in ink with a brush (252, 254), show logs cut up into geometrical pieces and set vertically like the shafts of columns or strange megaliths. Some of these lengths of wood have cuts made by the woodcutter's axe; others are seen in cross-section, and we can make out the long lines within, and the veins forming the texture of the wood. Sometimes a bird comes to land delicately on the bare trunks (254), and its airy grace contrasts with the huge forms.

The predominance of the face, which increases in warmth and flexibility without losing its monumental impassiveness, is one of the essential characteristics of Léger's work after the war. Five ink drawings and one gouache here are detailed female studies, half-length, or reduced to just the face. The face which inspired the artist was that of his wife Nadia (258), a face whose purity of line and subtle smile of happiness are accentuated by the ornamental grace of her bodice and prettily-trimmed sleeves. Hands held against the face are very important, and may often even hide an eye (259), as if to stress the idea that the eye and the hand should be in unison, or exchange their powers to give total perception. When three heads inclined at different angles are grouped together in the same drawing (261), the hands disappear, so that the gaze has full play on its own. A woman on her own, seen half-length, carries a bird in her arms (263), or a child with a flower (262). Two young women together hold the vase they

are offering (256), or hold up a flower mysteriously, like initiates (257). Léger, who was making ready to transpose his works on to pottery, was rediscovering, on his own, the nobility and perfection of antique design.

The gouache of the face hidden by the hand (260) is a significant example of the basic discovery made, in his final years, in New York, and prompted by the advertising searchlights as they swept randomly through empty space with their coloured beams of light: that of the dynamic dissociation of colour from drawing. 'The line having become increasingly stronger, the intensity of the black was sufficient for me, and so, relying on that, I was able to separate the colours: instead of putting them within the lines, I could go over the lines quite freely.' The drawing asserts itself on its own, in counterpoint, and the colour, thus dissociated from the drawing, attains to its maximum of transparence and intensity.

The chapter ends with three drawings on the theme of the farm. A piebald Norman cow, her horns enclosing the branches of the tree behind her, stretches out her muzzle towards the rectilinear chair on which the painter has placed his jacket and hat (264). In a second drawing (265), the cow again appears, between landscape and scaffolding. The last drawing (266) brings a cat and a cock together, amid thick vegetation and scudding clouds, in a composition designed in the manner of a tapestry.

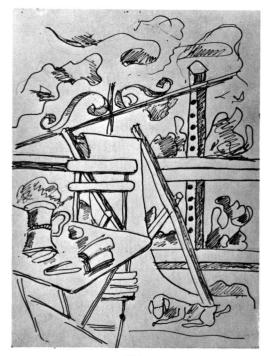

244

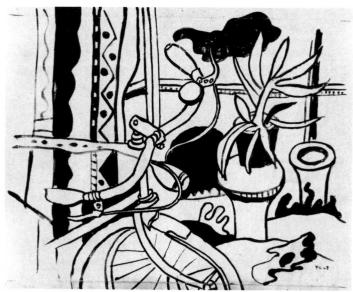

245

246

244 On the Farm
 pencil and ink, 37.5 × 27.5
 Collection Mme Nadia Léger

245 The Bicycle 1948
 ink, 30.5 × 39.5 cm
 signed and dated lower right: *F.L. 48*
 Private Collection

246 Tree and Rope 1948
 ink, 37.5 × 27 cm
 signed and dated lower right: *FL 48*
 Private Collection

247 Trees and Rope 1949
 ink
 signed and dated lower right: *FL 49*
 Private Collection
 To be compared with the painting 'Trees at Sunset', of 1952 (below)

T 65

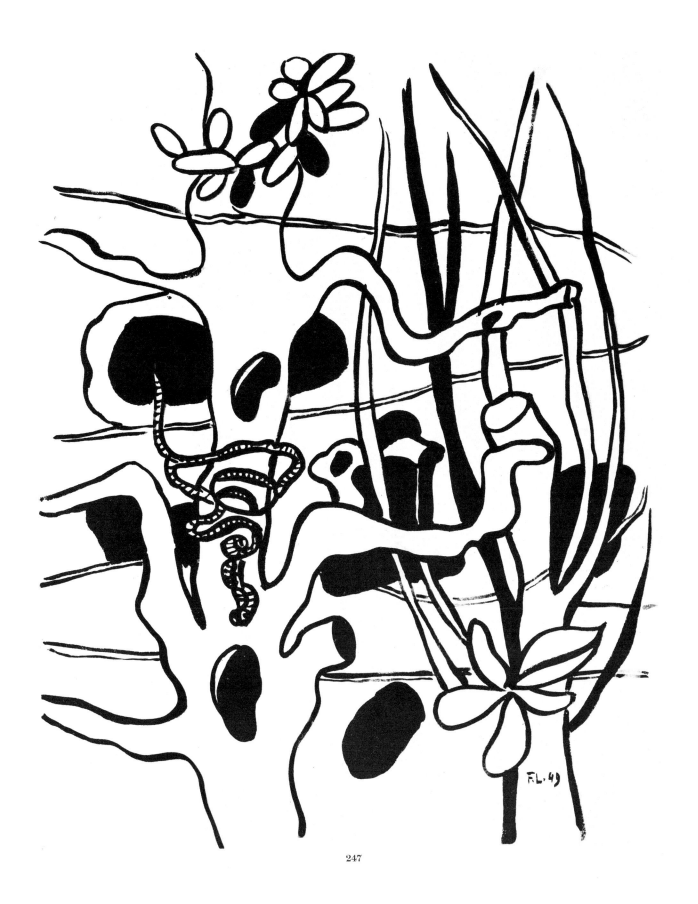

247

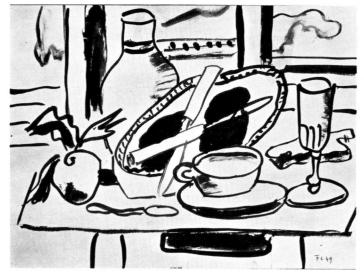

248

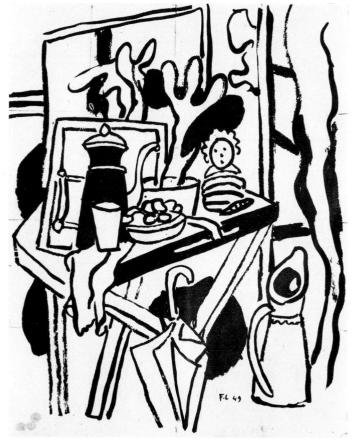

249

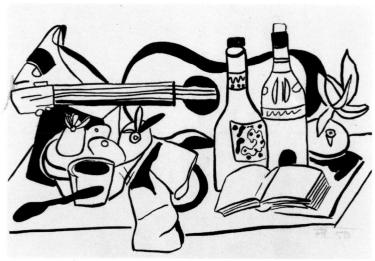

250

248 Still-life with Knives 1949
ink, 27 × 37 cm
signed and dated lower right: *F.L 49*
Private Collection
To be compared with the painting 'Still-life with Two Knives', of 1952 (below)

T 66

249 Still-life with Doll 1949
ink, 41 × 32.5 cm
signed and dated lower right: *F.L 49*
Private Collection

250 Still-life with Guitar 1950
ink, 27 × 37 cm
signed and dated lower right: *F L 50*
Galerie Beyeler, Basle

251 Still-life in the Kitchen 1951
gouache, 59.5 × 43 cm
inscribed, signed and dated lower right:
F.L.
51
A Mme et Monsieur Weber
cordialement F. Léger
Private Collection

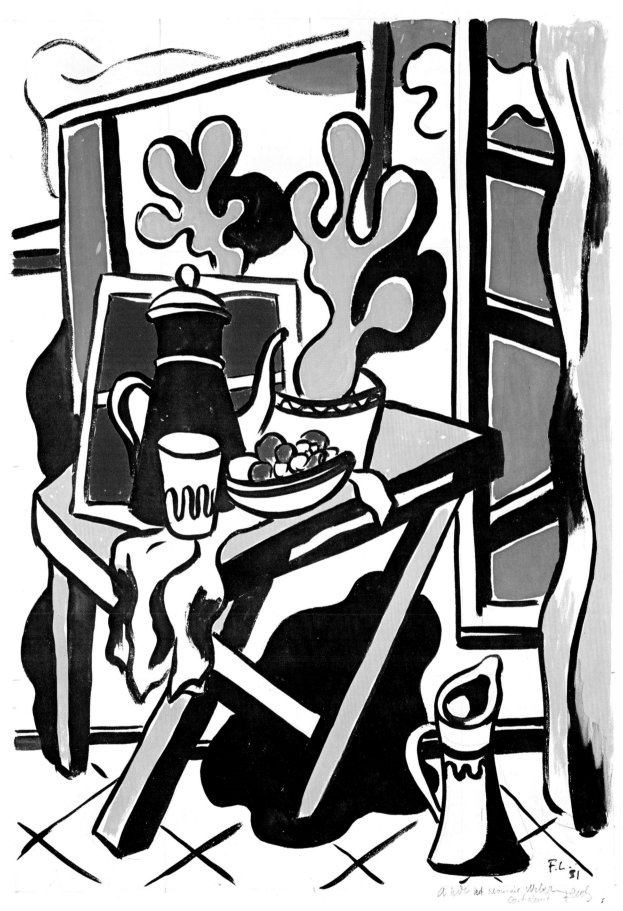

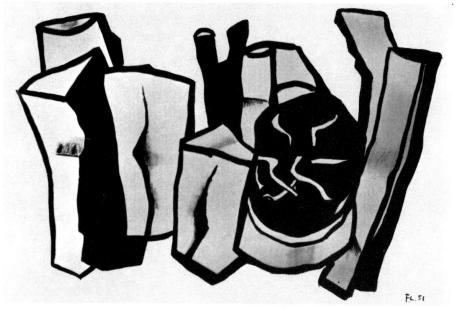

252

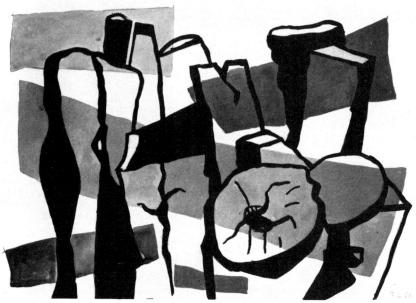

253

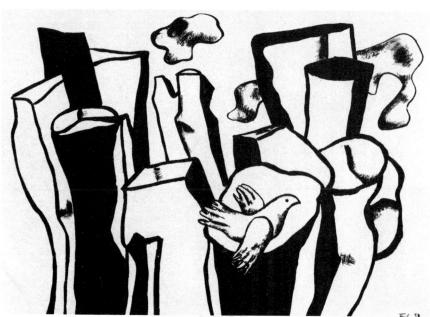

254

252 Logs 1951
ink, 50 × 65 cm
signed and dated lower right: *F.L. 51*
Private Collection

253 Logs 1951
gouache, 40 × 59 cm
signed and dated lower right: *F.L 51*
Private Collection, Paris
To be compared with the painting 'Tree Trunks on a Grey Background', of 1952 (below)

T 67

254 Bird Among Logs 1951
ink, 39 × 57 cm
signed and dated lower right: *F.L. 51*
Galerie Beyeler, Basle
To be compared with the painting 'Bird in Front of Tree Trunks', of 1952 (below)

T 68

255 Logs 1951
gouache
signed and dated lower right: *F.L. 51*
Collection Mme Ida Chagall, Paris

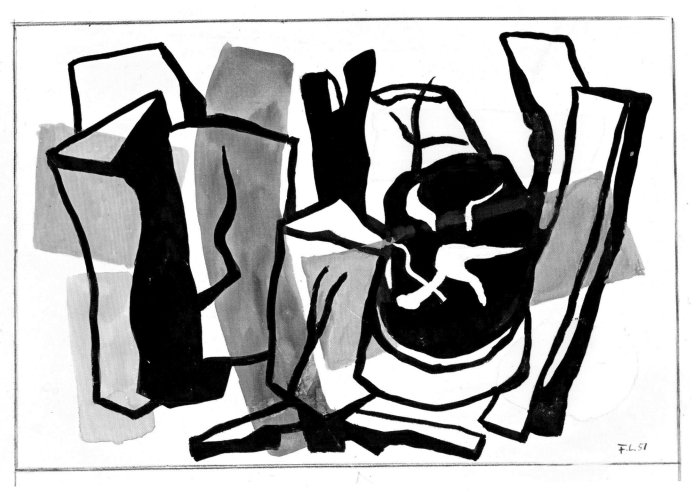

255

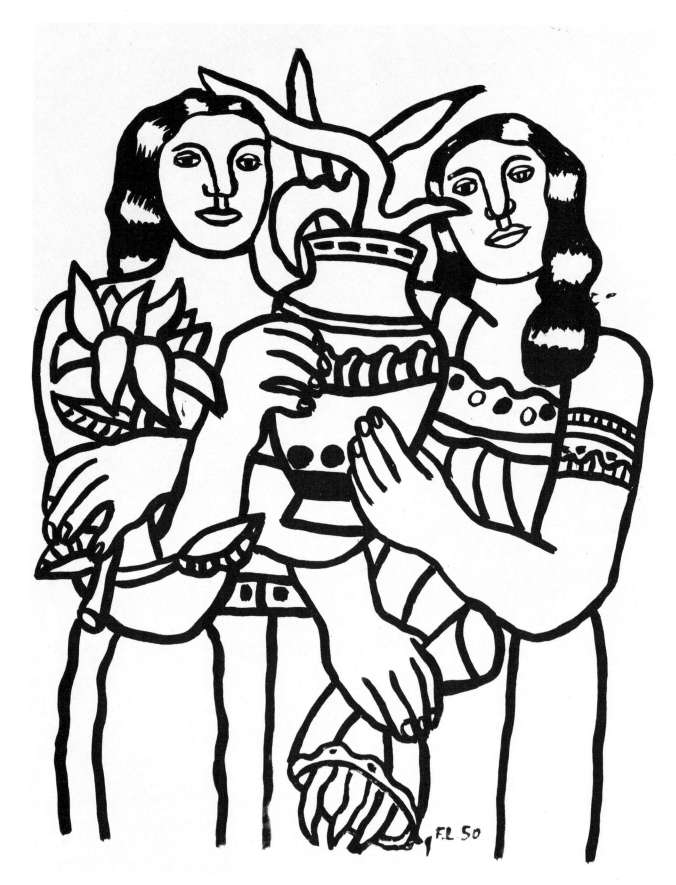

256

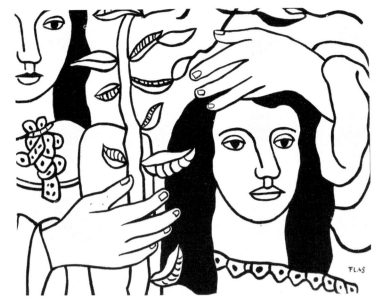

257

256 The Birthday 1950
ink, 68 × 55 cm
signed and dated lower right: *F.L. 50*
Galerie Maeght, Paris

257 Two Figures and a Flower 1948
ink, 50 × 65 cm
signed and dated lower right: *F L. 48*
Collection Louis Carré, Paris

258 Nadia
ink, 65 × 48 cm
signed lower right: *F.L.*
Private Collection

259 Woman with Black Hair 1952
ink, 66 × 50 cm
signed and dated lower right: *F.L. 52*
The Museum of Modern Art, New York
(Mrs Wendell T. Bush Fund)
*To be compared with the painting 'Woman with
Black Hair', of 1952 (below)*

258

T 69

259

260

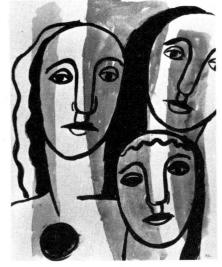

261

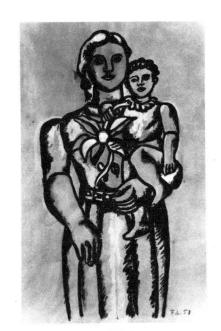

262

260 Face and Hand
gouache, 27.5 × 18.5 cm
signed lower right: *F.L*
Galerie Beyeler, Basle

261 Three Female Heads
gouache, 41 × 34.5 cm
signed lower right: *F.L.*
Private Collection, New York

262 Woman and Child 1951
ink and gouache, 50.5 × 34.5 cm
signed and dated lower right: *F.L. 50*
Private Collection

263 Woman with Bird 1950
ink, 64 × 49 cm
signed and dated lower right: *F.L. 50*
Private Collection, New York
*To be compared with the painting 'Woman with
Bird on a Red Background', of 1952 (below)*

T 70

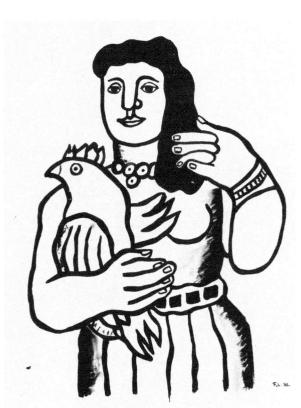

263

264

265

266

264 The Cow and the Chair 1953
 ink, 51 × 65.5 cm
 signed and dated lower right: *F.L. 53*
 The Waddington Galleries, London

265 The Farmer's Wife 1952
 gouache
 signed and dated lower right: *F.L. 52*
 Private Collection

266 The Cat and the Cock 1953
 gouache, 38.5 × 59 cm
 signed and dated lower right: *F.L. 53*
 Private Collection

11 The Constructors 1947–52

Léger's large painting *The Constructors* is one of the rare images of our time in which work is raised to epic, monumental stature. As always, the stimulus was visual. 'The idea came to me on the way to Chevreuse. There were three pylons with high-voltage cables being constructed near the road. Some men were perched on them, working. I was struck by the contrast between these men, the metal architecture and the clouds in the sky. Men are small and lost in a rigid, hard, hostile setting. That is what I wanted to depict, without making any concessions. I evaluated and gave their correct significance to the human achievement, the sky, the clouds, the sky.'

The definitive version of 1950 (Musée Fernand Léger, Biot) was preceded by gouaches in which Léger placed the emphasis successively on the metal framework (267) and on the collective effort of the men at work (270); and it was succeeded by several detailed variants which take up the theme of trousers (272–75) and of hands (277) misshapen by work. 'Our hands are the stars on our flag,' said Paul Éluard in his fine poem on *The Constructors*; and in a text written in memory of his friend Mayakovsky, Léger wrote: 'The heavy hands of the workmen are like their tools, and their tools are like their hands . . . their trousers are like mountains, like tree-trunks. A real pair of trousers does not have a crease.' Mayakovsky had said of Léger in 1923: 'He considers his work to be a trade comparable to the others. It is a pleasure to see the beauty of his industrial forms, his lack of fear when faced with the most brutal realism.'

One of Léger's last drawings (278), done in preparation for a large composition called *The Garage*, which was never painted, is related in both spirit and style to *The Constructors*, as is *Stalingrad* (279). The chapter ends with a powerful gouache (280), which was a project for one of the walls of the UN Building in New York.

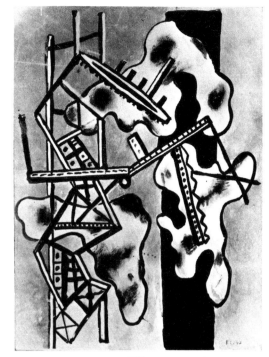

267

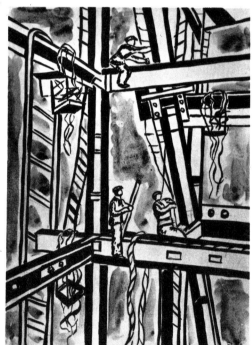

268

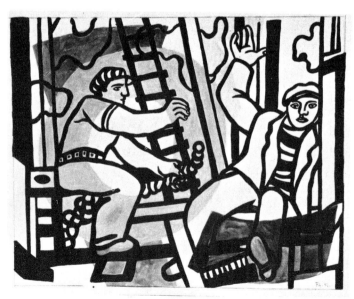

269

267 Clouds of Smoke in Metallic Architecture
1947
gouache, 42 × 32 cm
signed and dated lower right: *F.L. 47*
Galerie Louise Leiris, Paris

268 Study for *The Constructors* 1950
gouache, 40 × 30.5 cm
signed and dated lower right: *F L 50*
Private Collection

269 Study for *The Constructors* 1952
gouache, 54.5 × 66.5 cm
signed and dated lower right: *F.L. 52*
Private Collection

270 Constructors with Bicycle 1950
ink and gouache, 65 × 50 cm
signed and dated lower right: *F.L. 50*
Rosa Cristina Klein Collection, Stuttgart
*All these drawings should be compared with the
paintings on the theme of 'The Constructors'
(definitive version 1950, below)*

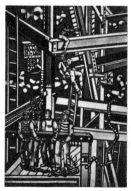

T 71

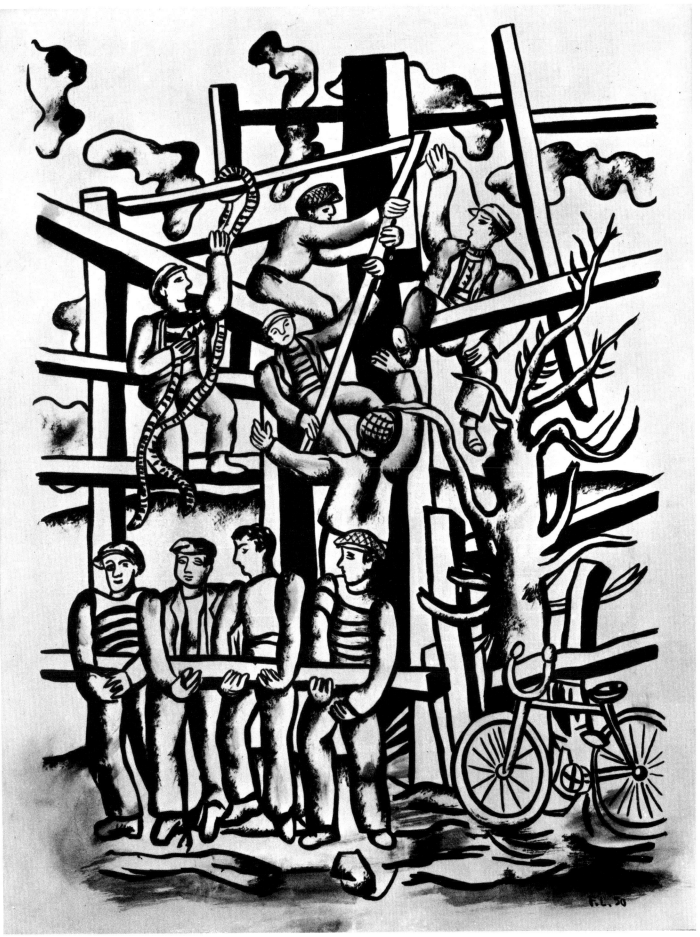

270

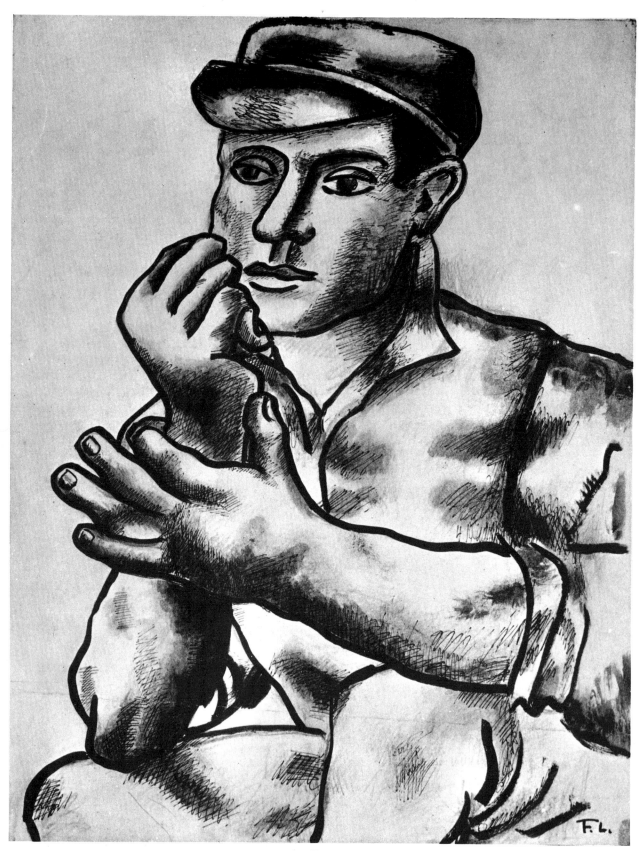

271

272

273

271 Workman Leaning on Elbow
ink, 80 × 65 cm
signed lower right: *F.L.*
Collection Mme Nadia Léger

272 Study of Legs 1951
ink, 50 × 64 cm
signed and dated lower right: *F.L. 51*
Galerie Louise Leiris, Paris

273 Study of Legs 1951
ink, 64 × 49 cm
signed and dated below: *F.L. 51*
Private Collection

274 Study of Legs 1951
ink, 32.5 × 49.5 cm
signed and dated below: *F.L. 51*
Private Collection

274

275

275 Study of Legs 1951
ink, 63 × 48 cm
signed and dated lower right: *F L. 51*
Private Collection

276 Study of Overalls
ink, 64.5 × 50 cm
Private Collection

277 Study of Hand 1951
drawing with gouache, 64 × 48 cm
signed and dated lower right: *F.L. 51*
Private Collection

276

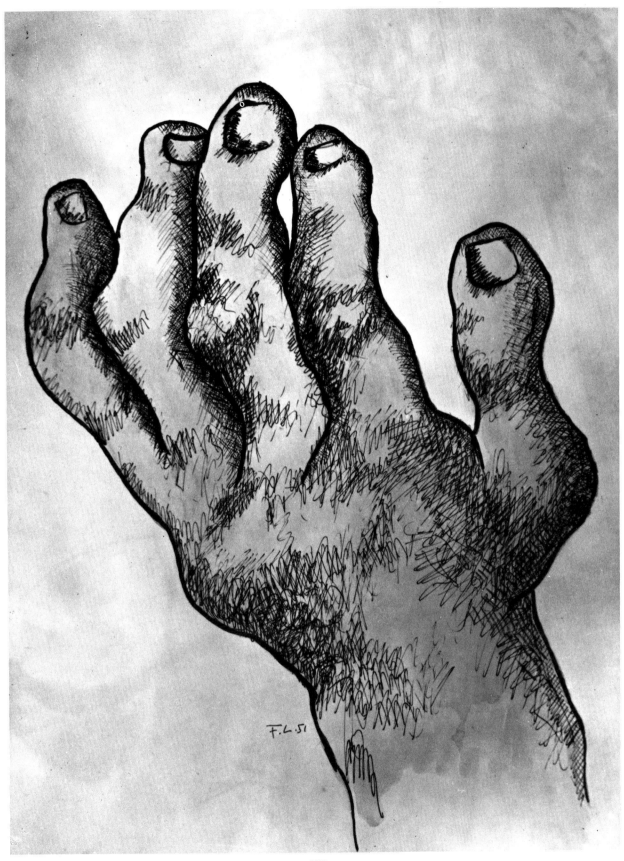

277

278

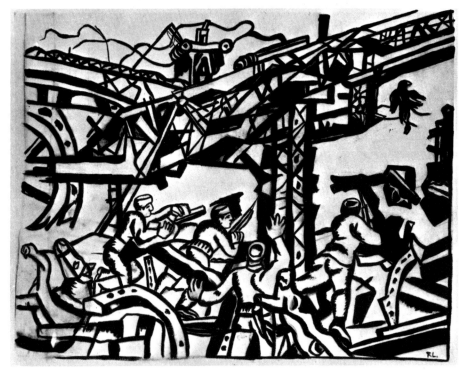

279

280

278 Figures with Truck
ink, 45 × 50 cm
Musée National Fernand Léger, Biot
*Study for a large composition Léger intended to
execute on the theme of the garage*

279 Stalingrad
ink, 59 × 80 cm
signed lower right: *F.L.*
Private Collection
On the back is 'The Picnic' (no. 288)

280 Project for a Mural Decoration for the
UN Building, New York
gouache, 19 × 20 cm
signed lower right: *F L*
Marlborough Fine Art Ltd, London

12 Circus and Parade 1947–54

This last chapter deals with sketches for, and variations on, two major compositions of 1954, *The Picnic* (Fondation Maeght, Saint-Paul-de-Vence) and *The Grand Parade* (Solomon R. Guggenheim Museum, New York), whose subjects and style are diametrically opposed to the hard, rectilinear painting of the *Constructors*. They sing the praises of fun-fairs and time off in the country, and are based on the principle of blithely free curved lines and colours.

The themes proceeded slowly before crystallizing in the painter's imagination. An isolated wash-drawing of 1943 (285) had already settled the arrangement of the whole of *The Picnic* just as it was taken up again ten years later in the gouaches which led up to the painting (288). There was a change in style and technique, but the elements of the landscape, the structure of the trees, the grouping of the people and the dog, and the scansion of the diagonal rhythms, had been established. The pile of tin cans on the left, so characteristic of 'the American scene', was replaced by the driver on his knees, checking over or repairing his car, one of whose wheels was strongly emphasized. This gave the pastoral scene its note of modernity and introduced the contrast between nature and machinery. Detailed studies (286, 287) show the power and accuracy with which Léger succeeded in characterizing his working-class couples, with their hands on each other's shoulders, as examples of the true and brotherly human beings he dreamed of. The structure of the human body, standing up or stretched out in a monumental fashion (284), the warm, human bonds between the woman relaxing and the children playing (282, 283), are the object of some powerful drawings, in which appear a number of rustic themes allied to *The Picnic*, derived from the scene of *Bathing* (281), framed between the tree and the pylon, or referring to the contemporary painting *The Camper* (283).

From Daumier to Seurat and Lautrec, right up to Rouault, Picasso, Matisse and Chagall, the magic of the fairground and the ritual entertainment of the circus fascinated painters, each of them finding there, according to his own nature, a comparison with his work and a reflection of his own activity. In an enthusiastic text which served as an introduction to his album of circus lithographs, *Le Cirque* (1950), Léger praised the magic of the circus-ring, and several of his statements throw light on the genesis of the last great picture on this theme. 'If I have drawn circus-folk, acrobats, clowns, jugglers, it is because I have been interested in their work for the last thirty years—since the time I was designing Cubist-style costumes for the Fratinellis. I did a number of drawings and studies for *The Grand Parade*. For I am a classical artist: my first drawings are always made on impulse, but I am sure of the material which is going to be useful to me. There was a year between the first version of *The Grand Parade* and its definitive state. This period included a great deal of work, both elaborating and synthesizing. The slightest alteration was pondered for a long time and worked out with the help of fresh drawings. Because a change in one place affects the balance of the whole, one is often obliged to rework the whole construction of the picture. In the first version, the colour depended on the shapes. In the definitive version, one can see what power, what vigour, is added by the use of colour freely applied.'

From 1918 onwards, some of Léger's best paintings were devoted to the circus, and the theme recurred periodically in his works until the time when he created, between 1947 and 1950, the big lithographs for *Le Cirque*. Then he accumulated basic material from which would be born the monumental composition which he finished in 1954 and exhibited in November at the Maison de la Pensée Française.

The reproduction of all the successive studies for this composition would need a whole volume with an index of components and a chronological index.

Only a few examples are given here. Two ink drawings, two of which are comprehensive studies (289, 292), and two studies of details (290, 291), recall the drawings of acrobats and musicians we have already met, and foreshadow that bewitching moment in the circus which Léger, like Seurat, chose to capture: the 'parade', presided over by a barker, which is the announcement and synthesis of the whole entertainment. 'This parade is like a recipe, and it is also powerful and dynamic. It hits you in the eye, it takes your breath away, it is like magic which draws you. Behind, to the side and in front, figures and limbs appear and disappear: dancers, clowns, huge scarlet mouths, pink legs, a

Negro eating fire, an acrobat walking on his hands.' The musicians, who looked as if they came from a dance-hall rather than a circus, were eliminated, and pure colours play the fanfare. Trapeze artists flying through the air, and a juggler throwing up his rings (293, 294), create the dynamic force and the circular rhythm. Beside her horse, which is looking around, a bareback rider with her legs crossed holds her arms over her head, as do the acrobats and the dancers (295, 296). This turning movement, which is characteristic of Léger's circus performers, was amplified in three lively gouaches, one of them with a yellow background (297), in which the clowns and dancers are joined by an acrobat walking on his hands (299, 300), whom we also see in a more rapidly drawn sketch (298), though he was to disappear in his turn. Finally, four large gouaches exemplify the unceasing pursuit of perfection. From two of them the horse is absent and the large stencilled letters CIR have appeared; in the two which follow (303, 304), the horse has come back, and the only letter that remains at the centre of the composition is C. It is the evocative axis around which is disposed on the platform the frieze of nine protagonists, between the orange rectangle on the left and the dominant red circle on the right. 'Go to the circus,' Léger said. 'You leave your rectangles, your geometrically-shaped windows behind and go into a land of circular movement.' For the dazzled spectator, the circle is a symbol of fraternal participation, and in this last great work it is the radiant promise that his works will endure.

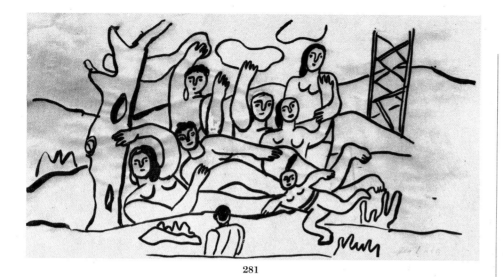

281

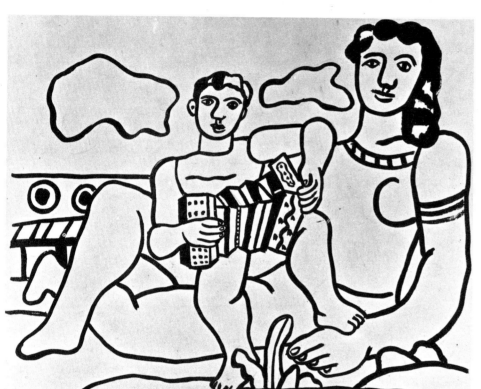

282

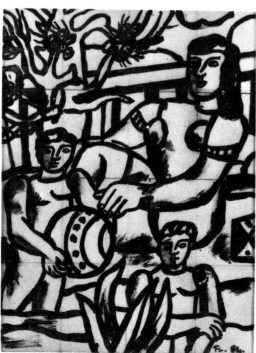

283

281 The Bathers
ink heightened with gouache, 27 × 50 cm
inscribed lower right: *les baigneuses*
Private Collection

282 Child with Accordion
ink, 53 × 75.5 cm
Galerie Maeght, Paris

283 Woman and Children 1954
ink, 24 × 18 cm
signed and dated lower right: *FL. 54*
Private Collection, Paris

284 Composition with Four Figures
ink and white gouache, 28.5 × 24 cm
Private Collection
*To be compared with the painting 'Composition
with Three Sisters', of 1952 (below)*

T 72

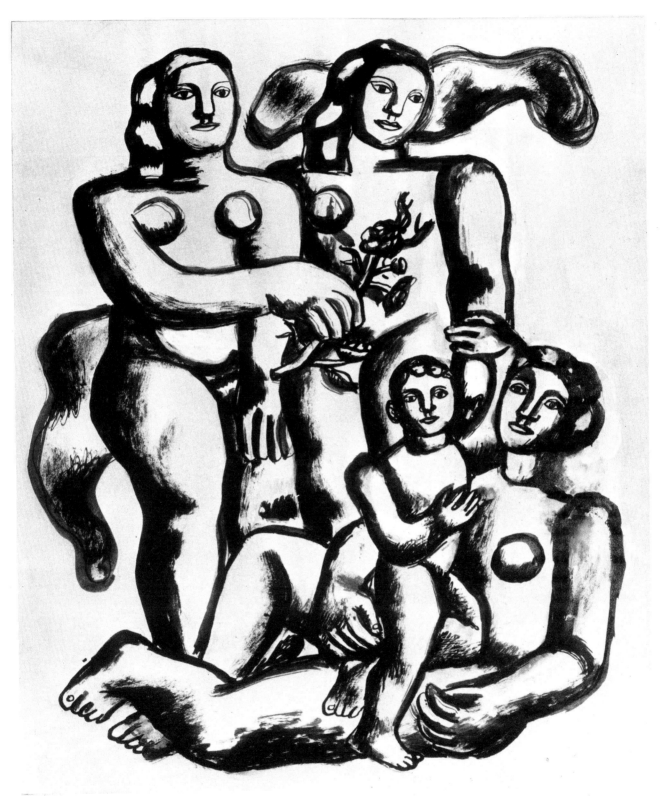

284

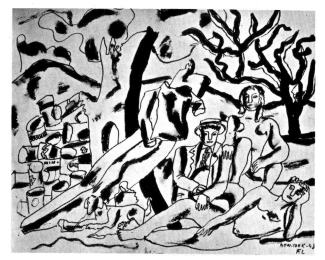

285

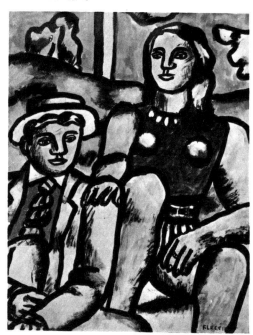

286

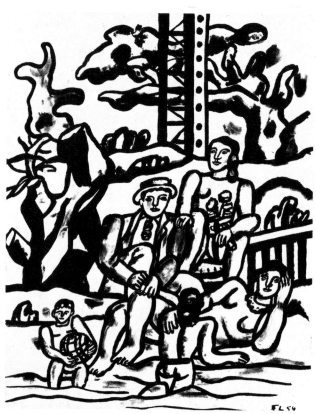

287

285 The Picnic
wash, 28 × 35 cm
inscribed, dated and signed lower right:
New York—43
F.L
Johnson International Gallery, Chicago
This drawing, executed as early as 1943, was at the origin of many studies, including nos. 286–88, which led to the final state of the picture 'The Picnic' in 1954 (below)

T 73

286 The Two Lovers
ink and gouache, 40 × 34 cm
signed and dated lower right: *F. LÉGER*
Collection Mme Nadia Léger

287 Study for *The Picnic* 1954
gouache, 65 × 50 cm
signed and dated lower right: *F.L. 54*
Private Collection

288 The Picnic
gouache, 59.5 × 80 cm
signed lower right: *F.L.*
Private Collection
On the back is 'Stalingrad' (no. 279)

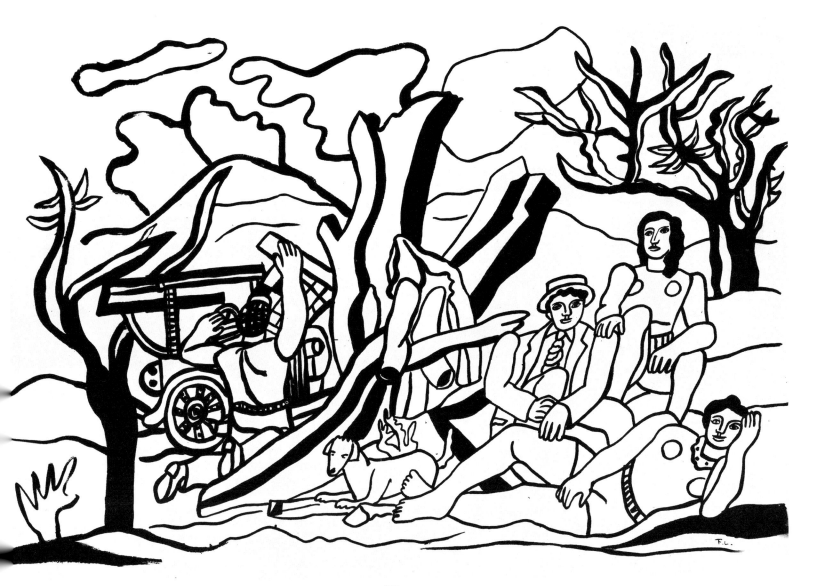

288

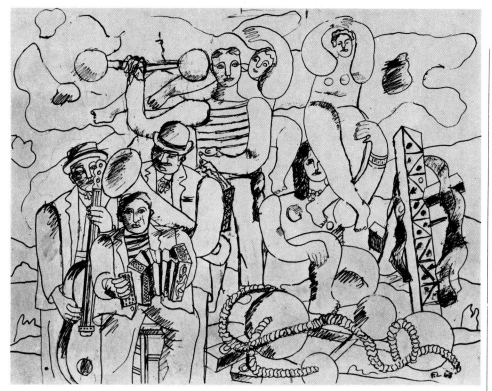

289

290

291

289 Acrobats and Musicians 1948
ink, 49.5 × 64.5 cm
signed and dated lower right: *F.L. 48*
Collection Mme Nadia Léger

290 Musicians
ink, 28 × 22 cm
Galerie Maeght, Paris

291 Acrobat 1953
ink, 23 × 25.5 cm
entitled lower right: *Grande Parade*
53
Galerie Maeght, Paris

292 Acrobats and Musicians 1953
ink, 62 × 76 cm
signed and dated lower right: *F.L. 53*
Galerie Maeght, Paris
Drawings 289 and 292 should be compared with the painting 'Acrobats and Musicians', of 1945 (below)

T 74

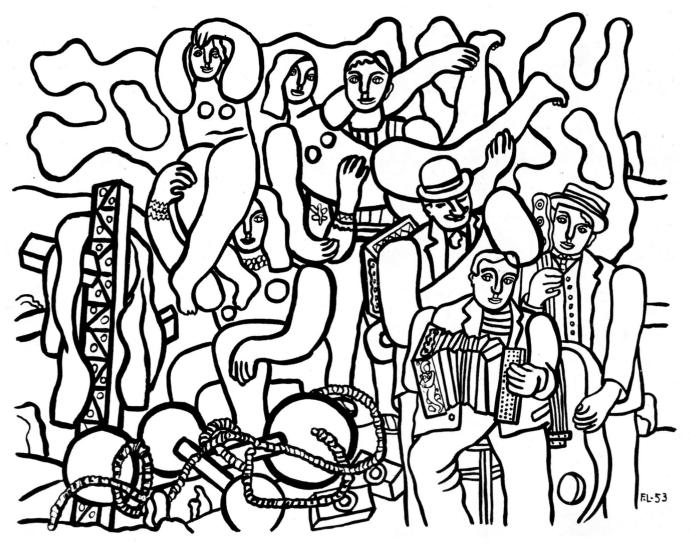

292

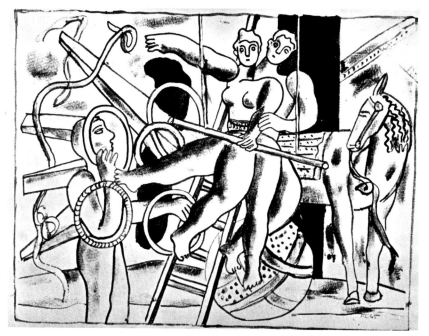

293

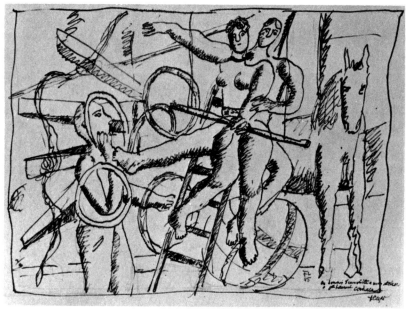

294

295

293 Juggler and Trapeze Artiste 1945
gouache, 23 × 30.5 cm
signed and dated lower right: *FL. 45*
Private Collection

294 Juggler and Trapeze Artiste 1945
ink, 21 × 28 cm
signed and dated lower right: *F.L*
45
and inscribed lower right:
en souvenir d'une visite à mon atelier
à Mlle Laurent cordialement F Léger
Collection Mlle Jeanne Laurent

295 The Female Rider
ink, 27 × 16.5 cm
inscribed lower right: *Grande*
Parade
Galerie Maeght, Paris

296 The Female Rider 1953
gouache, 30 × 41 cm
dated and signed lower right: *F L. 53*
Galerie Maeght, Paris

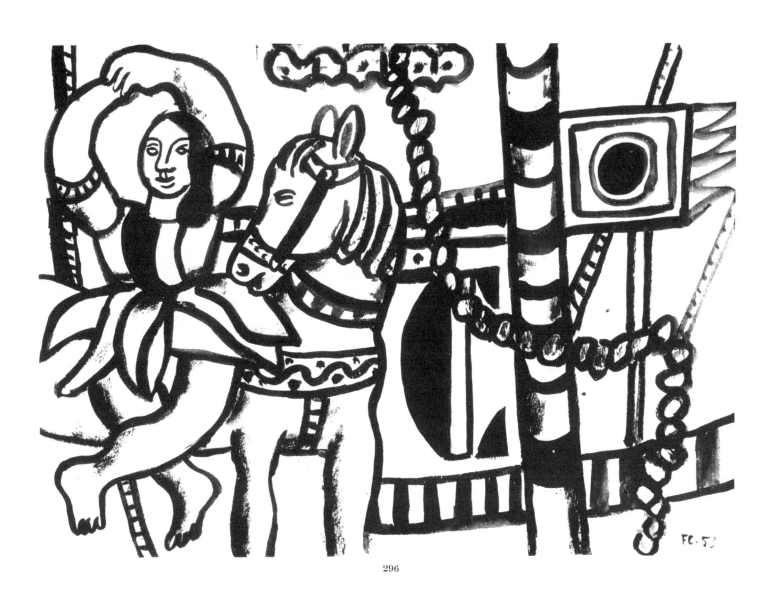

296

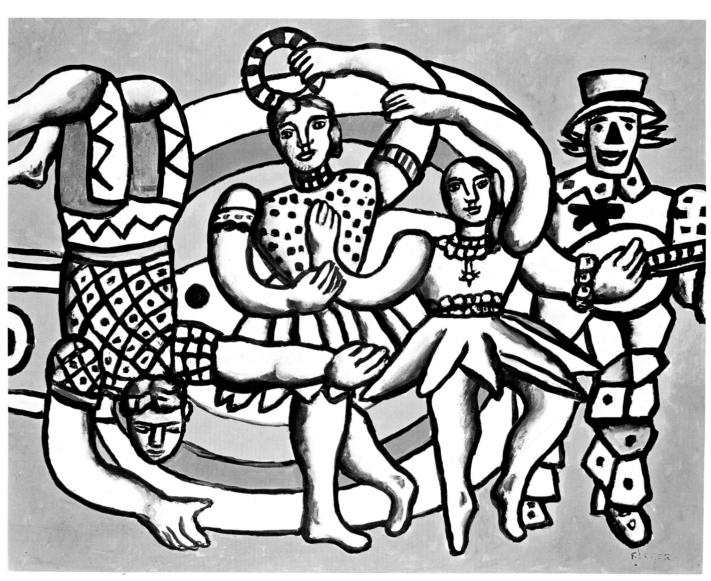

297

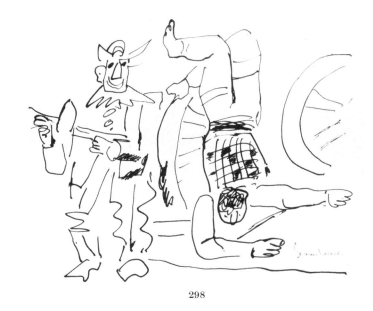

298

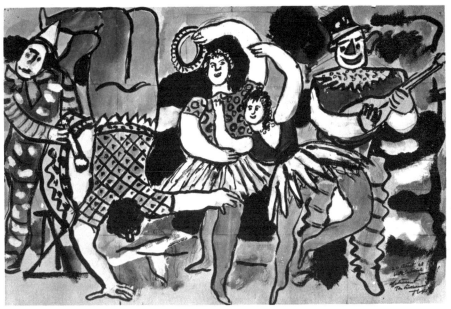

299

297 The Parade on a Yellow Background
gouache, 56.5 × 71.5 cm
signed lower right: *F. Léger*
Private Collection, Paris

298 Clown and Acrobat
ink, 25 × 29 cm. .
inscribed lower right: *Grande Parade*
Galerie Maeght, Paris

299 The Grand Parade (Study) 1948
gouache, 32 × 48.5 cm
dated, dedicated and signed lower right:
24 Août 48
Vive la Sainte
Jeanne!
affectueusement
Ton . . . normand
F. Léger

Private Collection

300 The Parade 1953
gouache, 52.5 × 77 cm
signed and dated lower right: *F.L. 53*
Galerie Maeght, Paris

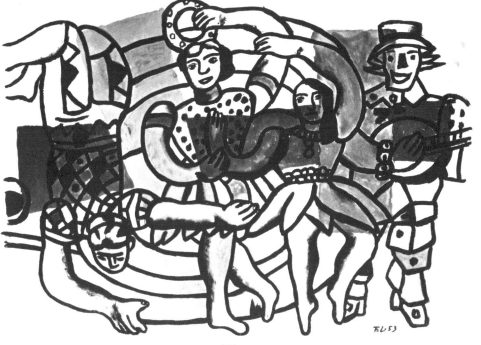

300

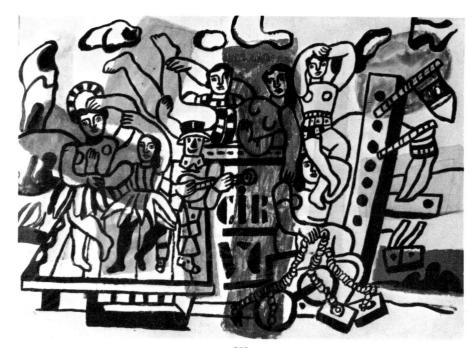

301

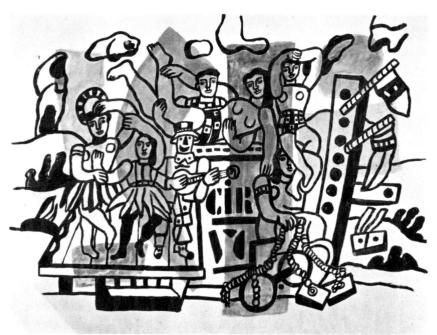

302

301 The Grand Parade
gouache, 74 × 101 cm
Collection Mme Nadia Léger

302 The Grand Parade
gouache, 77 × 105 cm
Galerie Maeght, Paris

303 The Grand Parade 1953
gouache, 52 × 73 cm
signed and dated lower right: *F L. 53*
Galerie Maeght, Paris

304 The Grand Parade
gouache, 50 × 64 cm
Private Collection
These four gouaches especially may be compared with the paintings of 'The Grand Parade', particularly the definitive version of 1954 (below)

T 75

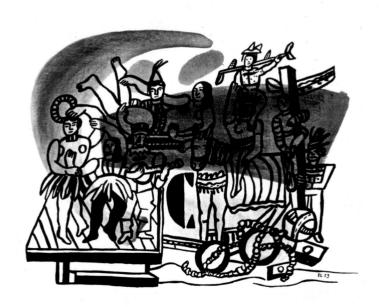

303

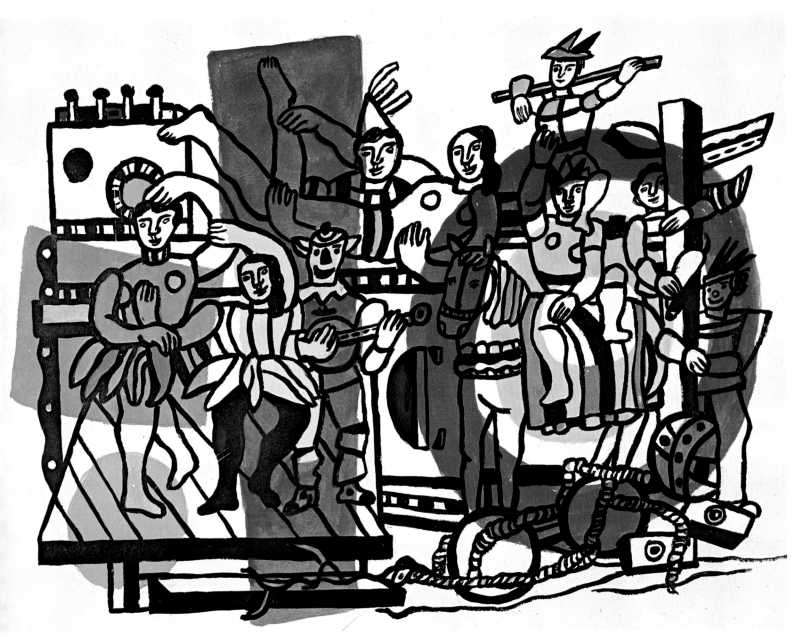

304

List of Documentary Illustrations

Captions T1–T75 (T standing for *tableau* in the original French edition of this book) refer to the paintings reproduced for purposes of comparison.

The medium is oil on canvas.

T1 Smoke over the Roofs 1912
Fumées sur les toits
46 × 55 cm
Private Collection, USA

T2 Woman in Red and Green 1914
La femme en rouge et vert
100 × 81 cm
Musée National d'Art Moderne, Paris

T3 Man with Pipe 1916
L'homme à la pipe
127.5 × 69 cm
Kunstsammlung Nordrhein-Westfalen, Düsseldorf

T4 The Card Game 1917
La partie de cartes
129 × 193 cm
Kröller-Müller Museum, Otterlo, Netherlands

T5 The Propellers 1918
Les hélices
81 × 65 cm
The Museum of Modern Art, New York
(Katherine S. Dreier Bequest)

T6 The Printer, Second Version 1919
Le typographe (2ᵉ état)
81 × 65 cm
Staatsgalerie moderner Kunst, Munich

T7 Mechanical Elements 1918–23
Éléments mécaniques
211 × 167.5 cm
Kunstmuseum, Basle
(Given by Raoul La Roche)

T8 Still-life with Mechanical Elements 1918
Nature morte aux elements mécaniques
Former Collection Maeght

T9 The Armistice 1919
L'armistice
55 × 38 cm
Collection Nelson A. Rockefeller, New York

T10 The Ship's Deck
Le pont du navire
Former Collection Rosenberg

T11 In the Factory (Motif for the Engine) 1918
Dans l'usine (motif pour le moteur)
Sidney Janis Gallery, New York

T12 The City 1919
La ville
230 × 297 cm
Philadelphia Museum of Art, Philadelphia

T13 The Man with a Pipe 1920
L'homme à la pipe
130 × 197 cm
Galerie Beyeler, Basle

T14 Still-life with Red Table 1919–20
Nature morte à la table rouge
73 × 92 cm
Private Collection, Paris

T15 Acrobats in the Circus
Les acrobates dans le cirque
97 × 117 cm
Kunstmuseum, Basle
(Given by Raoul La Roche)

T16 The Circus 1918
Le cirque
65 × 54 cm
Private Collection, Paris

T17 Two Women 1920
Deux femmes
Former Collection Rosenberg

T18 Repose 1921
Le repos
50 × 65 cm
Private Collection

T19 The Fishermen 1921
Les pêcheurs
61 × 92 cm
Collection Dr and Mrs Israel Rosen, Baltimore

T20 Women Dressing 1920
Femmes à la toilette
92 × 60 cm
Private Collection, Basle

T21 Woman with Bouquet 1921
Femme au bouquet
Former Collection Rosenberg

T22 Woman Reclining 1922
Femme couchée
65 × 92 cm
Private Collection

T23 The Meal, Large Version 1921
Le Grand Déjeuner
183 × 252 cm
The Museum of Modern Art, New York
(Mrs Simon Guggenheim Fund)

T24 Woman with Bouquet 1924
Femme au bouquet
65 × 50 cm
Private Collection

T25 Reading 1924
La lecture
114 × 146 cm
Musée National d'Art Moderne, Paris
(Baronne Napoléon Gourgaud Bequest)

T26 Three Women 1927
Trois femmes
140 × 97 cm
Private Collection

T27 Three Women with Flowers 1920
Trois femmes aux fleurs
97 × 130 cm
Private Collection

T28 Mother and Child 1921
La mère et l'enfant
92 × 65 cm
Former Collection Rosenberg

T29 Mother and Child 1922
La mère et l'enfant
171 × 241.5 cm
Kunstmuseum, Basle
(Given by Raoul La Roche)

T30 Landscape 1925
Paysage
92 × 65 cm
Louis Carré et Cie

T31 Man in Sweater 1924
L'homme au chandail
65 × 92 cm
Collection Mme Simone Frigério, Paris

T32 The Deck of the Tugboat 1920
Le pont du remorqueur
130 × 97 cm
Musée National d'Art Moderne, Paris
(Baronne Napoléon Gourgaud Bequest)

T33 Landscape with Figures 1924
Paysage animé
39 × 65 cm
Philadelphia Museum of Art, Philadelphia

T34 The Fruit-bowl 1925
Le compotier
Former Collection Rosenberg

T35 Still-life 1924
Nature morte
55 × 46 cm
Private Collection

T36 Rose and Compasses 1925
La rose et le compas
Private Collection

T37 Umbrella and Bowler (Derby) 1926
Parapluie et melon
125 × 98.5 cm
The Museum of Modern Art, New York

T38 Still-life with Bottle
Nature morte à la bouteille
Untraced

T39 Still-life c. 1925
Nature morte
Former Collection Rosenberg

T40 Composition with Two Profiles
Composition aux deux profils
Private Collection, USA

T41 The Ball-bearing 1926
Le roulement à billes
146 × 114 cm
Kunstmuseum, Basle

T42 The Accordion 1926
L'accordéon
130 × 90 cm
Stedelijk Van Abbemuseum, Eindhoven

T43 Composition with Profile 1926
Composition au profil
130 × 95 cm
Fondation Le Corbusier, Paris

T44 Mural Painting 1926
Peinture murale
180 × 80 cm
Collection De Menil, Houston

T45 Mechanical Elements 1924
Les éléments mécaniques
146 × 97 cm
Musée National d'Art Moderne, Paris
(Baronne Napoléon Gourgaud Bequest)

T46 Composition 1925
Composition
Former Collection Rosenberg

T47 Umbrella and Keys
Parapluie et clés
Untraced

T48 The Mona Lisa with Keys 1930
La Joconde aux clés
73 × 92 cm
Musée National Fernand Léger, Biot

T49 The Rose 1931
La rose
92 × 73 cm
Galerie Louis Leiris, Paris

T50 Two Women 1928
Deux femmes
Private Collection

T51 Contrasting Objects 1930
Contraste d'objets
97 × 130 cm
Musée National d'Art Moderne, Paris
(Given by Paul Rosenberg)

T52 The Bather 1931
La baigneuse
97 × 130 cm
Private Collection

T53 Tree Trunks 1931
Troncs d'arbre
92 × 65 cm
Private Collection

T54 The Black Tree 1937
L'arbre noir
92 × 65 cm
Private Collection

T55 Landscape with Figures 1937
Paysage animé
65 × 54 cm
Private Collection

T56 The Two Sisters 1935
Les deux sœurs
162 × 114 cm
Louis Carré et Cie

T57 Study for *Composition with Two Parrots* 1937
Étude pour la composition aux deux per-
roquets
162 × 97 cm
Private Collection

T58 Composition with Two Parrots 1935–39
Composition aux deux perroquets
228 × 324.5 cm
Musée National d'Art Moderne, Paris
(Given by the Artist)

T59 The Three Musicians 1944
Les trois musiciens
174 × 145 cm
The Museum of Modern Art, New York

T60 *La boxe*: Marionettes by Jacques Chesnais
1934
(Photograph)

T61 The Transmission of Power 1937
Le transport des forces
500 × 1000 cm
Palais de la Découverte, Paris

T62 Divers on a Yellow Background 1941
Les plongeurs sur fond jaune
92.5 × 222.3 cm
The Art Institute, Chicago
(Given by Mr and Mrs Maurice E. Culberg)

T63 Leisure: Homage to Louis David 1948–49
Les loisirs: hommage à Louis David
154 × 185 cm
Musée National d'Art Moderne, Paris
(Purchased by the State)

T64 Goodbye New York 1946
Adieu New York
112 × 127 cm
Musée National d'Art Moderne, Paris
(Given by the Artist)

T65 Trees at Sunset 1952
Les arbres au soleil couchant
65 × 54 cm
Private Collection, USA

T66 Still-life with Two Knives 1952
Nature morte aux deux couteaux
50 × 65 cm
Private Collection

T67 Tree Trunks on a Grey Background 1952
Les troncs d'arbres sur fond gris
73 × 92 cm
Private Collection

T68 Bird in Front of Tree Trunks 1952
Un oiseau devant les troncs d'arbres
73 × 92 cm
Private Collection, London

T69 Woman with Black Hair
La femme aux cheveux noirs
92 × 65 cm
Musée National Fernand Léger, Biot

T70 Woman with Bird on a Red Background
1952
Femme à l'oiseau sur fond rouge
92 × 73 cm
Private Collection

T71 The Constructors, Final Version 1954
Les constructeurs (état définitif)
300 × 200 cm
Musée National Fernand Léger, Biot

T72 Composition with Three Sisters 1952
Composition aux trois soeurs
162 × 130 cm
Staatsgalerie, Stuttgart

T73 The Picnic, Final Version 1954
La partie de campagne (état définitif)
240 × 300 cm
Fondation Marguerite et Aimé Maeght,
Saint-Paul-de-Vence

T74 Acrobats and Musicians 1945
Acrobates et musiciens
113 × 146 cm
Galerie Maeght, Paris

T75 The Grand Parade, Final Version 1954
La grande parade (état définitif)
299 × 400 cm
The Solomon R. Guggenheim Museum,
New York

One-Man Exhibitions

Main exhibitions of drawings and gouaches

1941 4–15 March Marie Harriman Gallery, New York.

1942 12–31 October Buchholz Gallery, New York.

1956 8–24 March French Institute, Athens.

1958 19 February–22 March Galerie Louise Leiris, Paris.

1963 1 October–10 November Modern Art Gallery, Zagreb.

1966 17 February–19 March Galerie Bongers, Paris.

1968 12 November–7 December Saidenberg Gallery, New York.

1969 6 May–15 June Galerie Günther Franke, Munich.

1970 December Galerie Claude Bernard, Paris.

Main exhibitions in which drawings appeared

1933 30 April–25 May Kunsthaus, Zurich.

1935 30 September–24 October The Museum of Modern Art, New York.

1950 17 February–19 March Tate Gallery, London.

1951 12 June–7 October Maison de la Pensée française, Paris: 'Les Constructeurs'.

1952 10 April–25 May Kunsthalle, Berne; 6 June–10 June Galerie Louis Carré, Paris: 'La Figure dans l'oeuvre de Léger'.

1953 Chicago, San Francisco, New York.

1955 February Städtisches Museum, Leverkusen. Musée des Beaux-Arts, Lyon.

1956 June–October Musée des Arts Décoratifs, Paris; October–November Palais des Beaux-Arts, Brussels;

11 December–28 January 1957 Stedelijk Museum, Amsterdam: 'Les Constructeurs'.

1957 March–May Haus der Kunst, Munich; 22 May–23 June Kunsthalle, Basle; 6 July–17 August Kunsthaus, Zurich September–October Museum am Ostwall, Dortmund.

1962 Galerie Berggruen, Paris: 'Contrastes de formes, 1912–1915'. The Solomon R. Guggenheim Museum, New York: 'Five Themes and Variations'.

1963 Pushkin Museum, Moscow. 23 October–24 November Moderna Museet, Stockholm.

1966 February–April Michael Hertz, Bremen. June–August Musée Cantini, Marseilles. June–September Musée d'Unterlinden, Colmar. November–December International Galleries, Chicago.

1967 April–May Museum, Tel-Aviv. 19 June–10 September Staatliche Kunsthalle, Baden-Baden.

1968 26 April–9 June Museum des 20. Jahrhunderts, Vienna. 12 October–2 December Nouveau Musée, Le Havre.

1969 16 December–8 February 1970 Städtische Kunsthalle, Düsseldorf.

1970 Museum of Contemporary Art, Montreal; Musée de Québec.

1971 Warsaw, Cracow, Poznan, Lodz. October–January 1972 Grand Palais, Paris. December Espace Cardin, Paris: 'Léger et le Théâtre'.

Figure and Books 1925 (pencil)

Writings dealing with Léger's drawings

Cooper, Douglas: *Fernand Léger, Dessins de Guerre.* Berggruen et Cie., Paris 1956.

Jardot, Maurice: *Léger, Dessins.* Editions des Deux Mondes, Paris 1953.

Vallier, Dora: *Carnet inédit de Fernand Léger: esquisses pour un portrait.* Editions des Cahiers d'Art, Paris.

Zervos, Christian: 'Une nouvelle étape dans l'oeuvre de Fernand Léger' [gouaches and drawings with colour], *Cahiers d'Art*, nos. 6–7, pp. 264–69, (Paris 1932).

Writings dealing with Léger's works

Cahiers d'Art, volume 8, nos. 3–4 (Paris 1933). *Numéro spécial publié à l'occasion de l'exposition Léger au Kunsthaus de Zurich.*

Cooper, Douglas: *Fernand Léger et le nouvel espace.* Editions des Trois Collines, Geneva 1949.

Delevoy, Robert: *F. Léger.* Skira, Geneva 1962 ('Le Goût de nôtre temps' series).

Deroudille, René: *Léger.* Bordas, Paris 1968 ('Initiation aux arts plastiques' series).

Descargues, Pierre: *Fernand Léger.* Editions du Cercle d'Art, Paris 1955.

Elgar, Franck: *Léger. Peintures 1911–1948.* Editions du Chêne, Paris 1948.

Francia, Peter de: *Léger's 'The Great Parade'.* Cassell, London 1969 ('Painters on Painting' series).

Garaudy, Roger: *Pour un réalisme du XXe siècle: dialogue posthume avec Fernand Léger.* Grasset, Paris 1968.

George, Waldemar: *Fernand Léger.* Gallimard, Paris 1929 ('Peintres nouveaux' series).

Jardot, Maurice: *Fernand Léger.* Hazan, Paris 1956.

Kuh, Katherine: *Léger.* The Art Institute, Chicago 1953

Léger, Fernand: *La Forme humaine dans l'espace.* Editions de l'Arbre, Montreal 1945.

Raynal, Maurice: *Fernand Léger, vingt tableaux.* Editions de l'Effort moderne, Paris 1920 ('Les Maîtres du cubisme' series).

Roy, Claude: *Fernand Léger: les constructeurs.* Editions Falaise, Paris 1951

Tadini, Emilio: *Fernand Léger.* Fratelli Fabbri, Milan 1964 ('I maestri del colore' series).

Teriade, E.: *Fernand Léger.* Editions Cahiers d'Art, Paris 1928 ('Les Grands Peintres d'aujourd'hui' series).

Vallier, Dora: 'La Vie fait l'oeuvre de Fernand Léger', *Cahiers d'Art*, no. 2, pp. 133–172 (Paris 1954).

Verdet, André: *Fernand Léger, le dynamisme pictural.* Editions P. Callier, Geneva 1955 ('Peintres et sculpteurs d'hier et d'aujourd'hui' series).

———: *Fernand Léger.* Sadea-Sansoni, Florence 1969 ('I maestri del Novecento' series).

Zervos, Christian: *Fernand Léger: œuvres de 1905 à 1952.* Editions Cahiers d'Art, Paris 1952.

———: 'De l'importance de l'objet dans la peinture: IV. Léger'. *Cahiers d'Art*, no. 7 (Paris 1930).

See also the catalogues of the exhibitions mentioned.

Writings by Léger

Fonctions de la peinture. Editions Gonthier, Paris 1965 ('Bibliothèque Médiations' series). Translated as *The Functions of Painting.* The Viking Press, New York, and Thames and Hudson, London 1973 ('The Documents of 20th-Century Art' series).

Fernand Léger. Editions Gonthier-Seghers, Paris, 1959 ('Propos et présence' series).

Photographic Credits

WITHDRAWN

(Page references to the documentary illustrations are given in parentheses.)

A.C.L., Brussels, 63, 64.
Hélène Adant, Paris, 155.
Georges Allié, Paris, 143, 144, 145, 150, 151, 152, 153, 164, 186.
Archives Photographiques, Caisse Nationale des Monuments Historiques, Paris, 6, 70, 79, 80, 89, 91, 109, 119, 126, 146, 148, 198, 199, 200, 201, 203, 230, 231, 232, 234, 242, 244, 245, 246, 247, 249, 284, (p. 56 below).
Archives Photographiques, Clichés Rosenberg, (pp. 55 above, 66 above, 84, 92, 97 centre and below l. and r.).
Cahiers d'Art, Paris, 147, 167, 180.
Cauvin, Paris, 43, 45.
Christie's, London, 40.
Galerie Berggruen, Paris, 47, 55, 71, 99, 101, (p. 52).
Galerie Claude Bernard, Paris, 75, 112, 129, 172, 238, 258, 293.
Galerie Louis Carré, Paris, 207, 208, 221, 224, 233, 236, 237, 240, 257.
Galerie Louise Leiris, Paris, 1, 4, 11, 18, 32, 41, 59, 86, 87, 104, 113, 141, 154, 157, 159, 160, 173, 184, 188, 195, 196, 209, 220, 222, 223, 229, 248, 252, 262, 264, 266, 267, 268, 269, 270, 272, 273, 274, 276, 277, 278, 285, 296, 299, (pp. 68 below, 73, 90 below, 109, 111 above, 132 above, 140, 172 above).
Galerie Maeght, Paris, 174, 256, 282, 290, 291, 292, 295, 298, 300, 302, 303, 304.
Galerie Weiller, Paris, 213.
Hachette, Paris, 78, 95.
Yves Hervochon, Paris, 37.
Hans Hinz, Basle, 255.

Jacqueline Hyde, Paris, 5, 9, 30, 38, 44, 48, 50, 54, 57, 61, 62, 72, 73, 74, 90, 96, 97, 98, 105, 114, 116, 117, 121, 122, 124, 125, 130, 131, 133, 134, 136, 137, 138, 139, 140, 142, 149, 161, 166, 171, 175, 176, 179, 183, 185, 192, 193, 214, 215, 216, 217, 218, 225, 235, 239, 241, 253, 275, 279, 288, 294, 297.
Luc Joubert, Paris, 68.
Marlborough Fine Art, London, 83.
Marlborough-Gerson Gallery, New York, 280.
Jean Mazenod, Paris, 190.
Jacques Mer, Antibes, 2, 3, 13, 17, 34, 35, 42, 76, 85, 178, 211, 219, 226, 271, 286, 289, 301, (pp. 28, 30, 50, 55 below, 56 above, 64 below, 75, 78 below, 81 above, 81 below, 82, 107 below, 132 below, 138, 143, 150, 160, 164, 168, 170, 172 below, 175, 177, 190).
Musée de la Guerre, Vincennes, 31.
Nationalmuseum, Stockholm, 15, 49, 60, 77.
O. E. Nelson, New York, 212, 280.
Öffentliche Kunstsammlung, Basle, 12, 51, 65, 182.
Philadelphia Museum of Art, Philadelphia, 8, 20, 102, 120, 127, 132, 169.
Piccardy, Grenoble, 58.
Réunion des Musées Nationaux, Paris, 7, 10, 27, 28, 29, (p. 76 centre).
Rijksmuseum Kröller-Müller, Otterlo, 92, 93, 94.
John D. Schiff, New York, 88, 118, 123, 128.
Sotheby & Co., London, 26, 36.
The Museum of Modern Art, New York, 25, 81, 115, 177, 181, 259.
The Solomon R. Guggenheim Museum, 53, 67.
Eileen Tweedy, London, 39.
Marc Vaux, Paris, 19, 52, 56, 287.

Photographs not listed above have been supplied by the owners of the works.

4942-1971. — Imprimerie Reliure Maison Mame, Tours. D. L. 3e trimestre 1973.
Printed in France